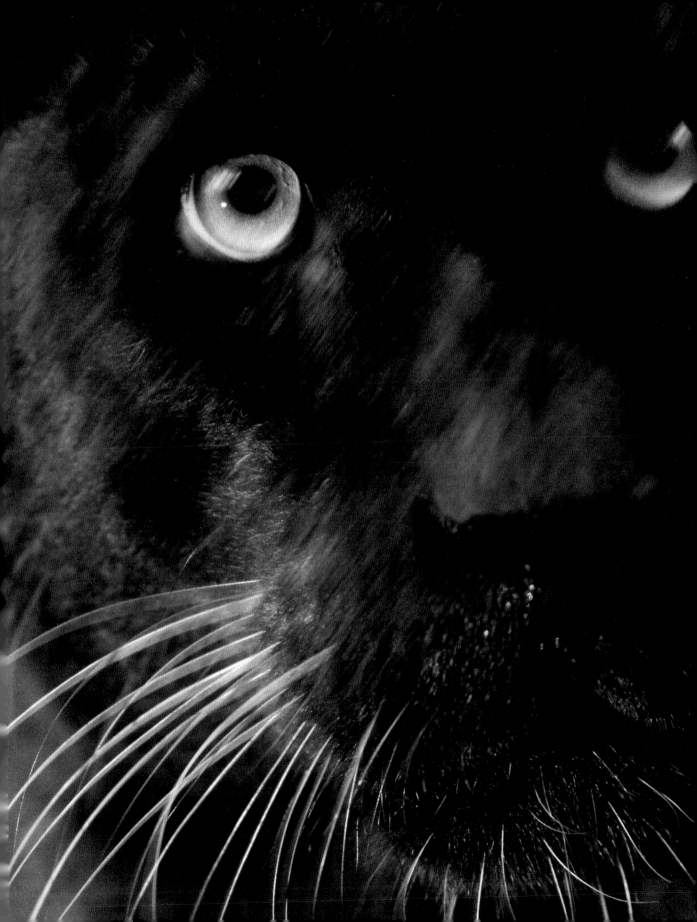

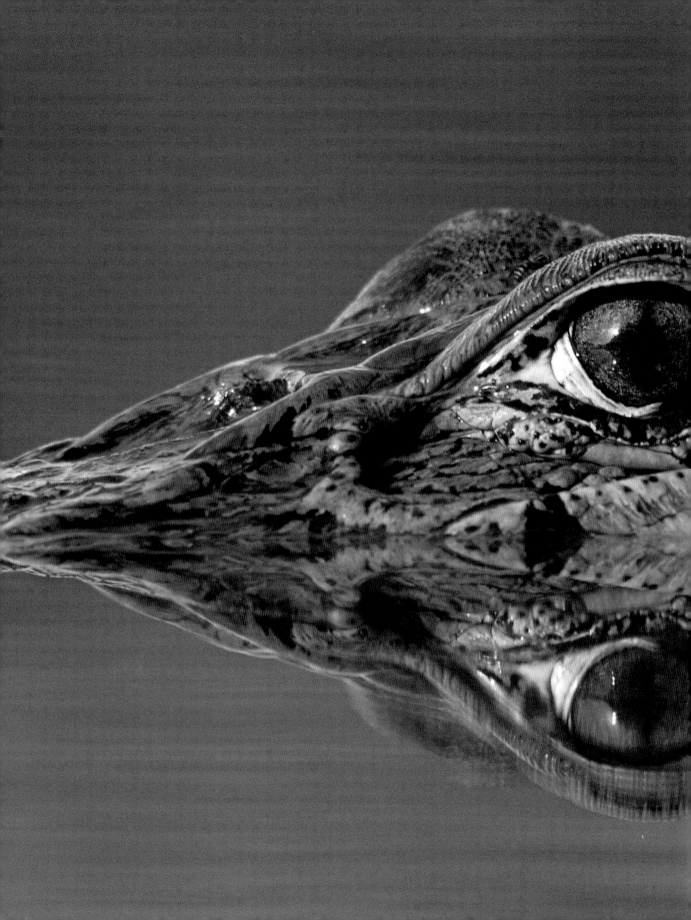

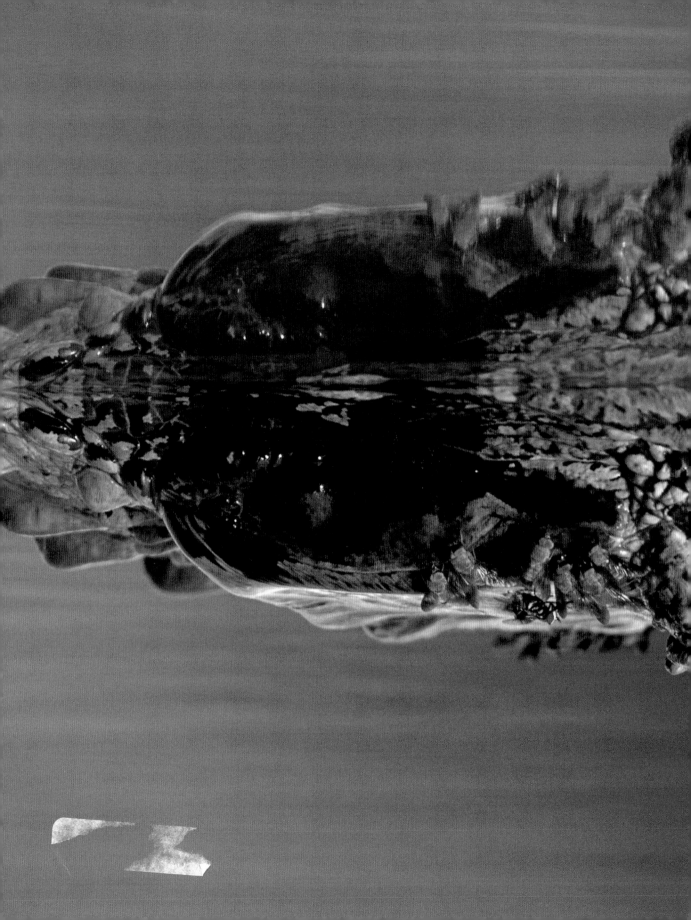

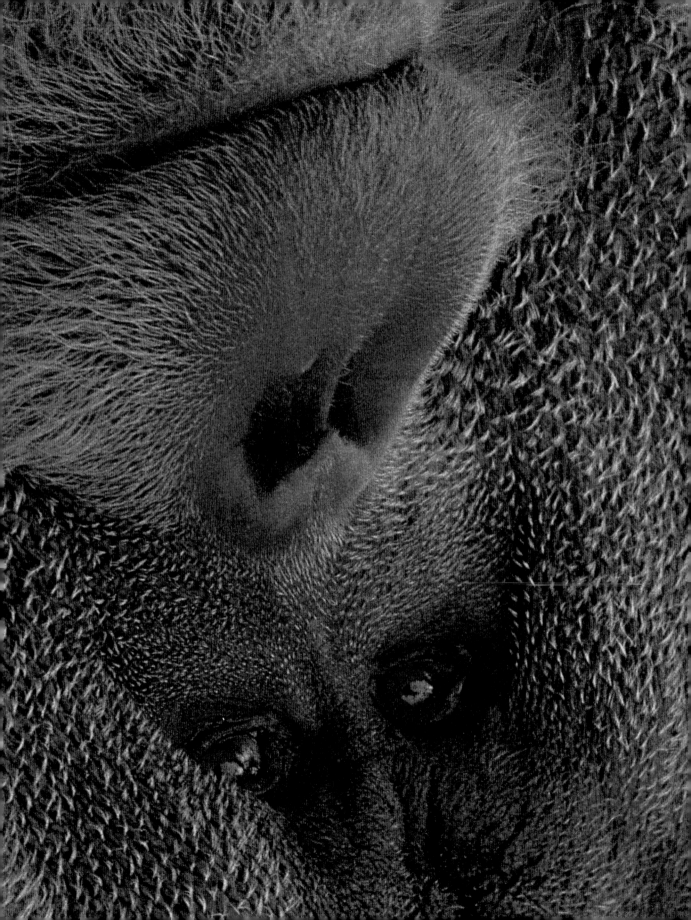

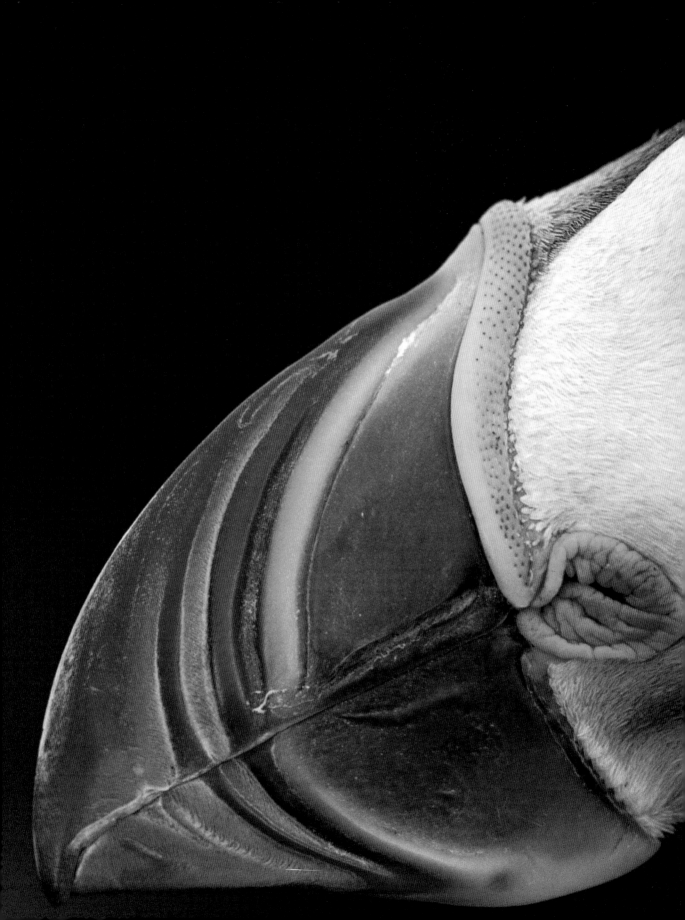

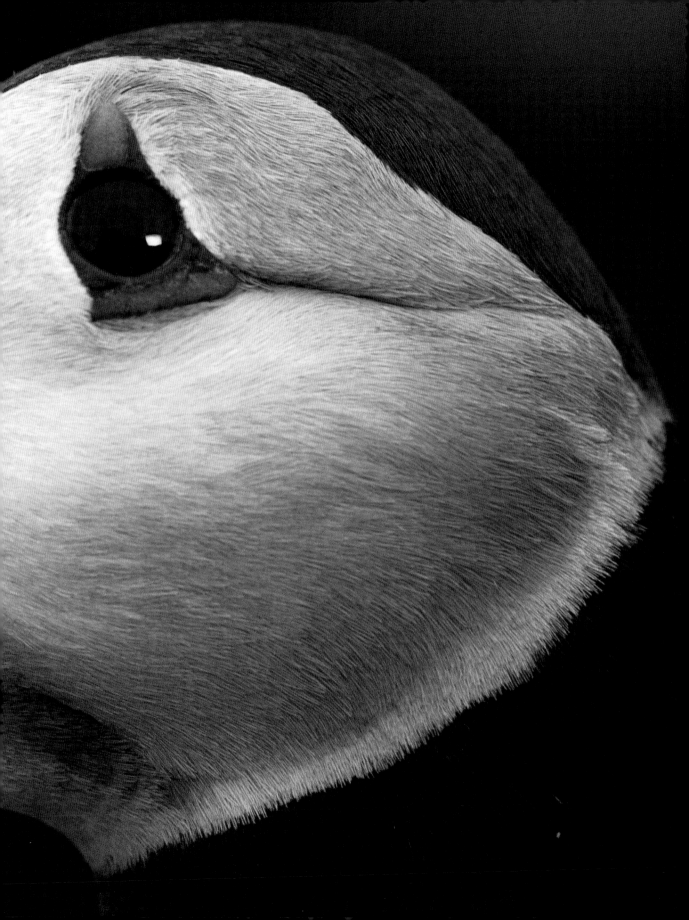

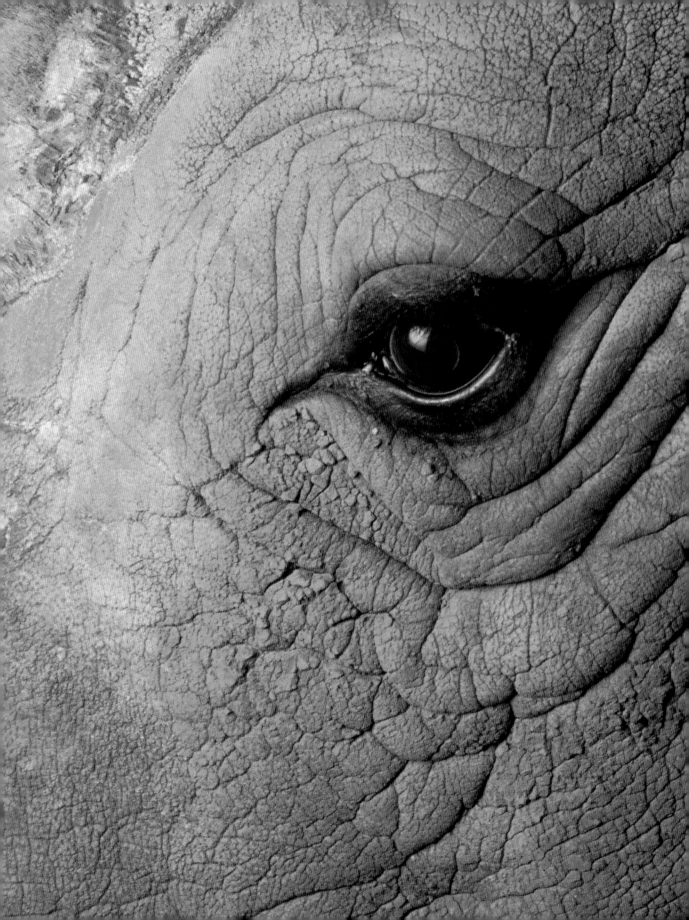

INTIMATE ENCOUNTERS

EYE T

WITH THE ANIMAL WORLD

O EYE

FRANS LANTING

EDITED BY CHRISTINE ECKSTROM

TASCHEN

KÖLN LONDON LOS ANGELES MADRID PARIS TOKYO

For my mother and father

Produced by Terra Editions
in association with
TASCHEN GmbH

Copyright © 1997, 2003 Terra Editions, Santa Cruz, California
www.lanting.com

Published by TASCHEN GmbH
Hohenzollernring 53, D-50672 Köln
www.taschen.com

Original edition: © 1997 Benedikt Taschen Verlag GmbH

Photographs copyright © 1997 Frans Lanting

Design: Jennifer Barry Design, Sausalito, California

Editor: Christine Eckstrom, Santa Cruz, California

Publisher's coordinator: Christiane Blaß, Cologne

COVER: *Cougar, Belize*
PAGE 1: *Black Leopard*
PAGES 2-3: *Black Caiman, Peru*
PAGES 4-5: *Orangutan*
PAGES 6-7: *Atlantic Puffin, Iceland*
PAGES 8-9: *White Rhinoceros*

ISBN 3-8228-2830-0

Printed in Italy

CONTENTS

INTRODUCTION

I have always been drawn to animals. But the thought of a life centered around that passion did not occur to me until after I had embarked on a career in economics. I should have realized that my heart was in a different place when the week after I graduated with a master's degree, I was back in a marsh next to the university, photographing birds. Two years later, after I had moved to California for a research project, I abandoned all caution, took up a camera—and never looked back. How I made the transition from academics to nature photography is still a mystery to me. I plunged in without formal training in either photography or biology. Perhaps this absence of qualifications has helped me to maintain an open mind. Although I often use the findings of field science as the basis for my work, I like to go beyond a scientific approach to the point where I see eye to eye with my subjects. Ultimately the animals are my teachers. They define themselves in their encounters with me—and no two are alike.

During my youth in Holland I read a children's book that made a deep impression on me. *The Wonderful Adventures of Nils,* published by the Nobel Prize-winning Swedish author Selma Lagerlöf in 1907, tells the story of a boy who shrinks to the size of an elf, climbs on the back of a barnyard goose, and joins a flock of wild geese migrating north. For a year Nils travels with the geese, who introduce him to Eagle, Raven, Bear, and other animals. He learns to see the world through their eyes. But when Nils finally returns to his family's farm and regains his former size, he loses his standing among the animals. The geese, suddenly afraid of their companion, take off—but not until after they plead with him to become an advocate for their needs.

As sentimental as it may be, this children's story has resonated with me, and even today it reflects some of my basic beliefs and aspirations as a naturalist. I have spent much of the past two decades in the company of animals, trying to understand and interpret their ways. The conditions under which I work are often a far cry from Nils's intimacy with his wild geese. Long lenses, remotely controlled cameras, and other complicated contraptions—plus a great reserve of patience—are often prerequisites to overcoming the distance most animals like to keep from the camera. There are, however, some places where things are simpler, where the appearance of *Homo sapiens* does not trigger immediate fright or flight. In the course of

my wanderings around the globe I have been privileged to spend time in a number of such Shangri-las, and I think back to those occasions with great pleasure. Living with albatrosses on a small island in the middle of the Pacific Ocean, roaming with a troop of lemurs through a forest in Madagascar, camping out among giant tortoises in a Galápagos volcano—those were times when I shrank in size and learned to see the world through other eyes. The intimacy of those encounters provided the inspiration for this book.

In previous books like *Madagascar, A World Out of Time* and *Okavango, Africa's Last Eden,* my goal was to show the relationship between animals and their worlds, including the human environment which more than ever shapes their fate today. In this book I have attempted to do the opposite. I removed animals from the context in which they live, and brought together species and situations from around the world in order to celebrate the kinship of all life.

In the first section, "One on One," animals are represented in a range of attitudes to show their individuality, followed by a gallery of their emotional responses to contact—to me and to others. "Two by Two" presents individuals in a social context, as itinerant pairs overcoming antagonistic impulses before they become mates, and ultimately as parents nurturing the next generation. In "All in All" animals are featured as members of societies. They are shown as individuals within multitudes, and great congregations are portrayed as the single entities they can become. This last section culminates in a display of the dynamic qualities of wildlife on the move. In some instances my presence shaped the nature of the encounter. In others, animals either ignored me or forgot about me, and I was able to be a passive observer of their lives.

Wildlife photography was originally a personal escape for me. It was an excuse to seek out animals on their own ground. But over time I have come to realize that there is a social component to my solitary work as well. Like the boy in the Swedish story, I hope my experiences can be a bridge between the animal world and the millions of people who will never crouch before an elephant or hunt with lions in the African night. What my eyes seek in these encounters is not just the beauty traditionally revered by wildlife photographers. The perfection I seek in my photographic compositions is a means to show the strength and dignity of animals in nature. This book is my tribute to them.

Frans Lanting
Santa Cruz, California

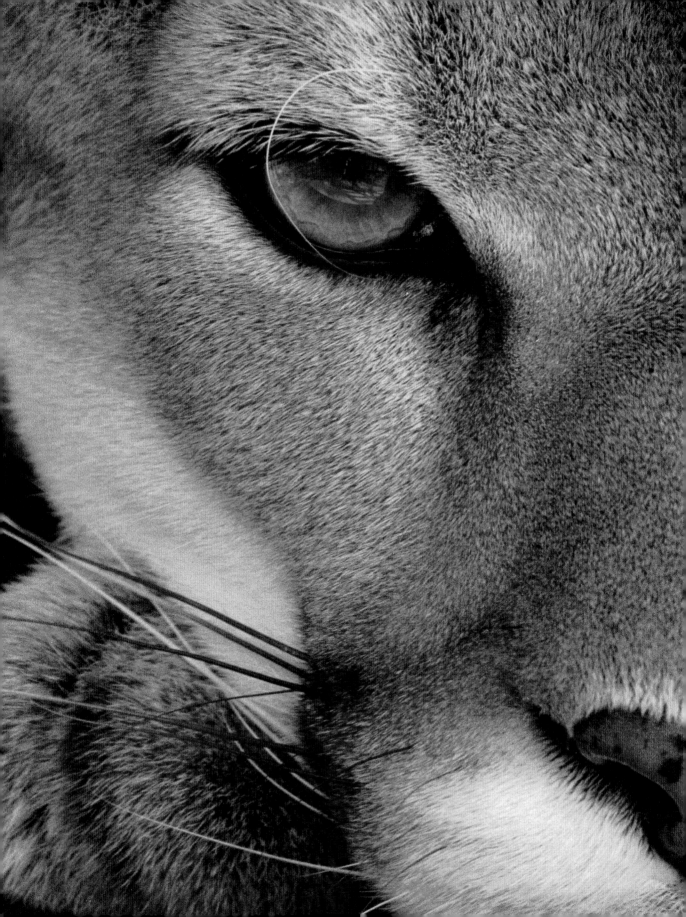

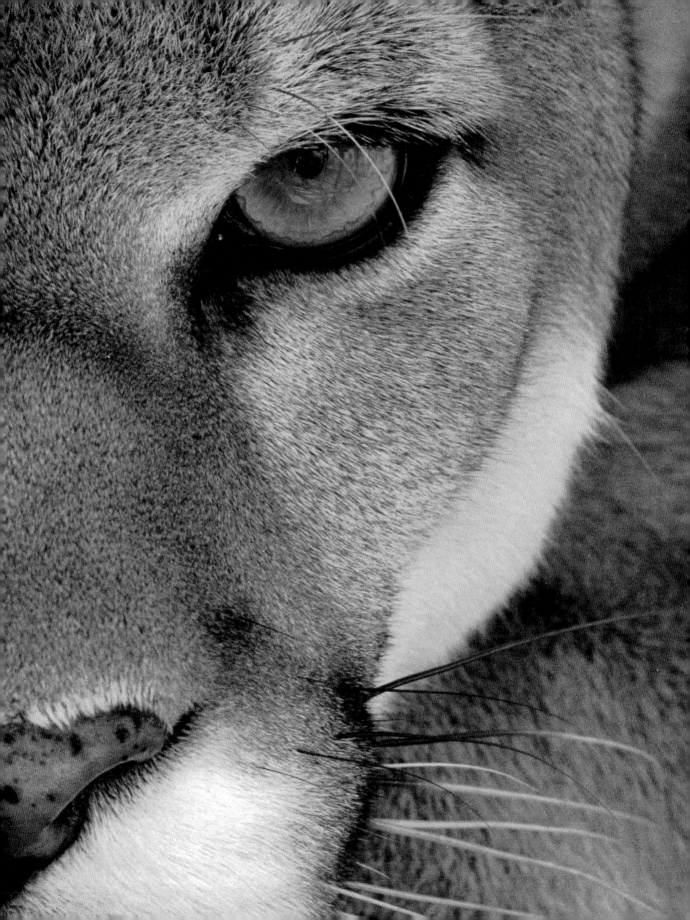

ONE ON ONE

ANIMAL PEOPLE

The native people of the northwest coast of North America are renowned for their wood carvings of animals immortalized in totem poles and great masks. This rich material culture is paralleled by a powerful narrative tradition. Some of their stories have been widely told; others are considered the legacy of bands and families. During a summer I spent traveling this coastal region, a Kwakiutl elder honored me by sharing a legend that belongs to his people. He took me to a sacred cave on his island and there, surrounded by the sweet scent of cedars, we sat down and he told me this story:

Once upon a time, he said, all creatures on the face of the earth were one. Even though they looked different on the outside, they all spoke the same language. From time to time they would come together at this cave to celebrate their unity. When they arrived at the entrance, they all took off their skins. Raven shed his feathers, Bear his fur, and Salmon her scales. Inside the cave, they danced. But one day a human, attracted by the commotion, crawled into the cave and surprised the animals in the act of dancing. Embarrassed by their nakedness they fled, and that was the last time they revealed themselves this way.

The mythical understanding that underneath their separate identities all animals are one has been a guiding principle in my photographic work. I aim to get past the feathers, fur, and scales. I like to get under the skin. It doesn't matter whether I am focusing on a three-ton elephant or a tiny tree frog. I want to get up close and face them, eye to eye.

Sometimes it is easy to see the connections between humans and the rest of creation. The bonds are clear in the case of bonobos, the great apes most like ourselves. To look into their eyes is to imagine ancient ties, to feel the shock of the familiar. Other times it is harder. With a cold-blooded crocodile I have to take more time and reach into the recesses of my own mind to conjure a sense of its world.

People who know me as a wildlife photographer sometimes ask if I ever photograph people. The question implies a separation between humans and other animals that does not exist for me. People are always present in my photographs, whether the images appear to be of sanderlings, chameleons, or cougars. You just have to learn to look past their disguise.

We now know that we share up to ninety-eight percent of our genes with our closest relatives in the animal kingdom. What I try to do as a photographer is to use that small difference in our genetic makeup which has given us the ability to imagine, and look at all that we have in common with other living things. When I raise my camera to other creatures, I drop my skin like the animals at the sacred cave. That's when I can see who they really are.

PAGES 16–17: *Cougar, Belize*

RIGHT: *Bonobo*

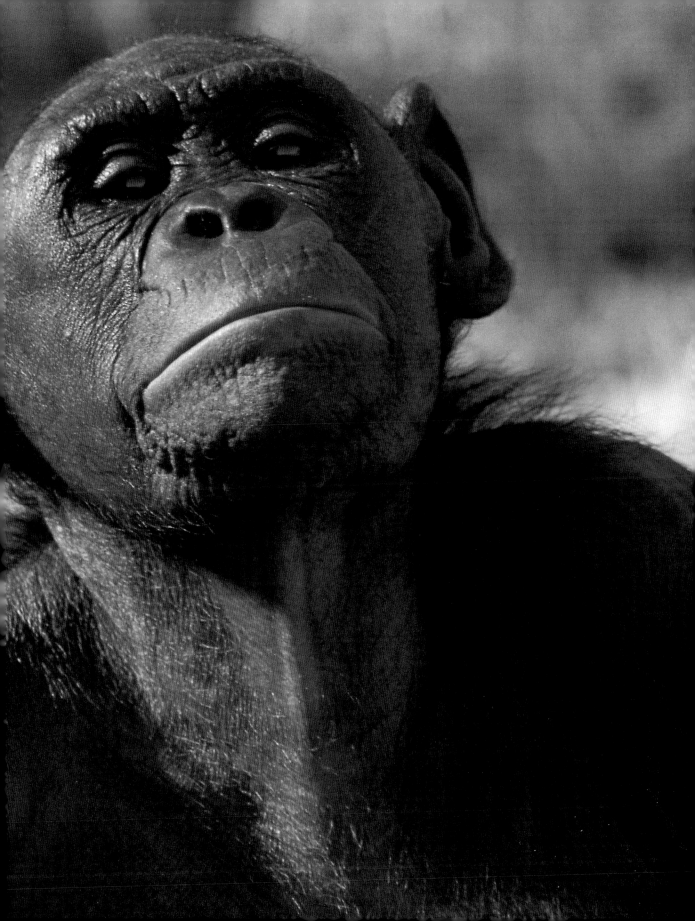

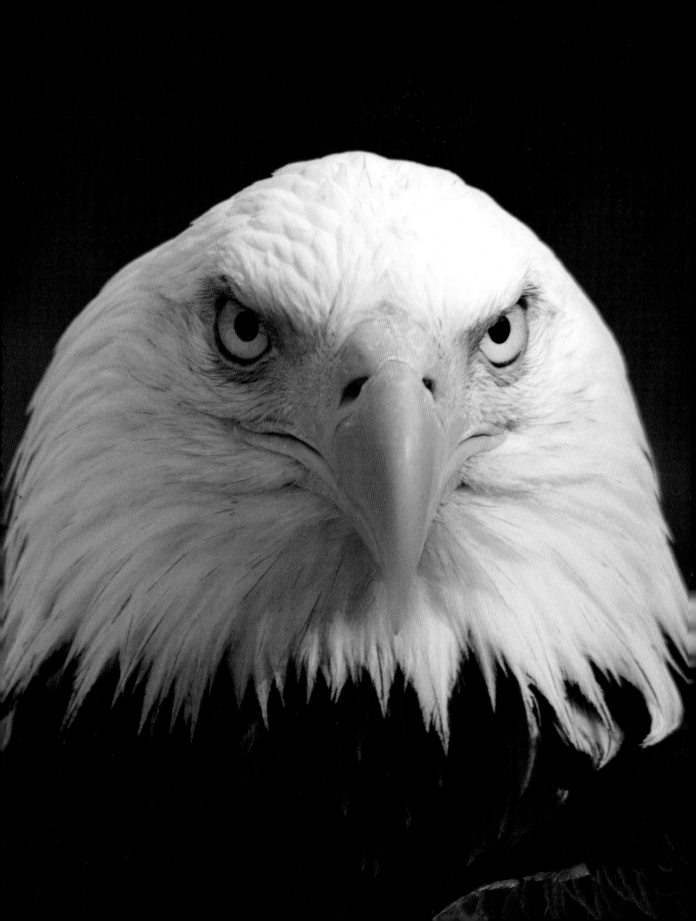

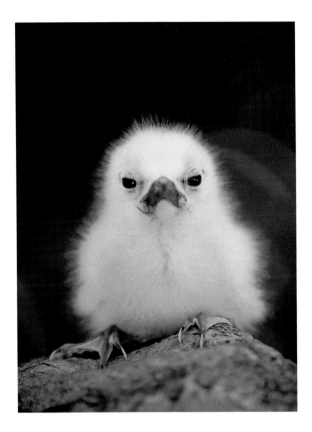

LEFT: *Bald Eagle*
ABOVE: *Fairy Tern, Hawaii*
PAGES 24-25: *Striated Caracaras, Falkland Islands*

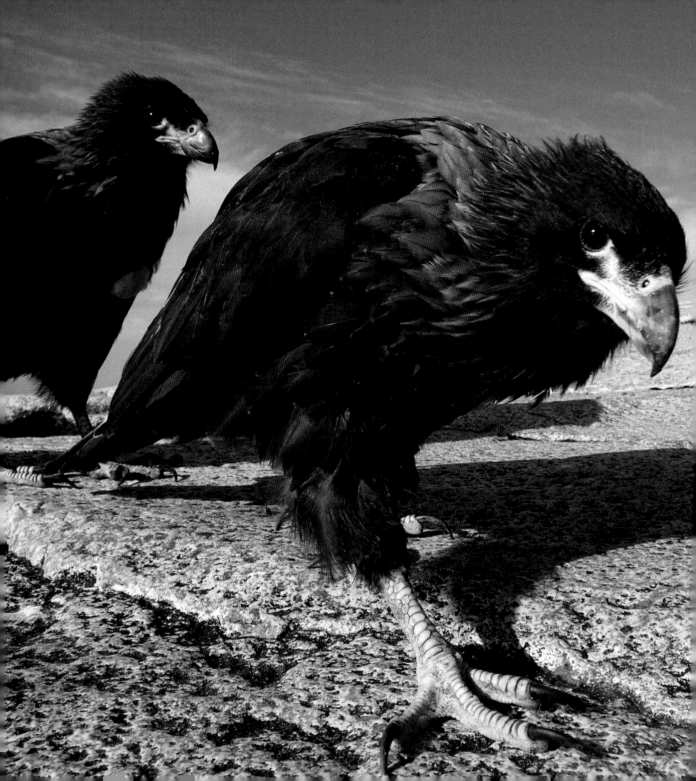

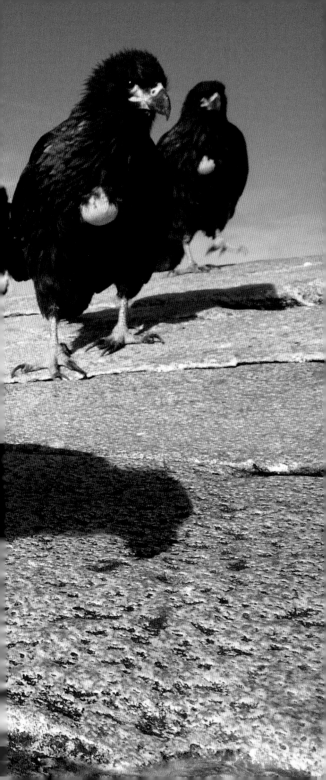

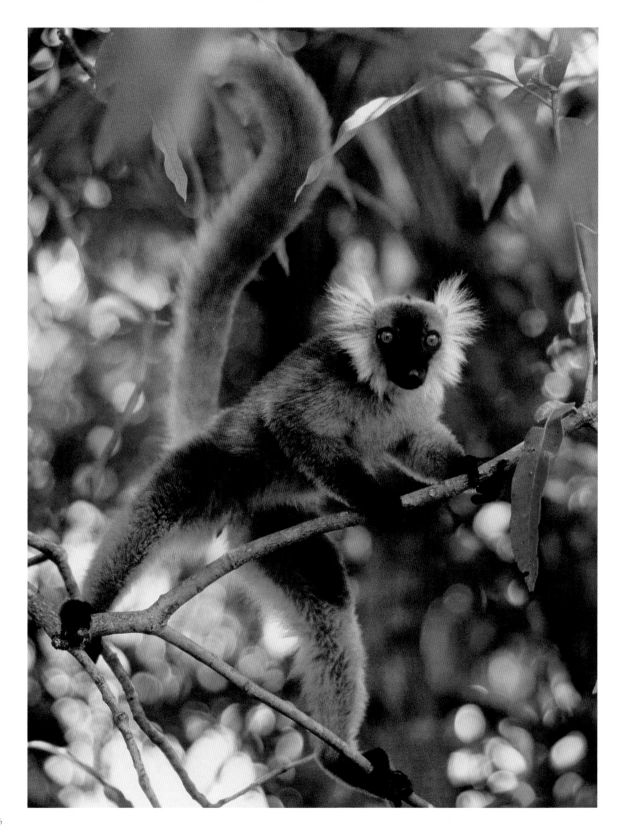

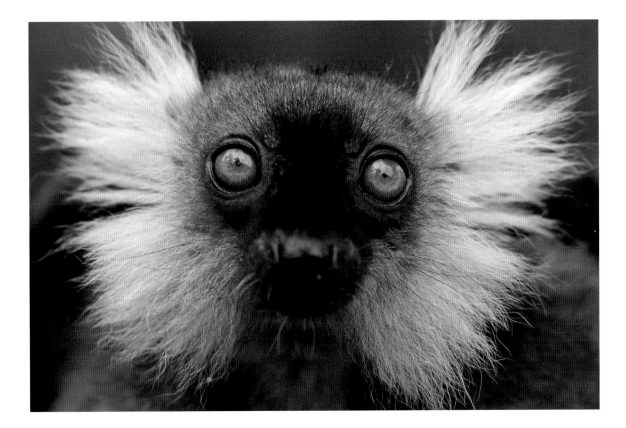

LEFT AND ABOVE: *Black Lemur, Madagascar*
PAGES 28–29: *Tarsier, Borneo*
PAGE 30: *Keel-Billed Toucan, Belize*
PAGE 31: *Great Curassow, Belize*

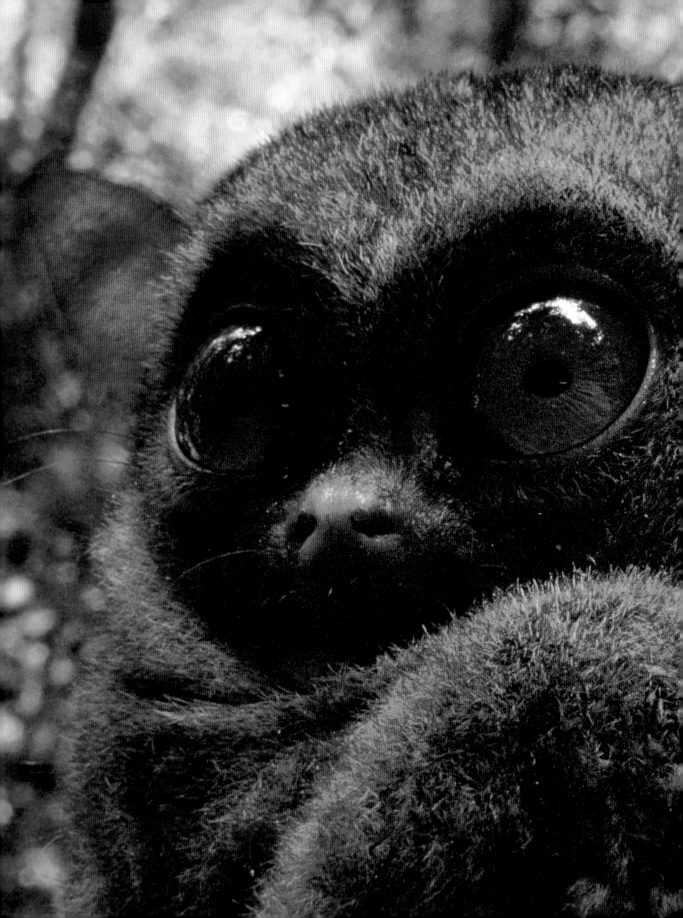

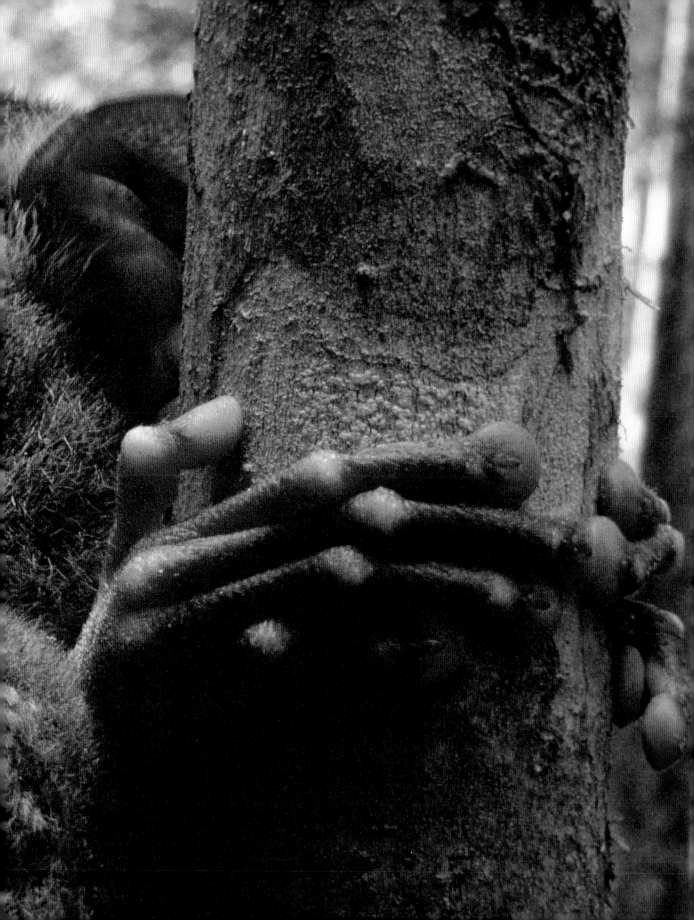

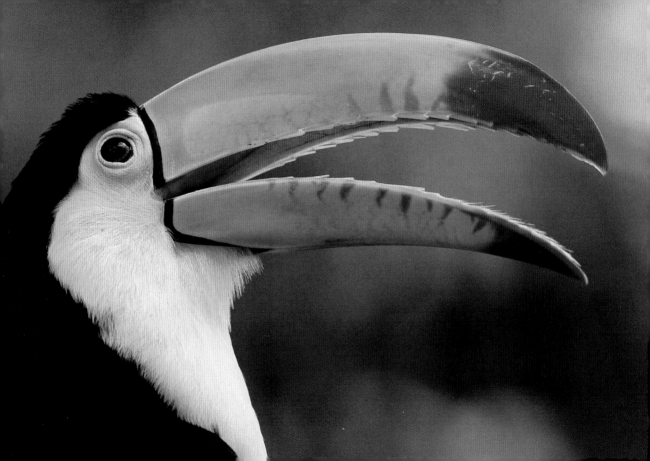

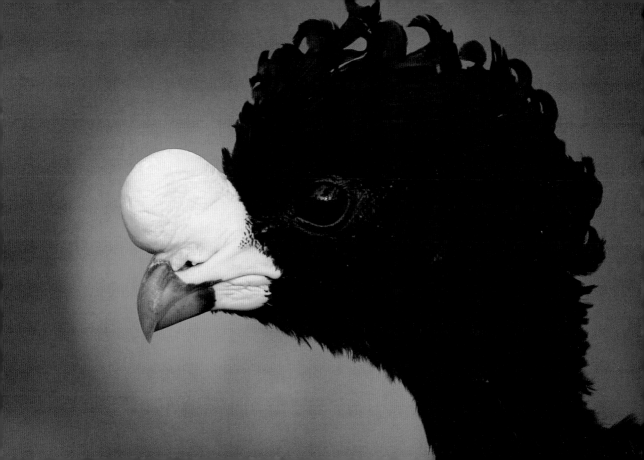

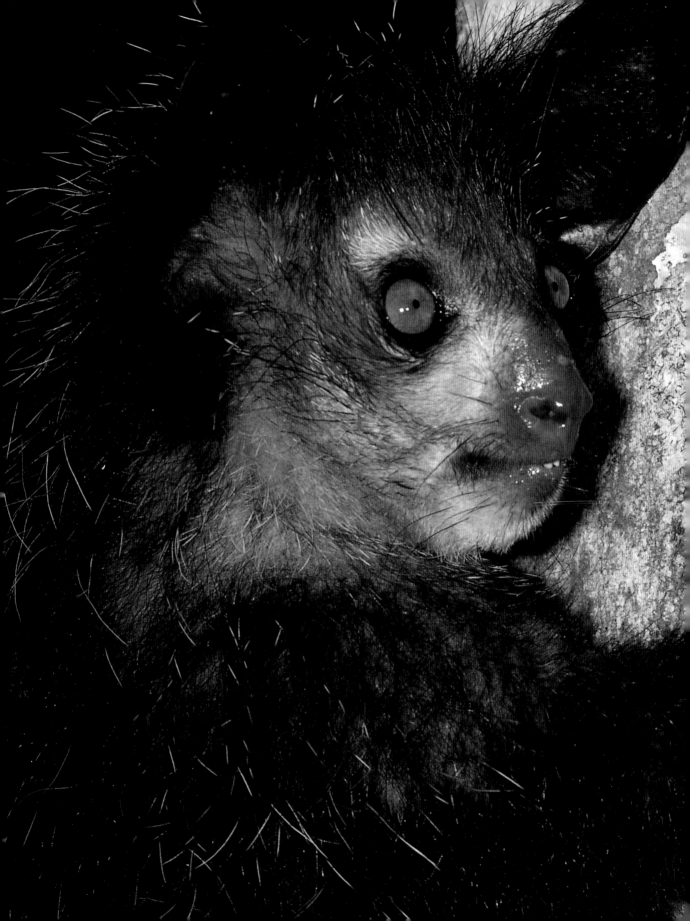

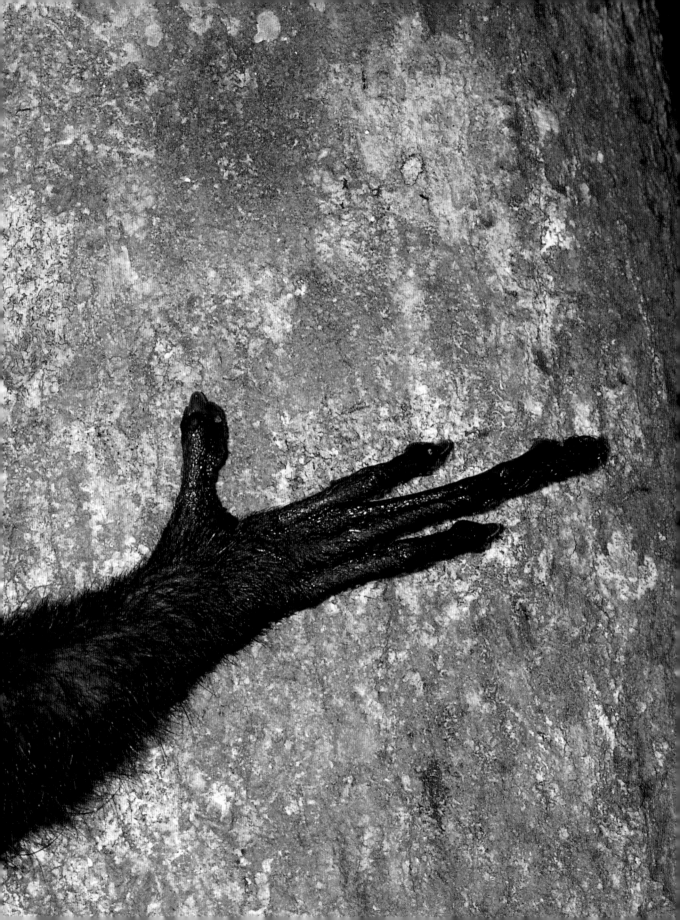

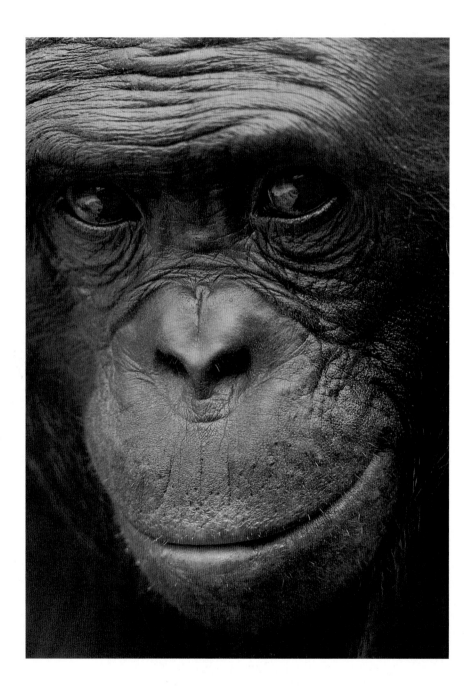

PAGES 32–33: *Aye Aye, Madagascar*
ABOVE: *Bonobo*
RIGHT: *Orangutan*
PAGES 36–37: *Bonobo*

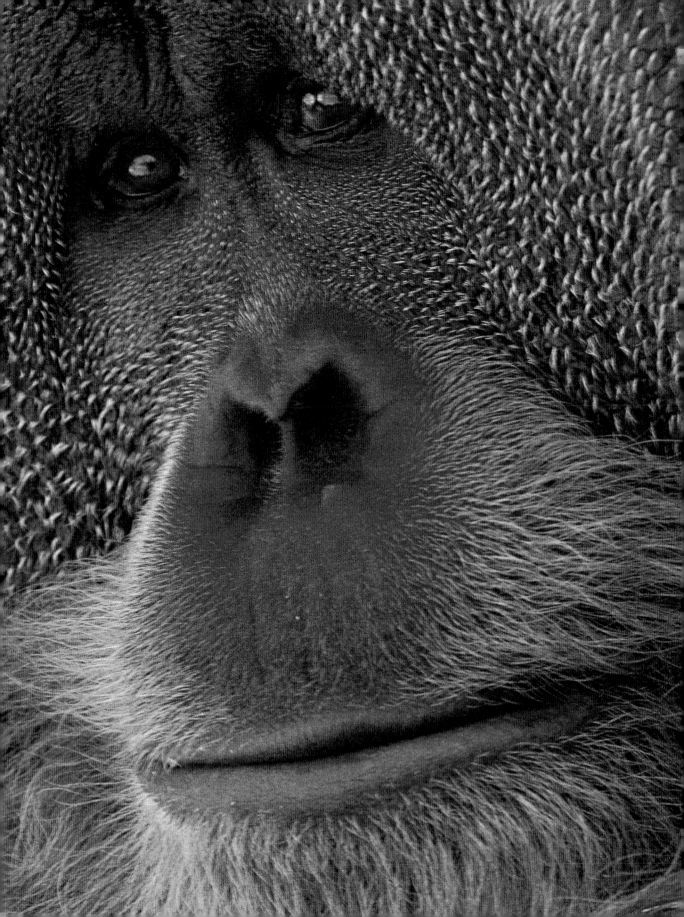

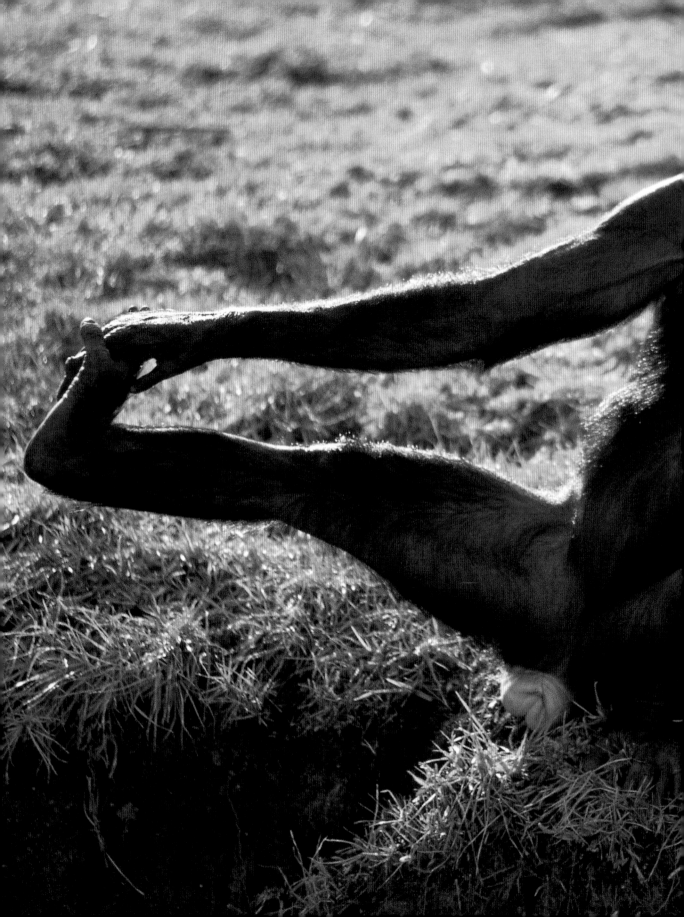

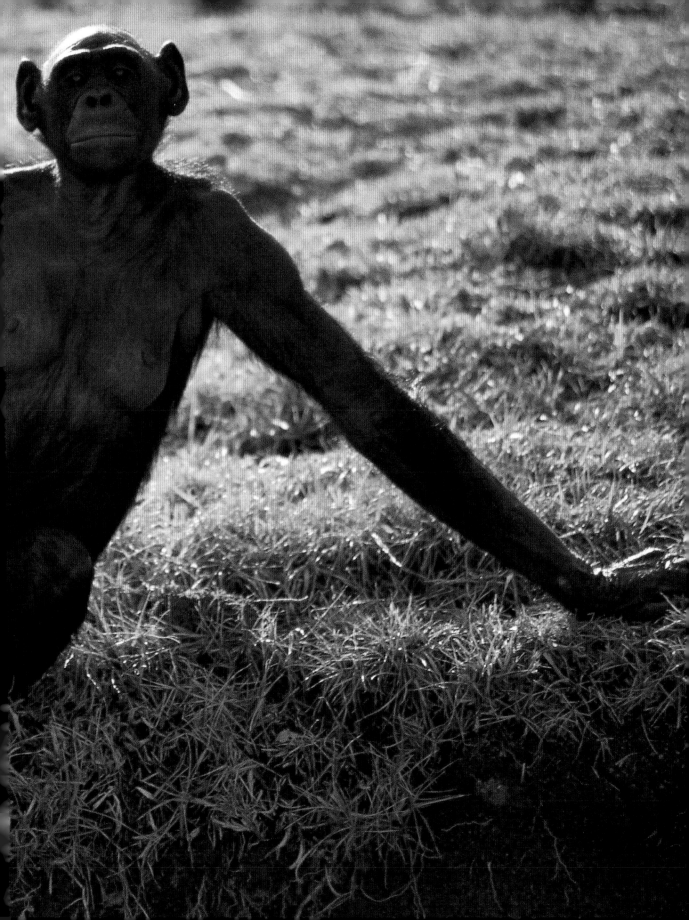

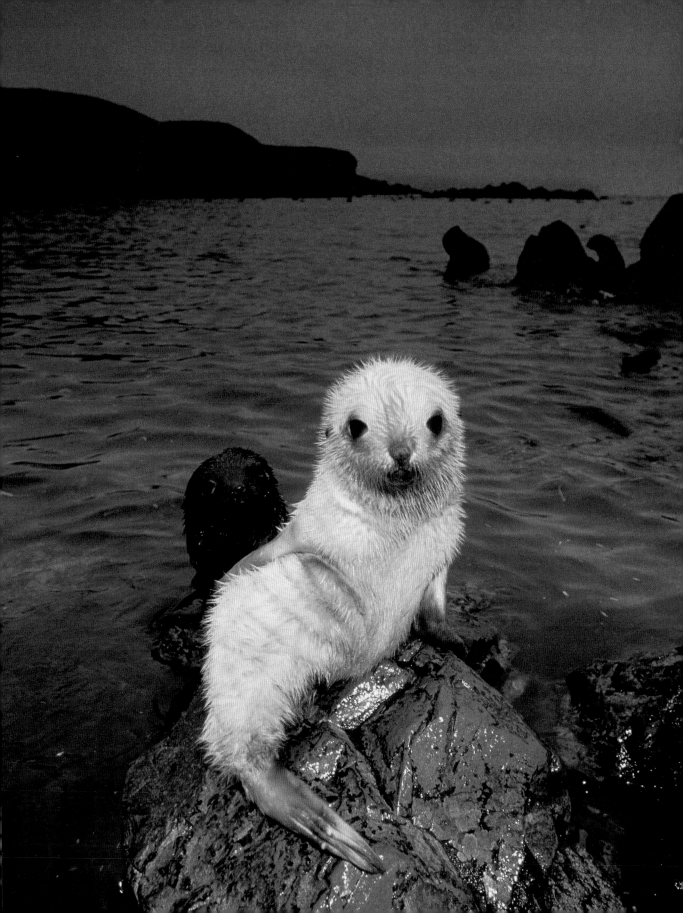

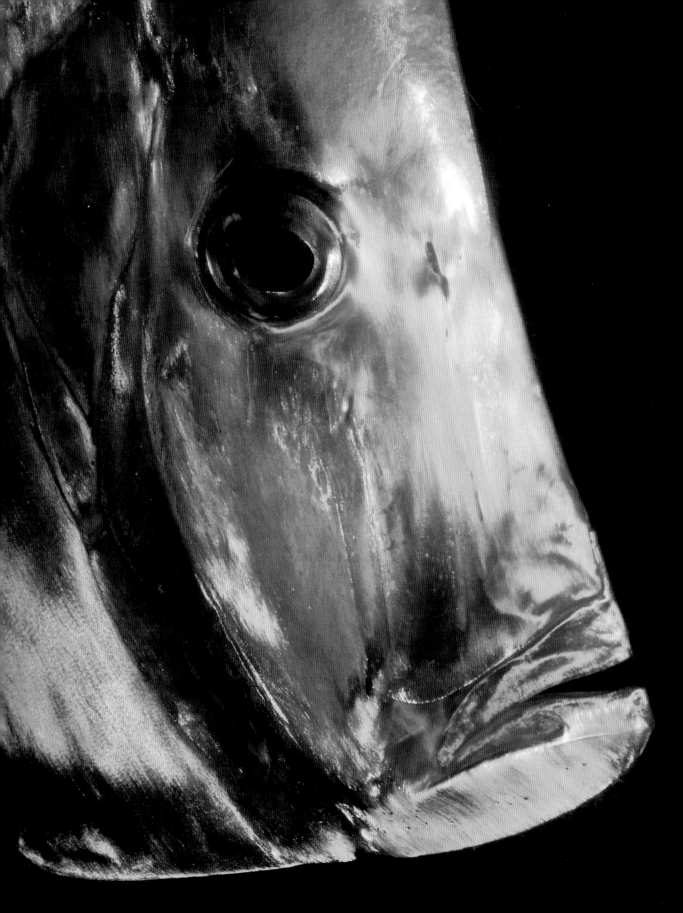

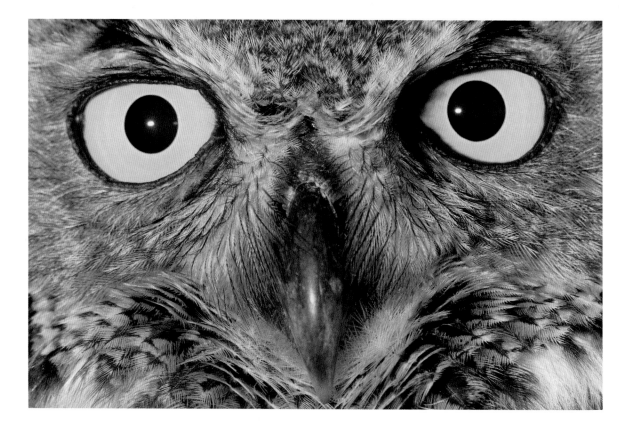

ABOVE: *Great Horned Owl, California*
RIGHT: *Owl Butterfly, Peru*
PAGES 44–45: *Peacock*
PAGES 46 AND 47: *Paraguay Caimans, Brazil*
PAGE 48: *Hyacinth Macaw, Brazil*
PAGE 49: *Red-Eyed Tree Frog, Belize*

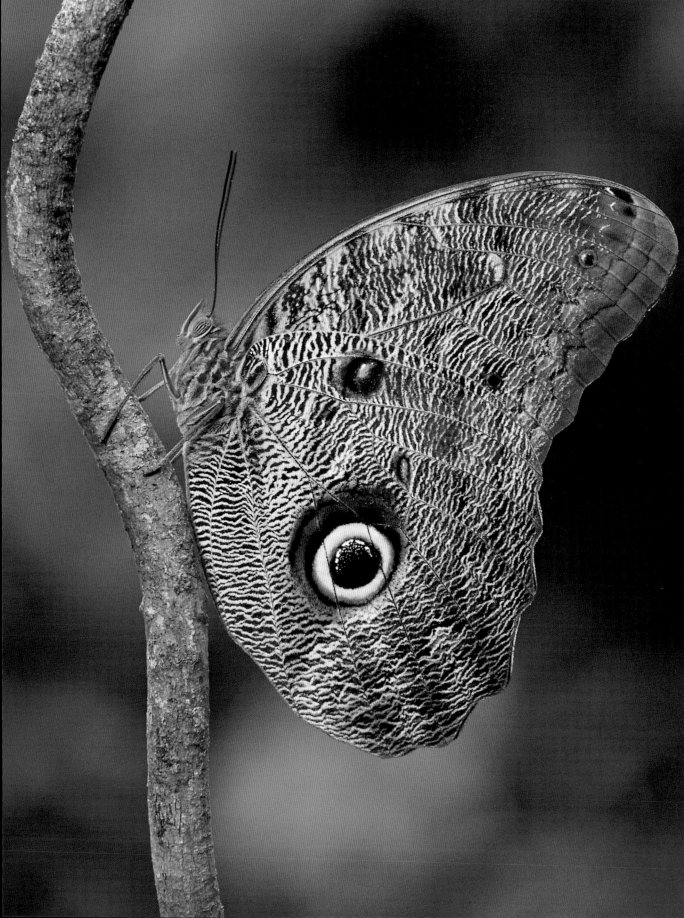

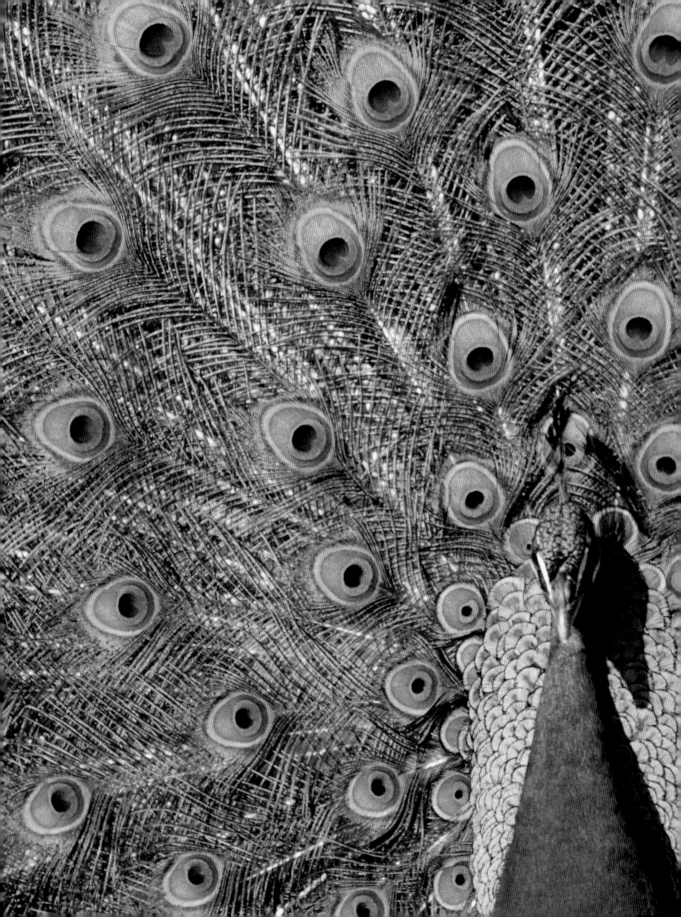

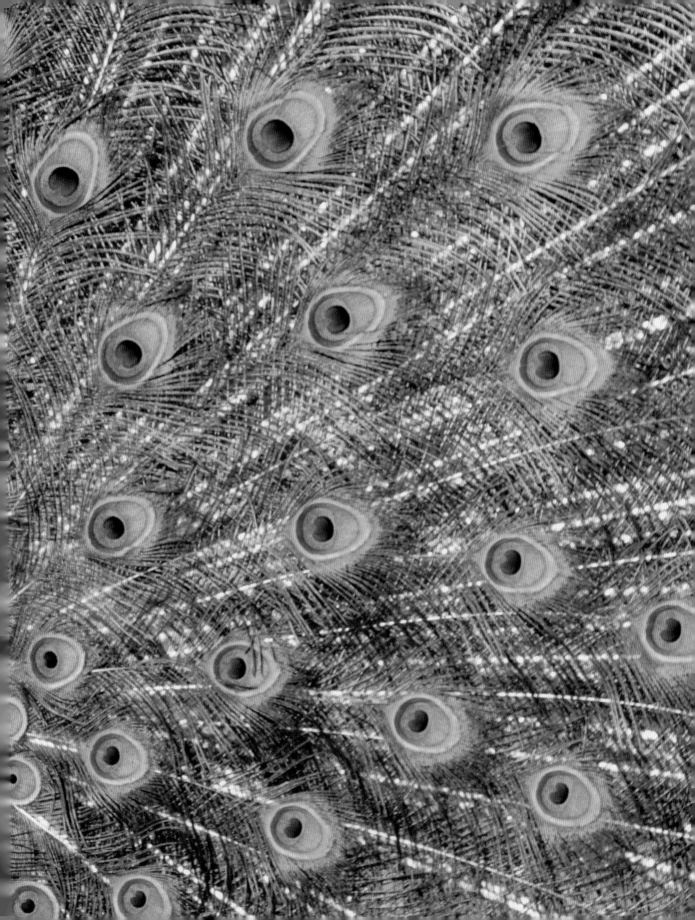

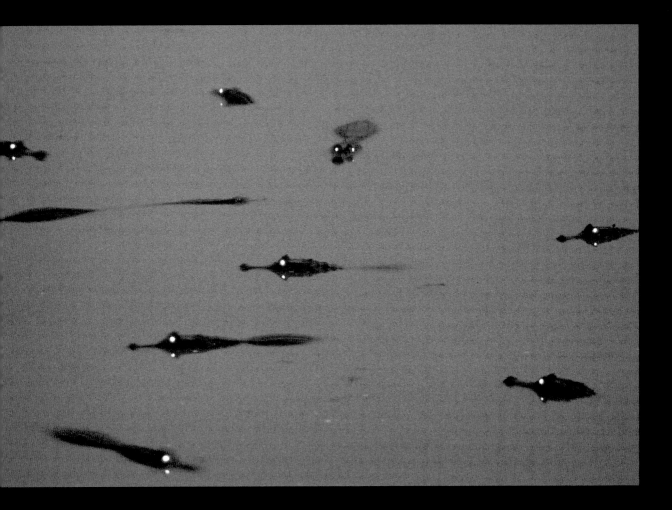

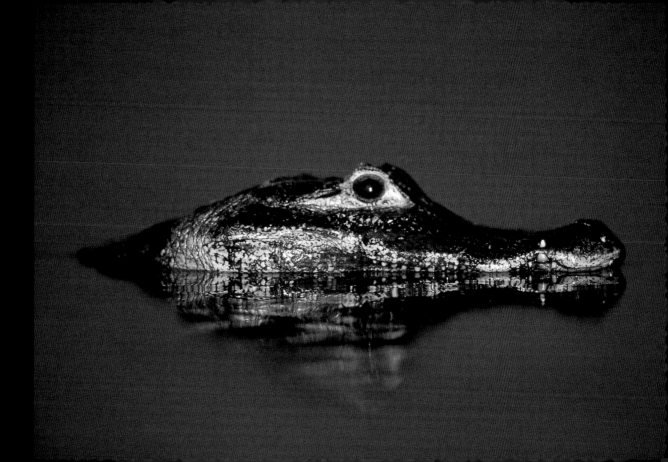

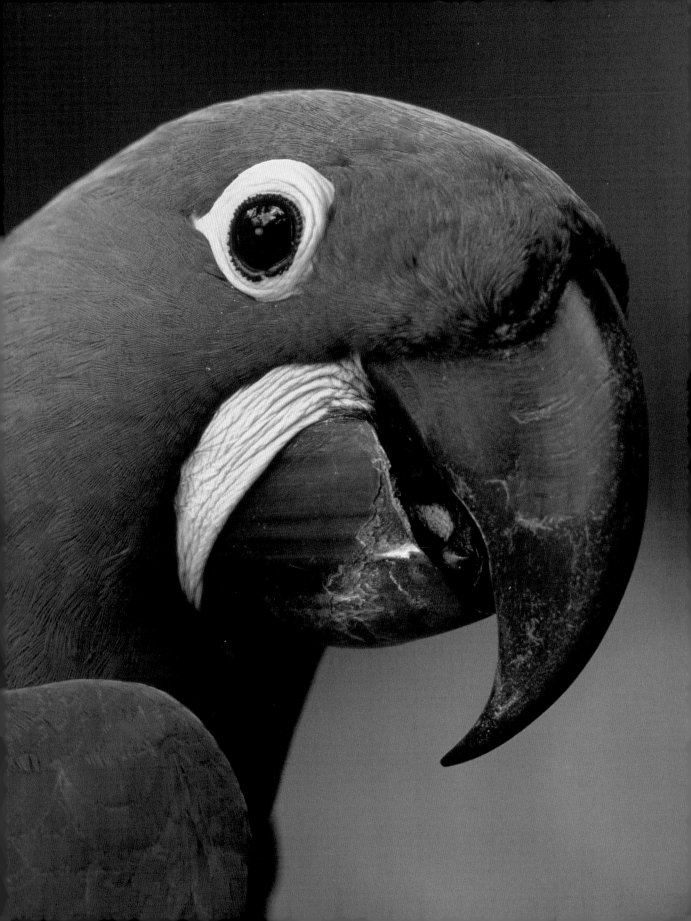

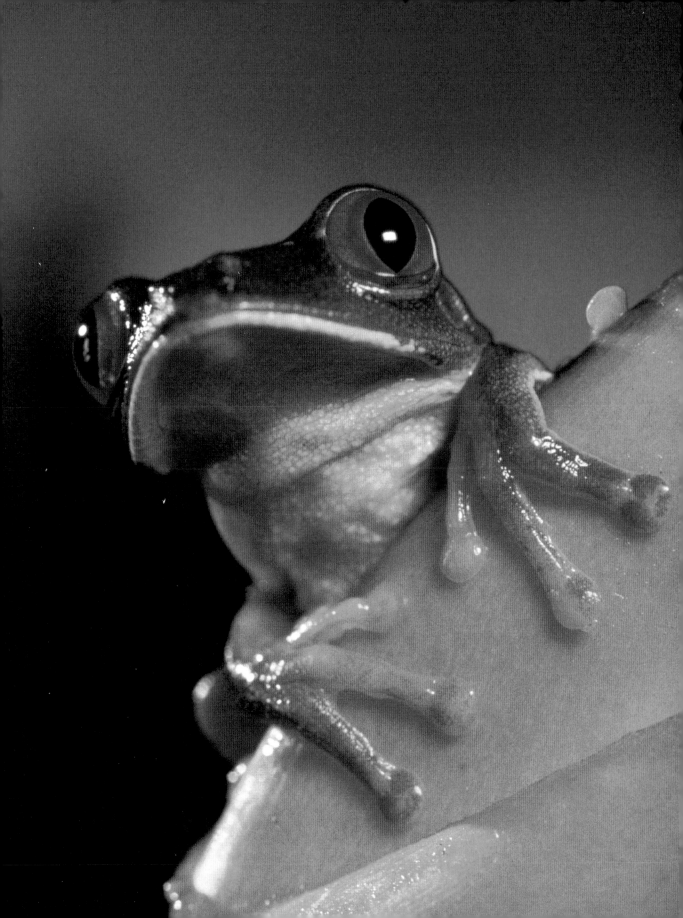

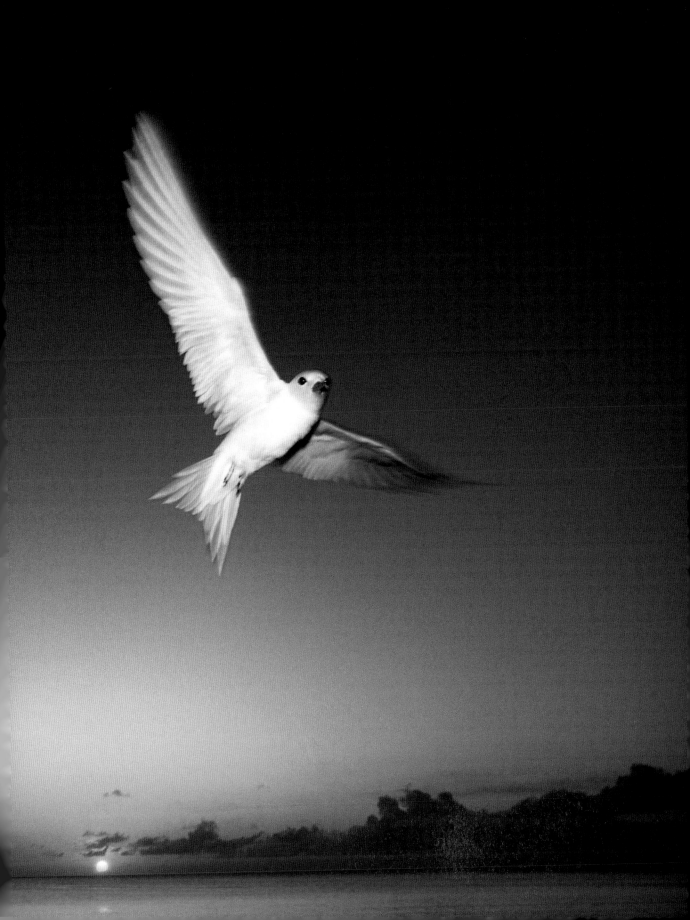

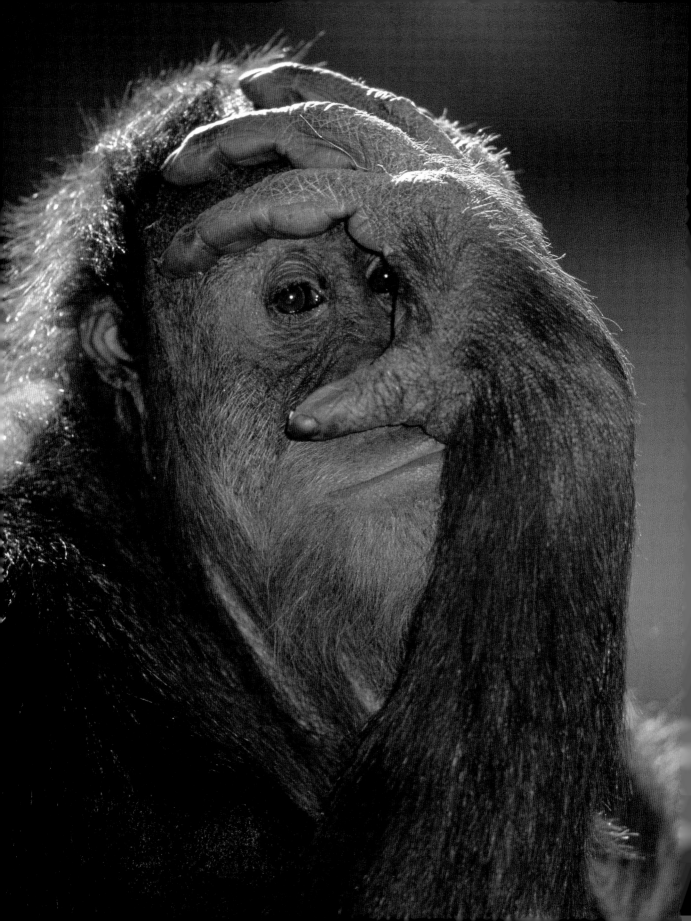

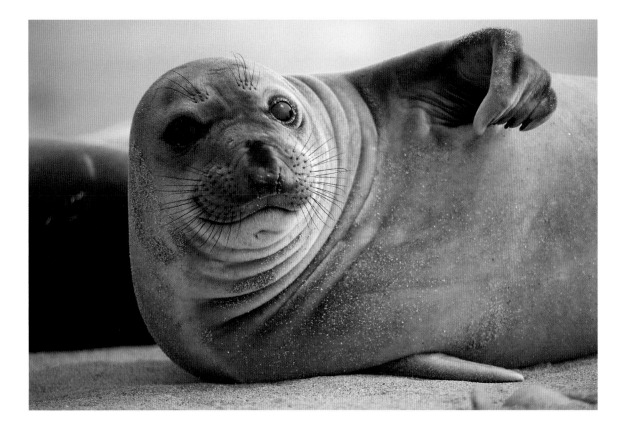

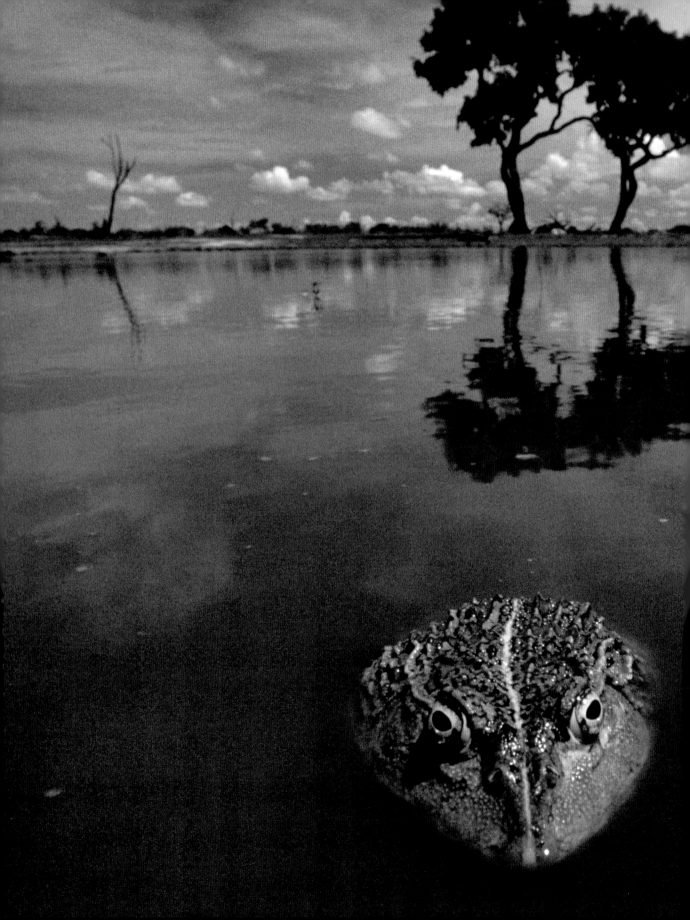

LEFT: *African Bullfrog, Botswana*
PAGES 56-57:
African Lion, Tanzania
PAGES 58-59:
African Lion, Kenya

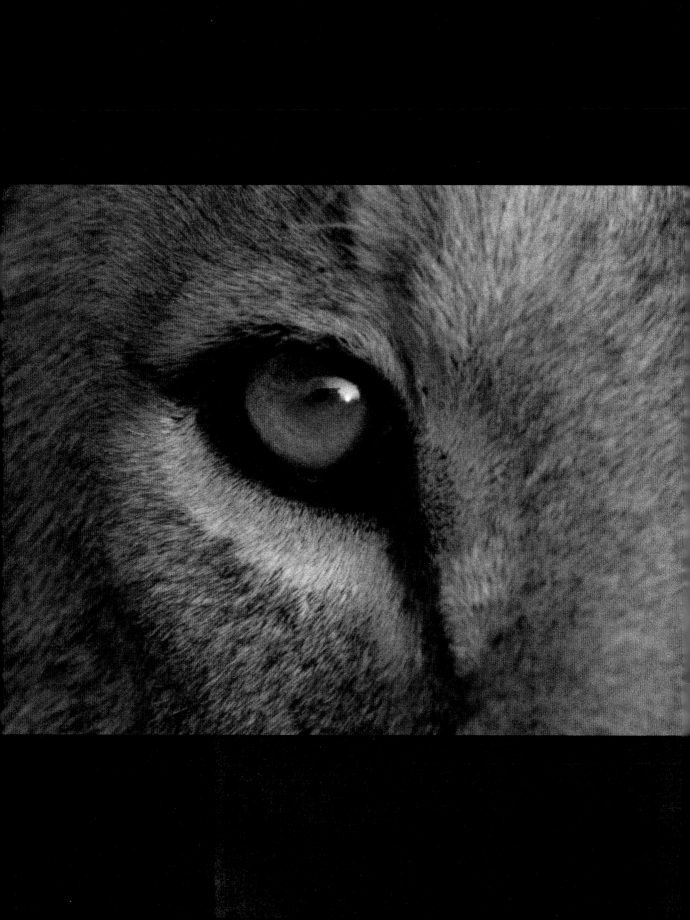

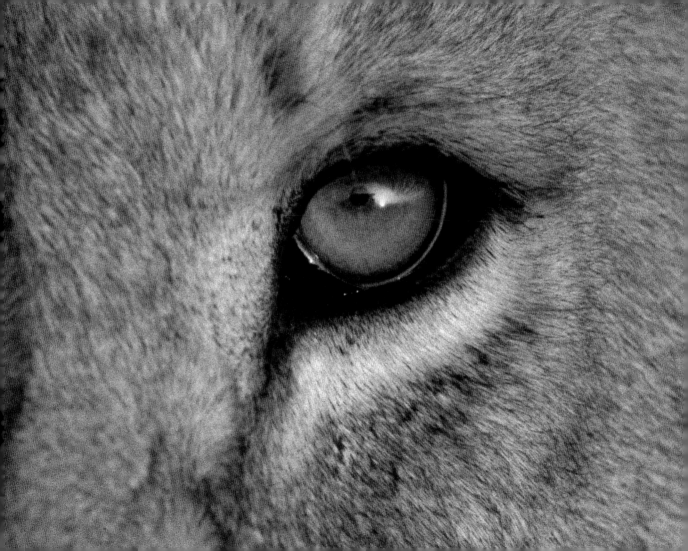

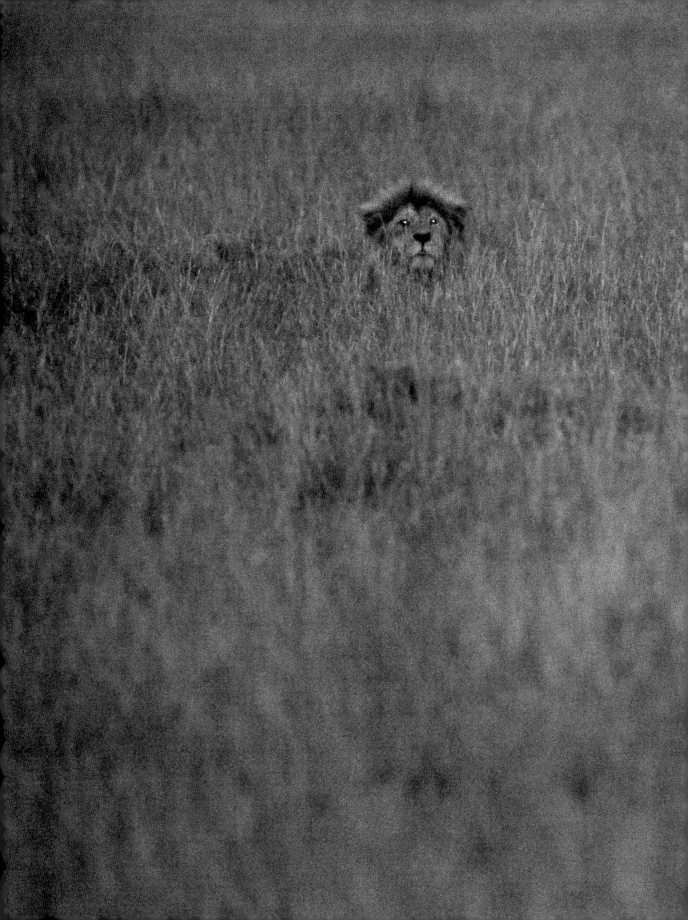

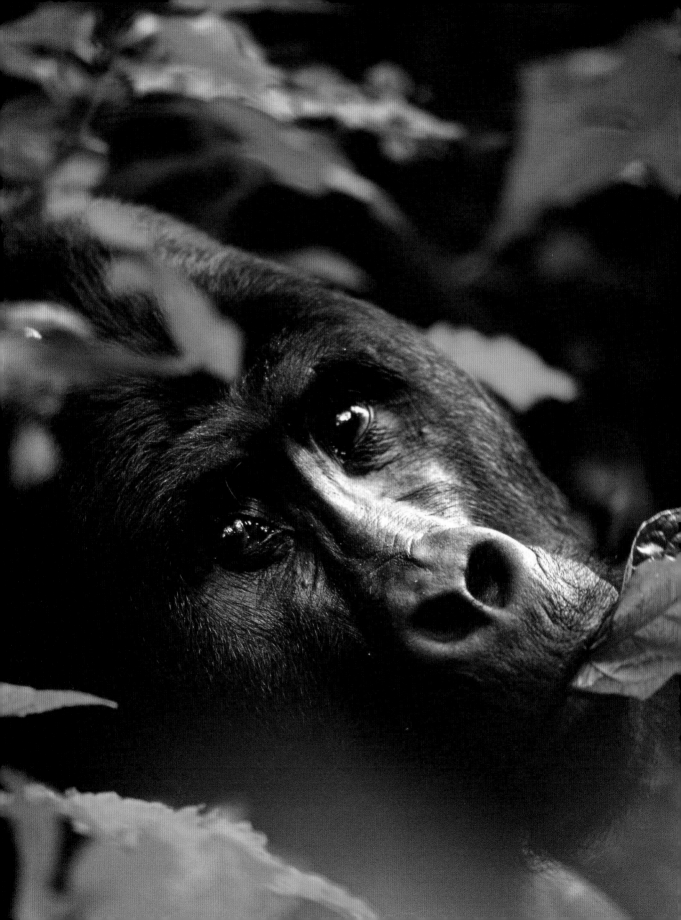

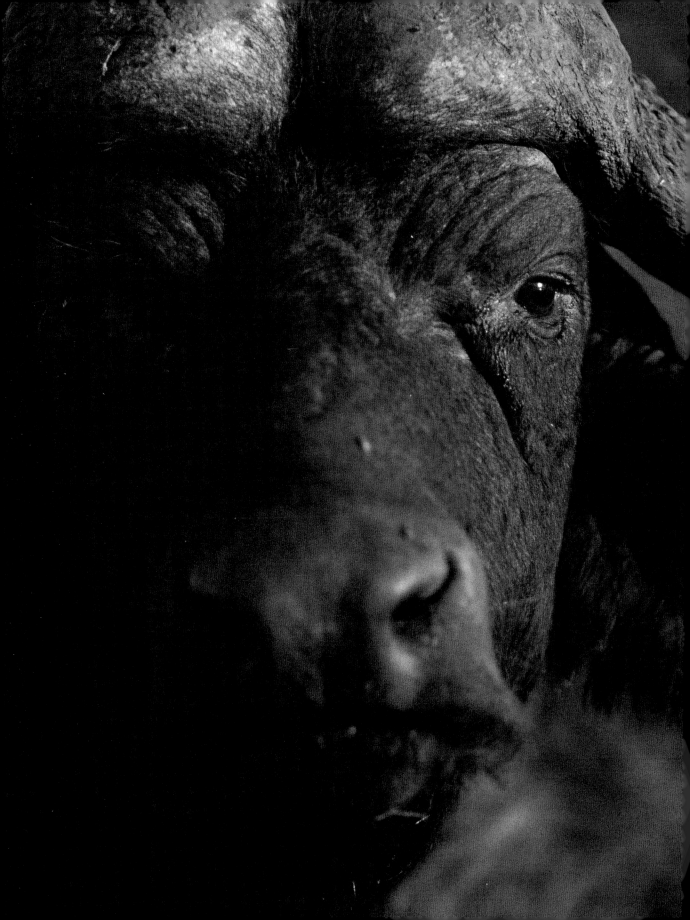

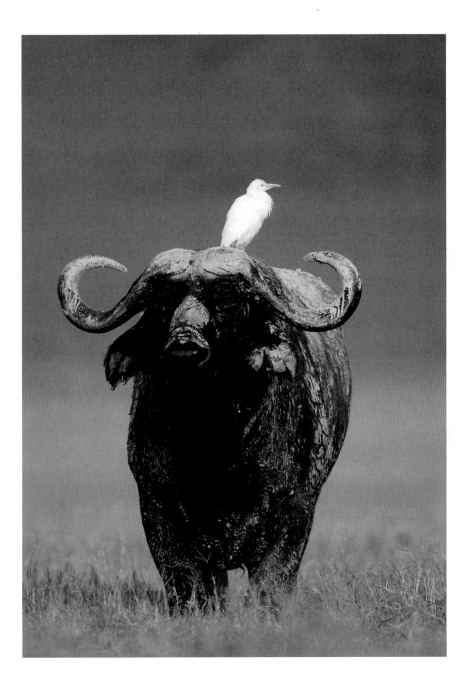

PAGE 60: *Eastern Lowland Gorilla, Congo*
LEFT: *Cape Buffalo, Botswana*
ABOVE: *Cape Buffalo and Cattle Egret, Tanzania*
PAGES 64–65: *African Elephant, Botswana*

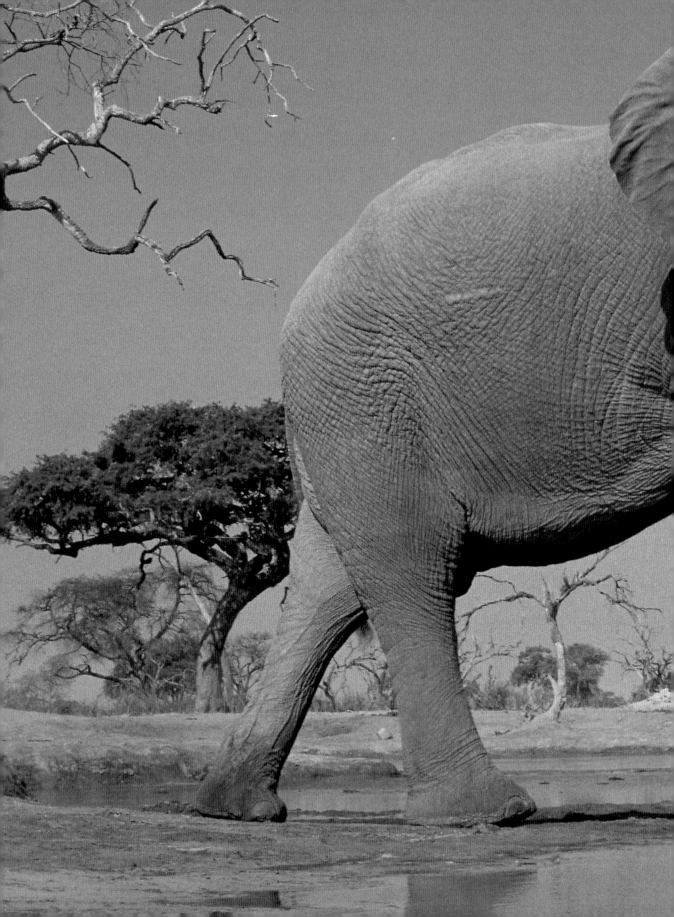

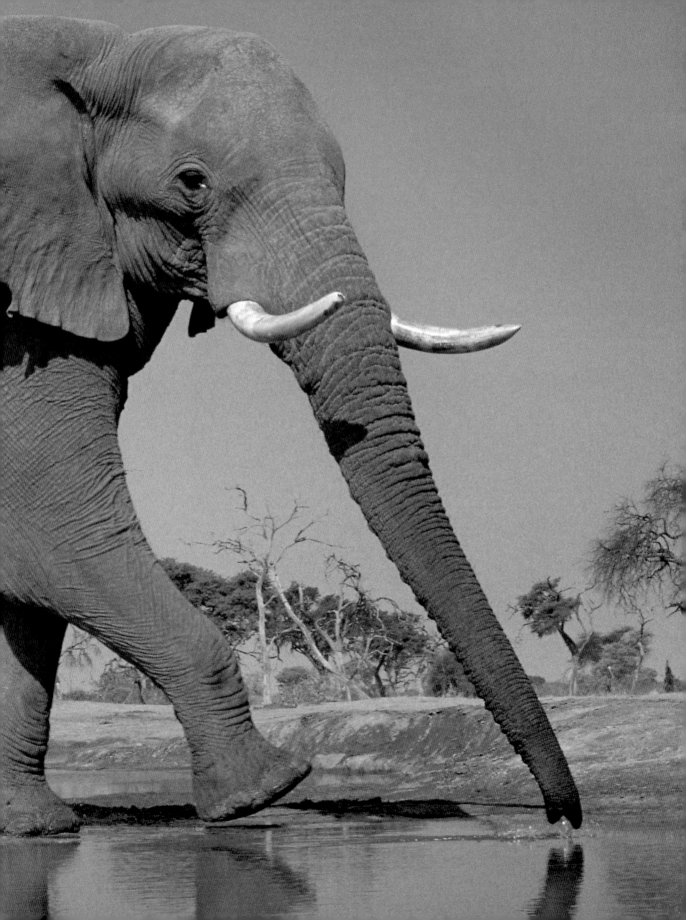

RIGHT: *Black Rhinoceros, Tanzania*
PAGES 68-69: *Orangutan, Borneo*
PAGE 70: *African Lion, Botswana*
PAGE 71: *Leopard, Namibia*

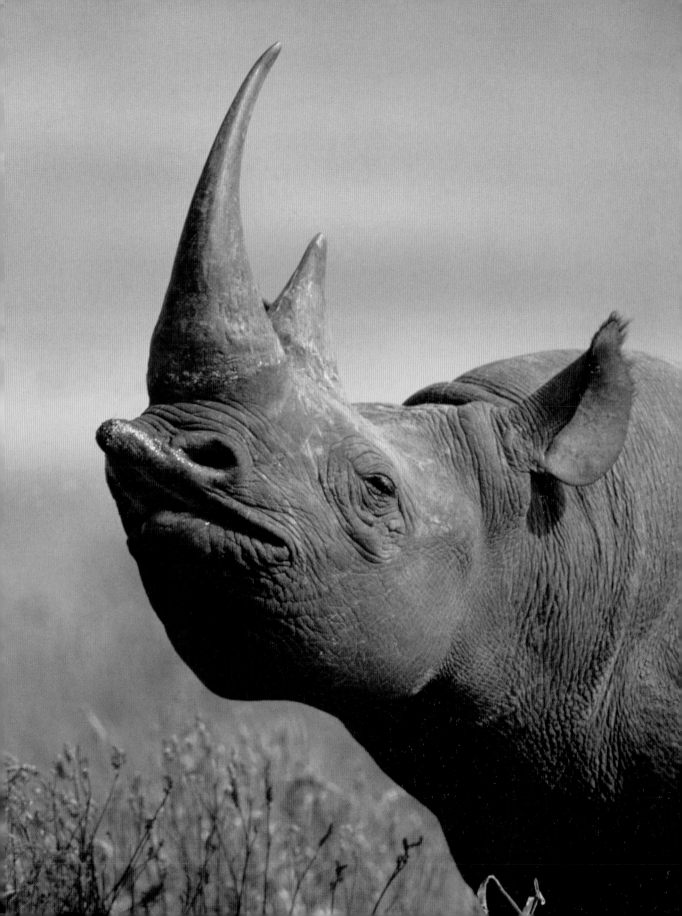

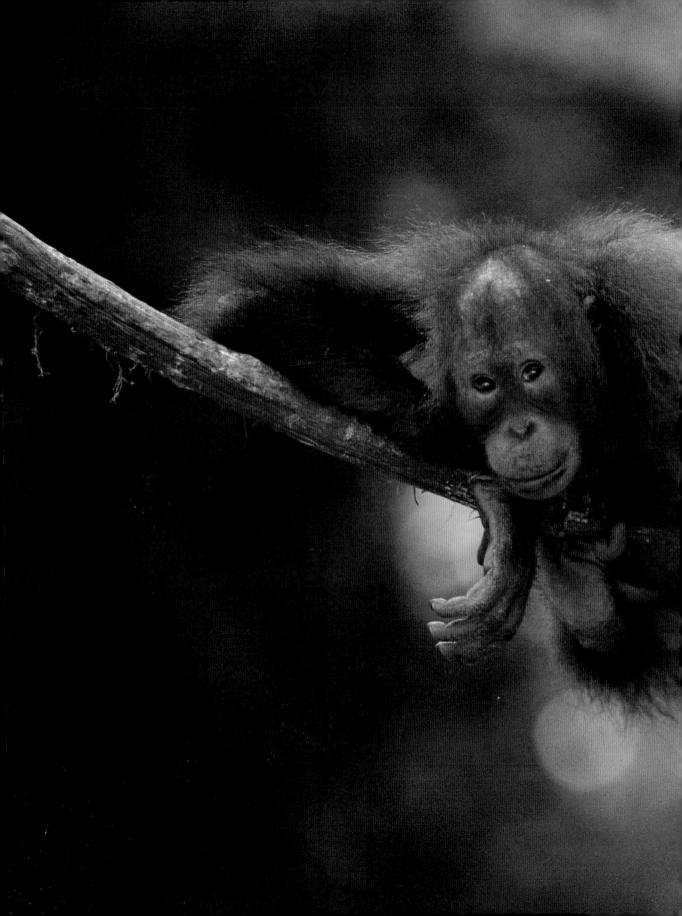

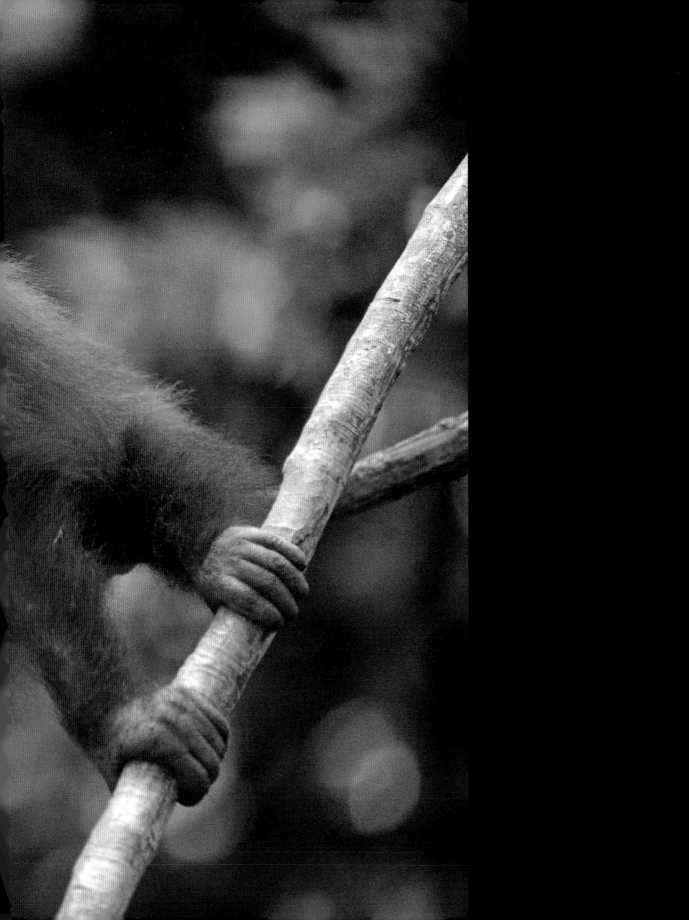

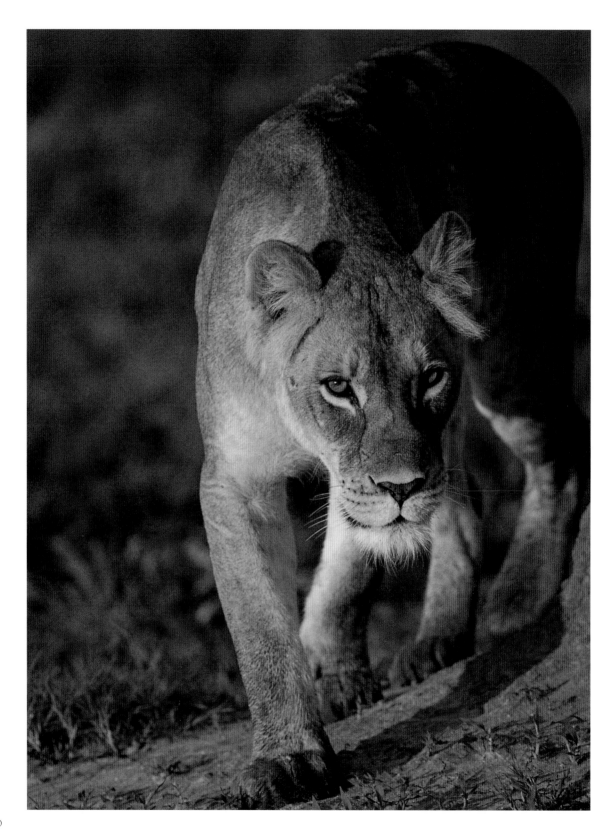

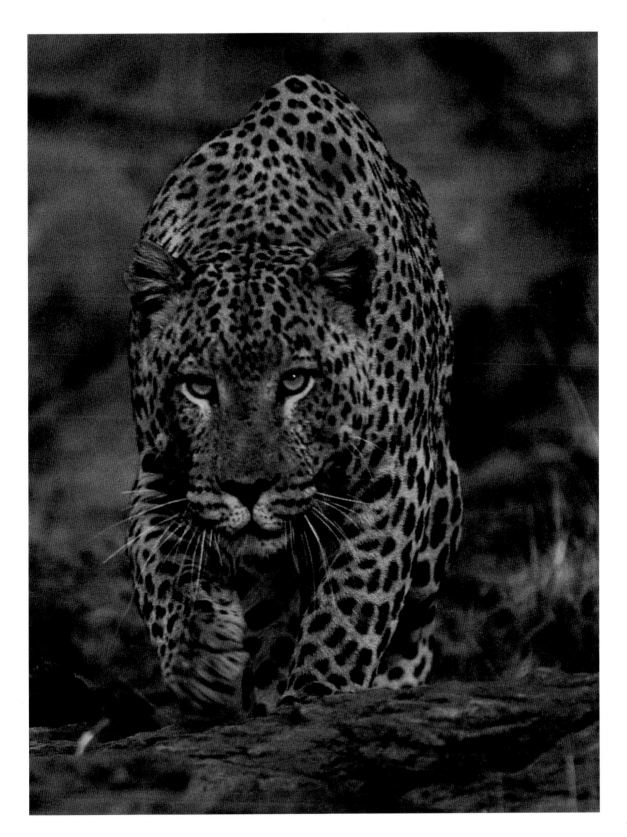

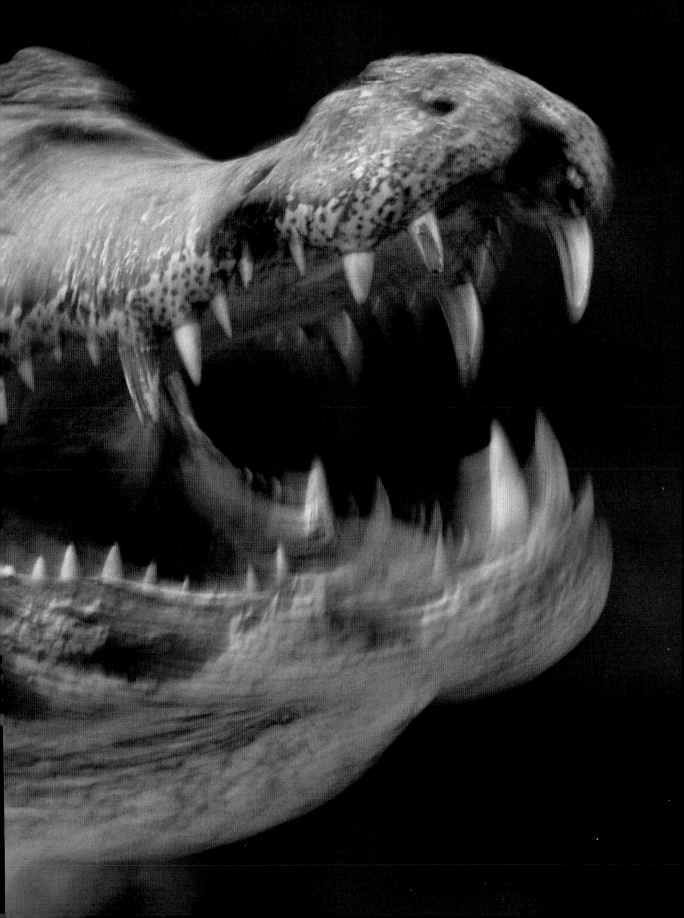

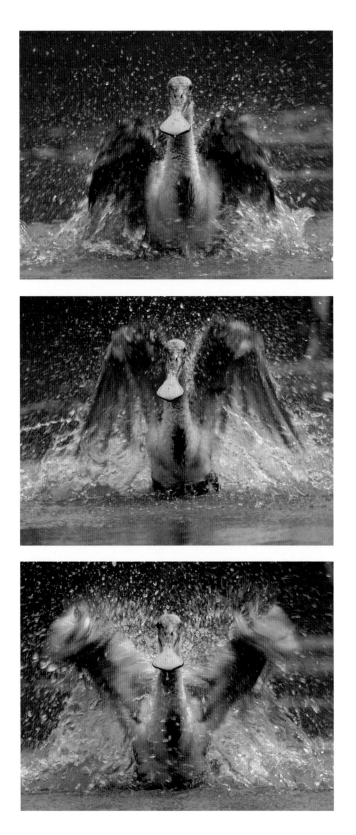

PAGES 72–73:
Paraguay Caiman, Brazil
LEFT AND RIGHT:
Roseate Spoonbill, Brazil

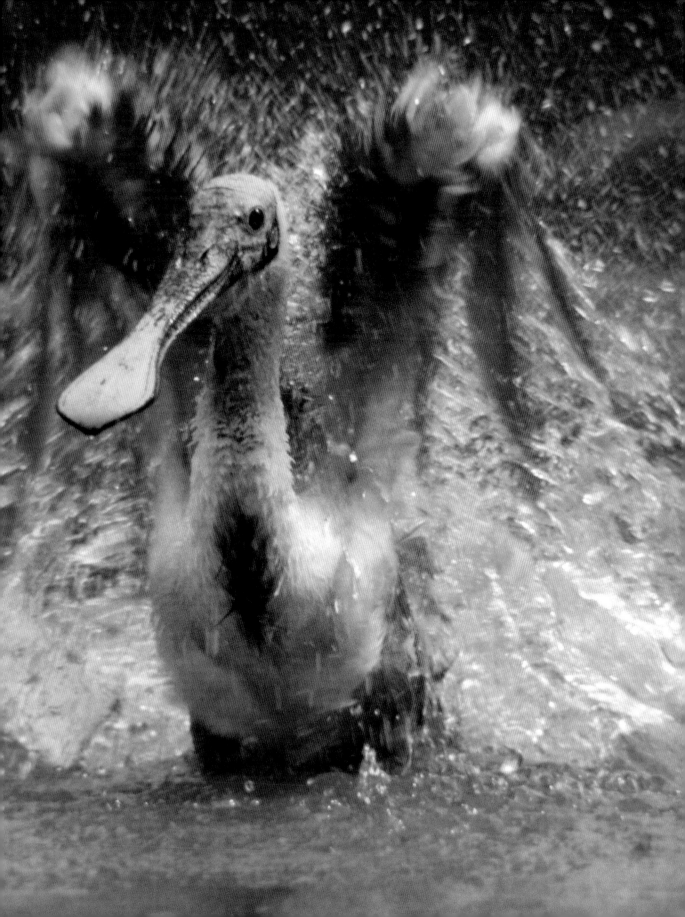

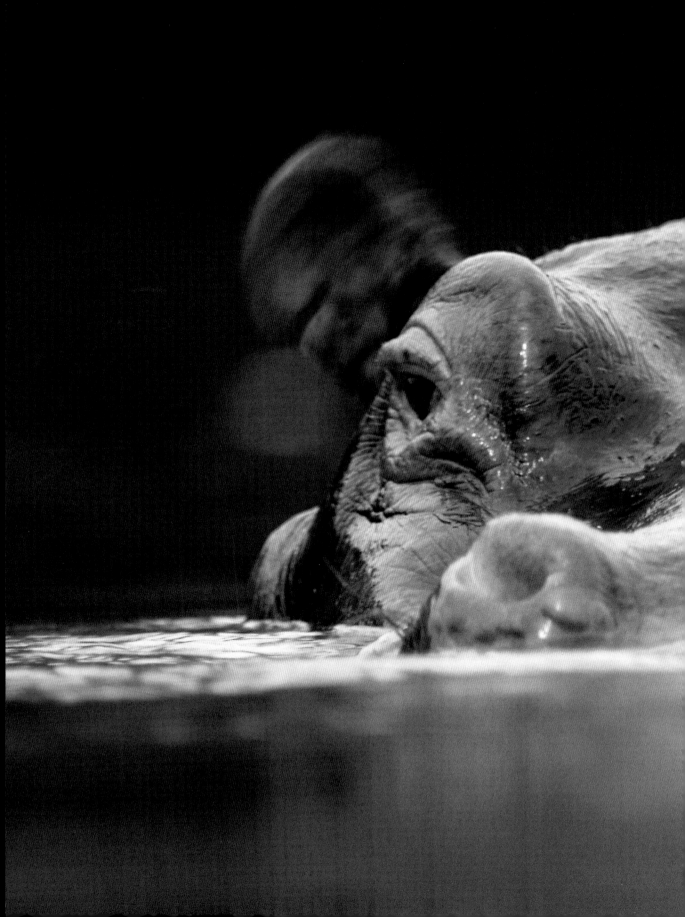

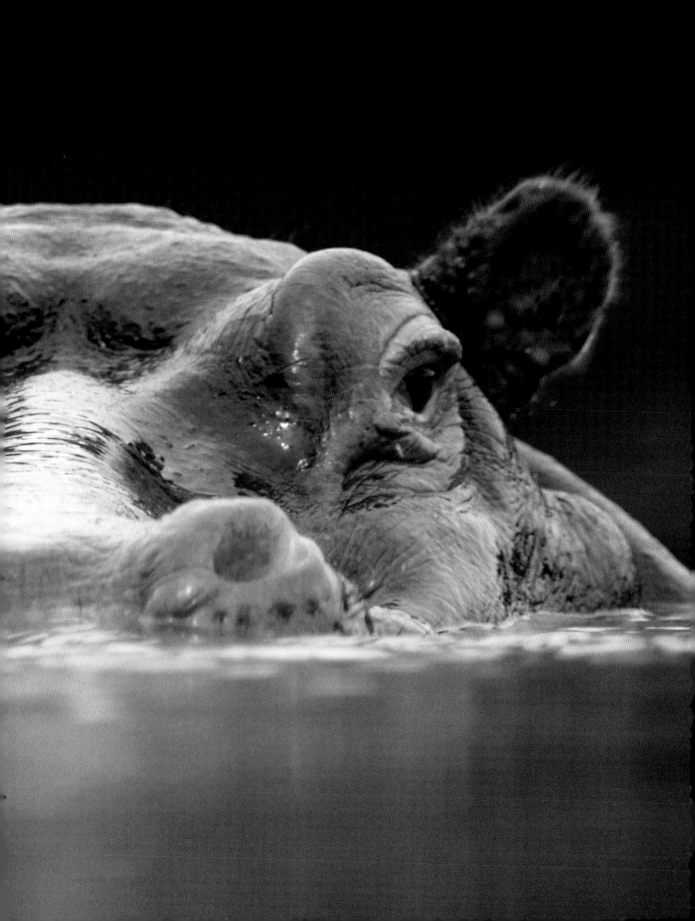

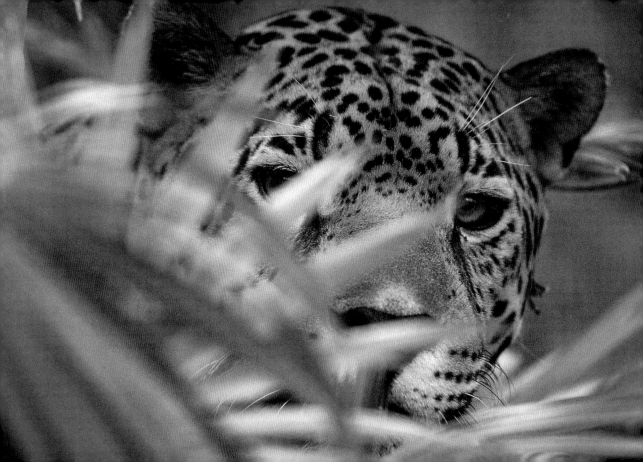

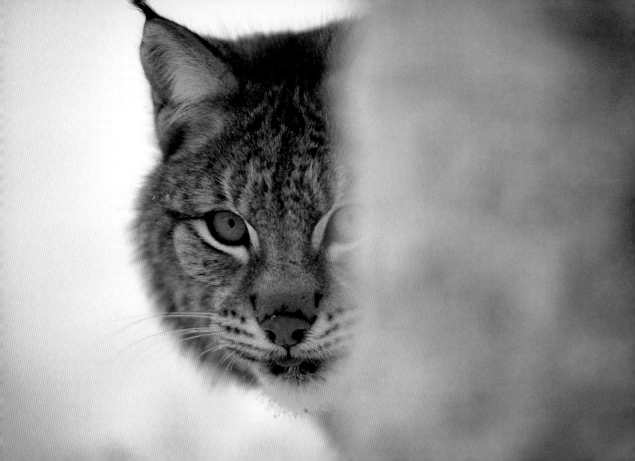

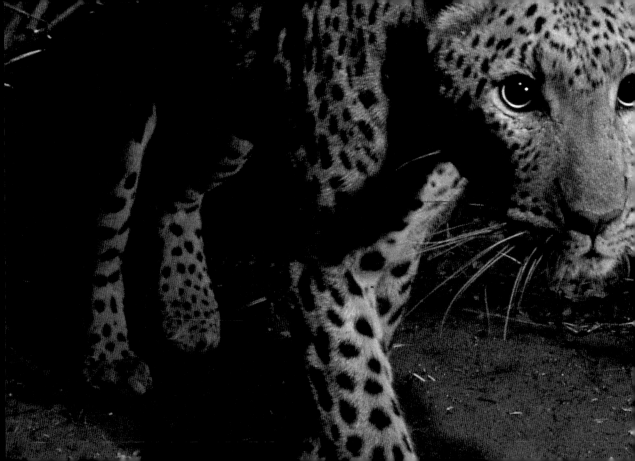

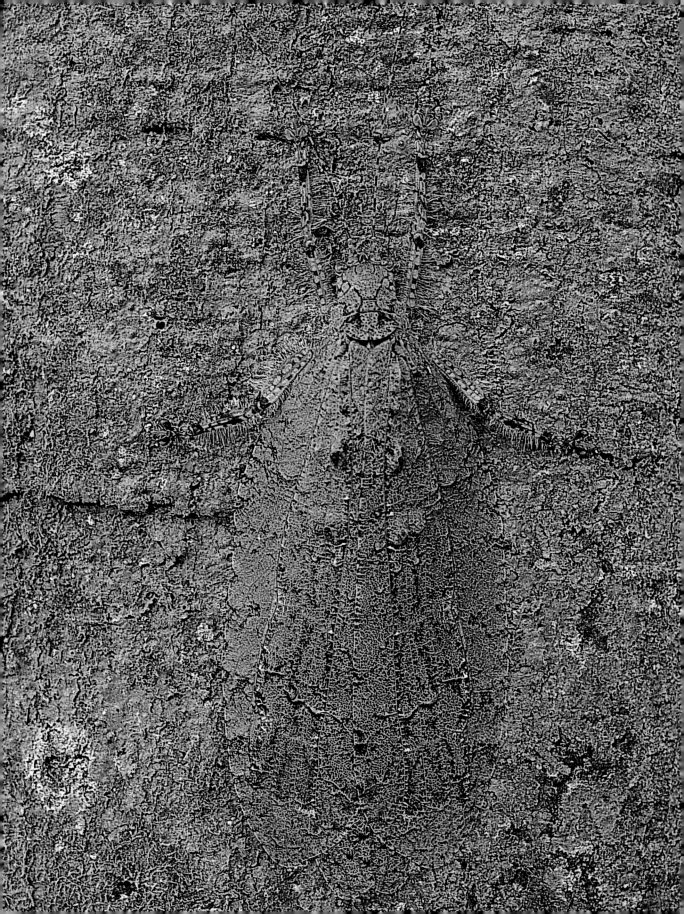

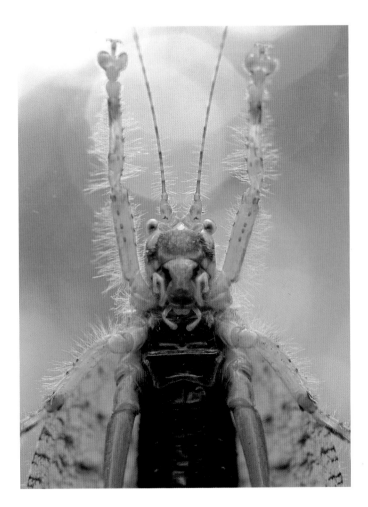

LEFT AND ABOVE: *Katydid, Borneo*
PAGES 76–77: *Hippopotamus, Congo*
PAGE 78: *Jaguar, Belize*
PAGE 79: *Lynx, Finland*
PAGES 80–81: *Leopard, Botswana*

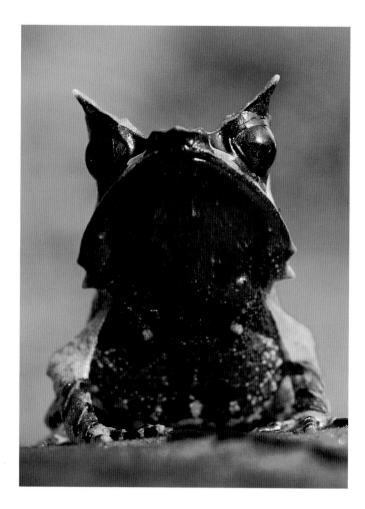

ABOVE: *Horned Frog, Borneo*
RIGHT: *Leaf Insect, Borneo*
PAGE 87: *Orangutan, Borneo*

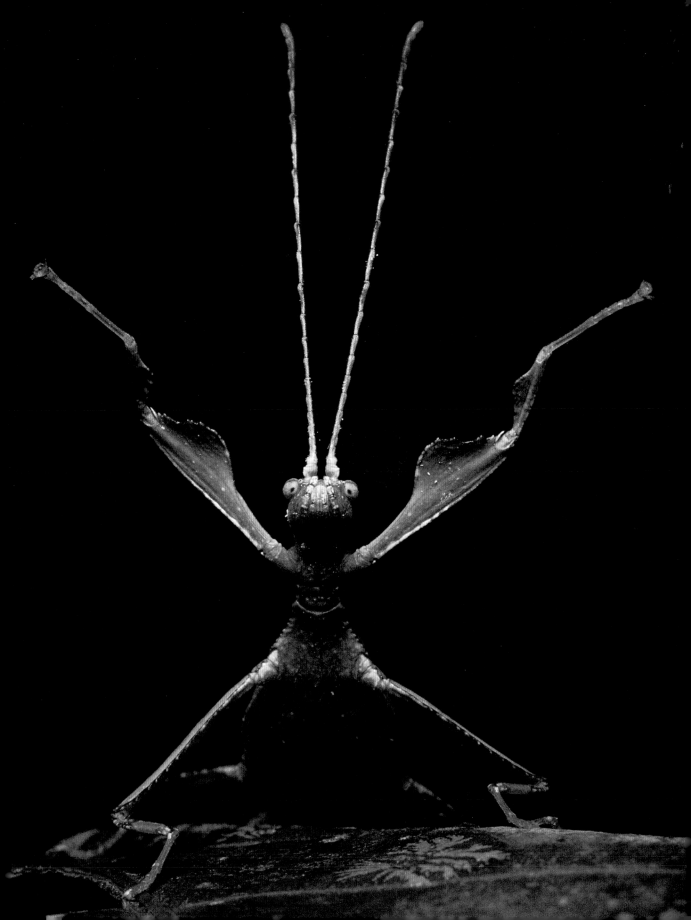

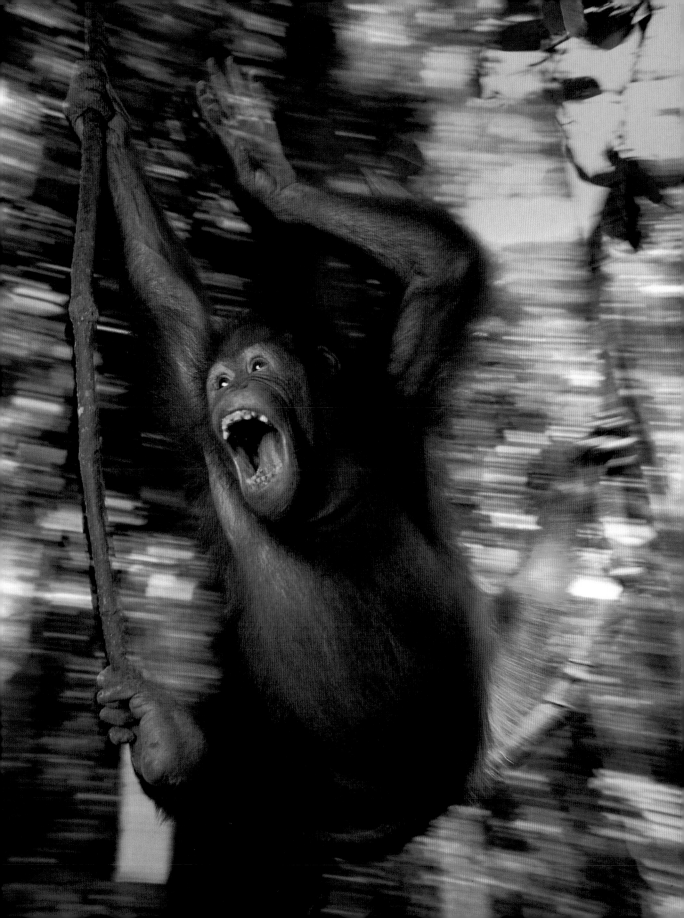

RIGHT: *Hippopotamus, Botswana*
PAGE 91: *Bonobo*

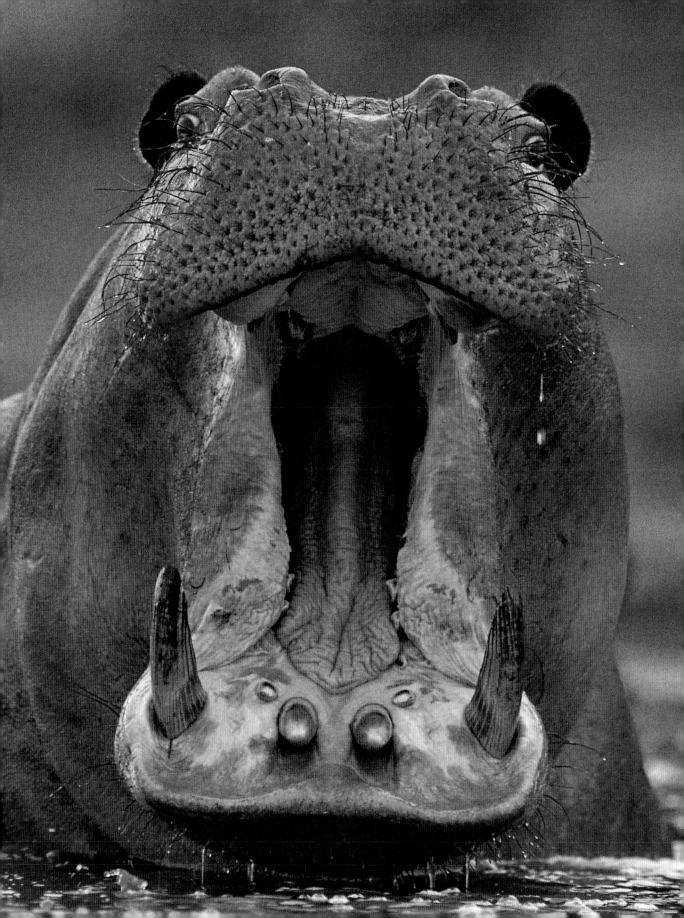

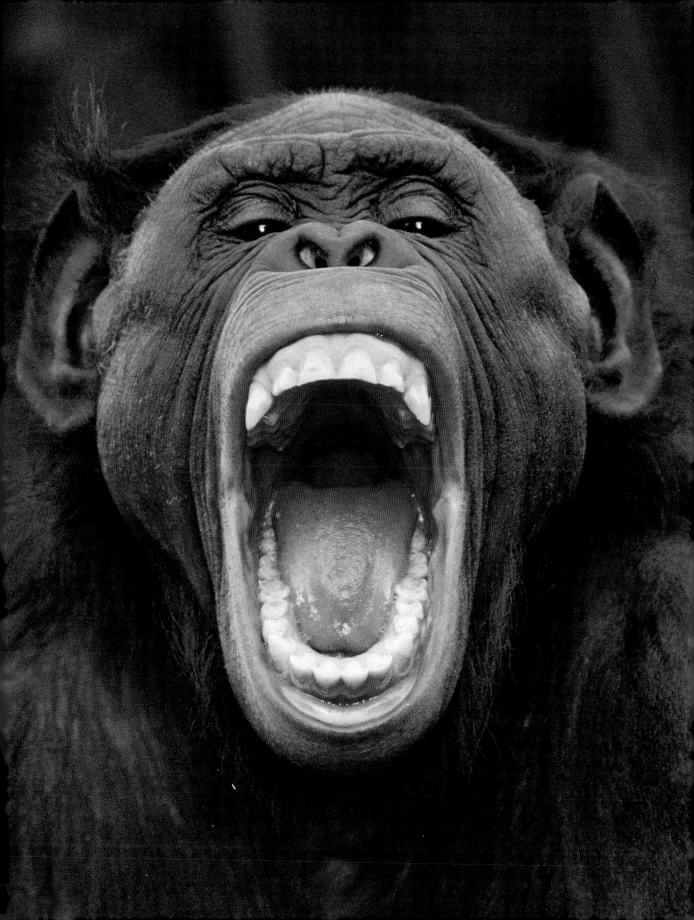

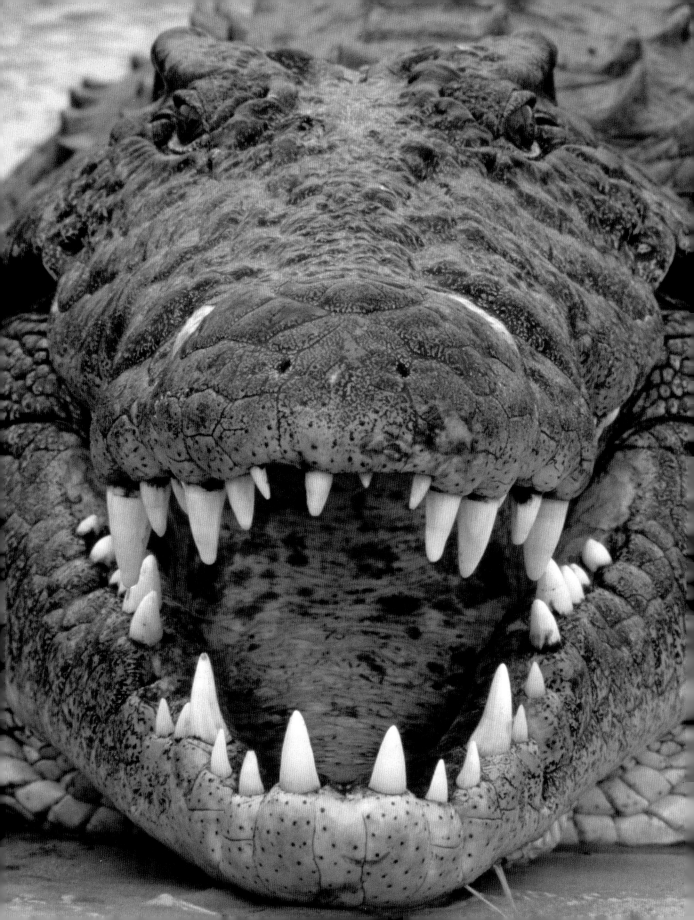

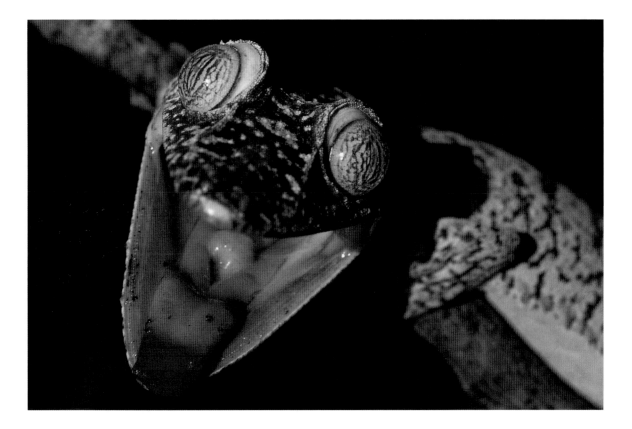

LEFT: *Nile Crocodile, Botswana*
ABOVE: *Leaf-Tailed Gecko, Madagascar*
PAGES 94–95: *Great Skua, Falkland Islands*
PAGES 96–97: *Plains Zebra, Botswana*

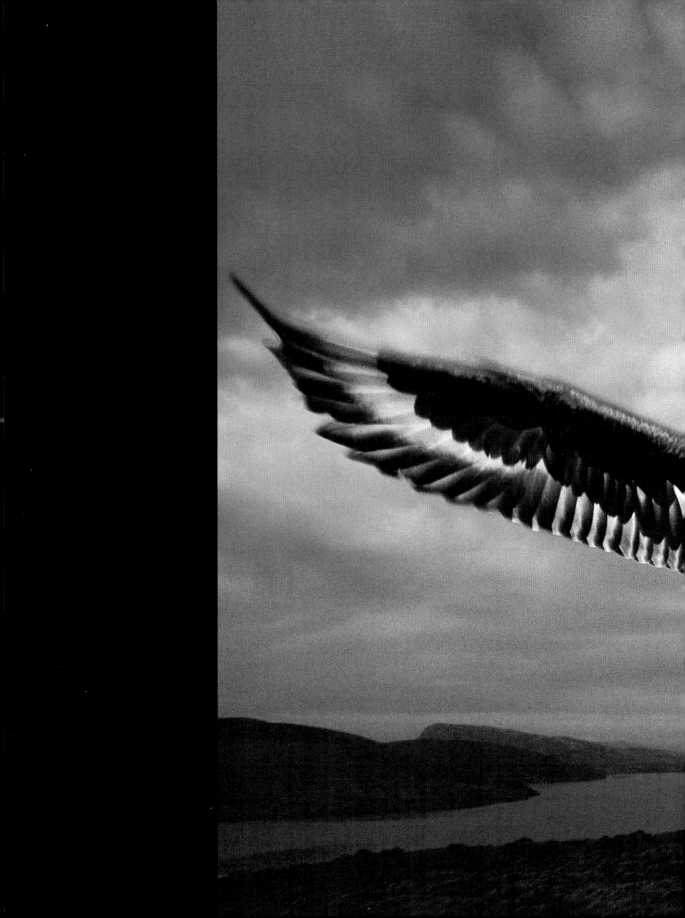

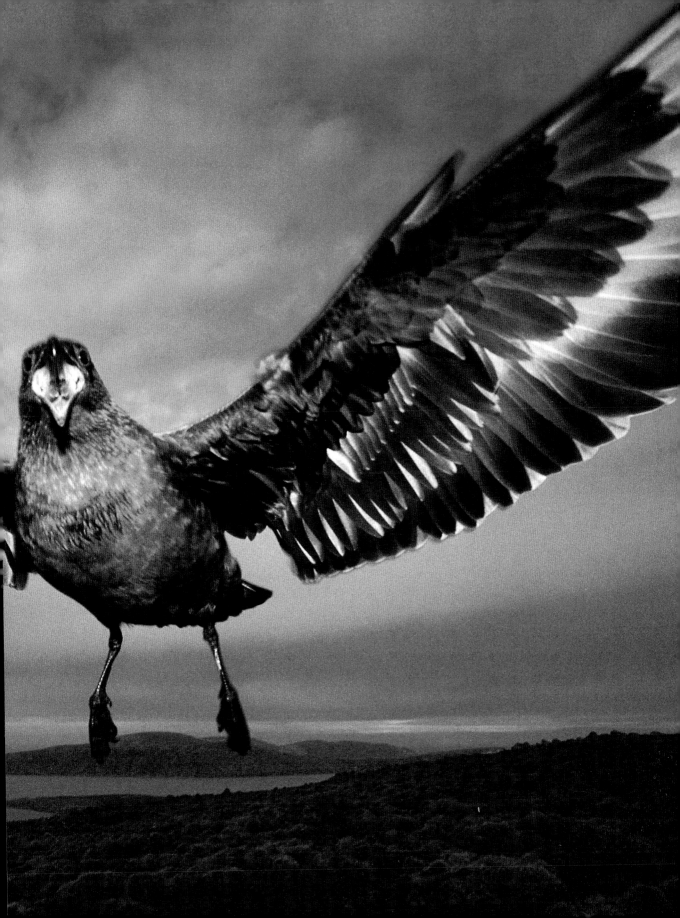

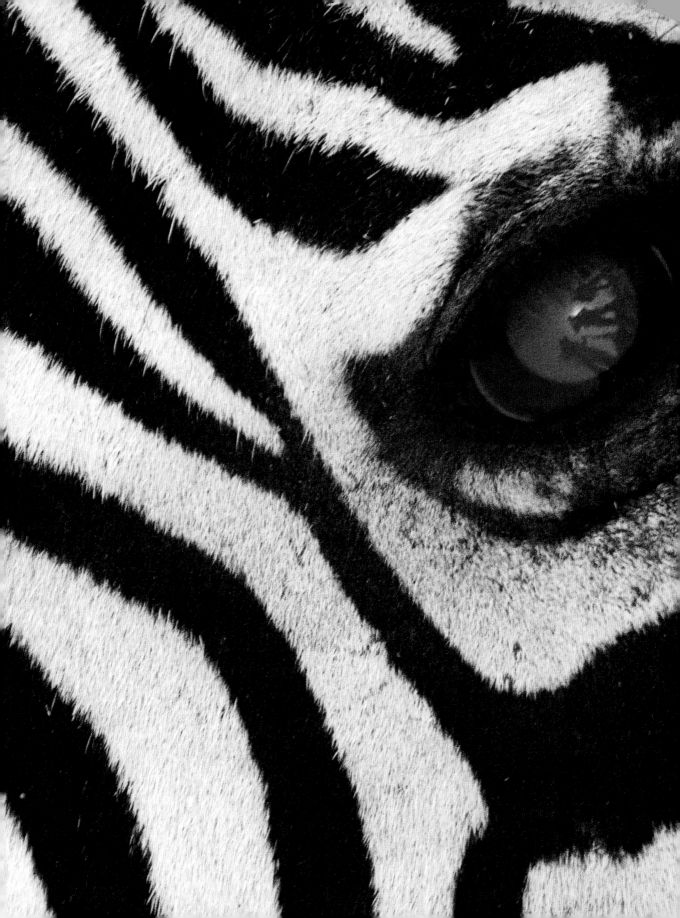

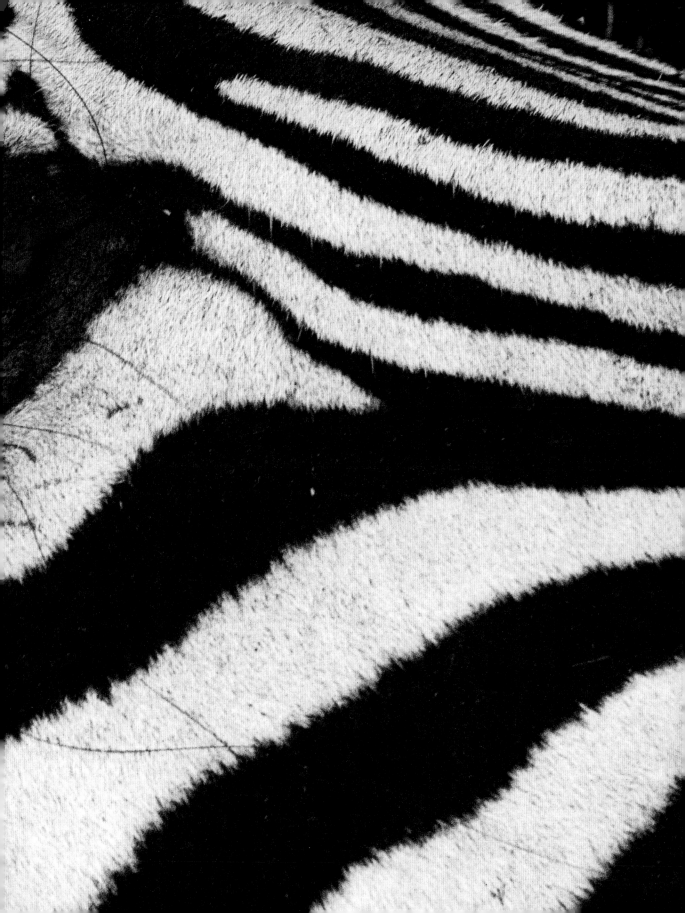

LEFT: *Sportive Lemur, Madagascar*
PAGES 100–101: *African Lions, Kenya*
PAGES 102–103: *Hawaiian Monk Seal, Hawaii*
PAGES 104–105: *Parson's Chameleon, Madagascar*

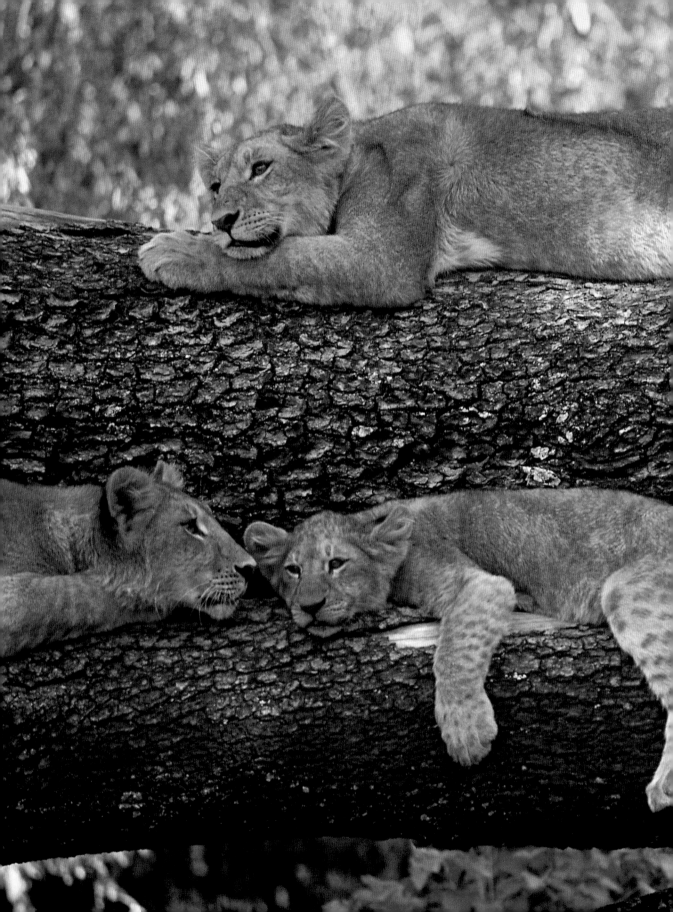

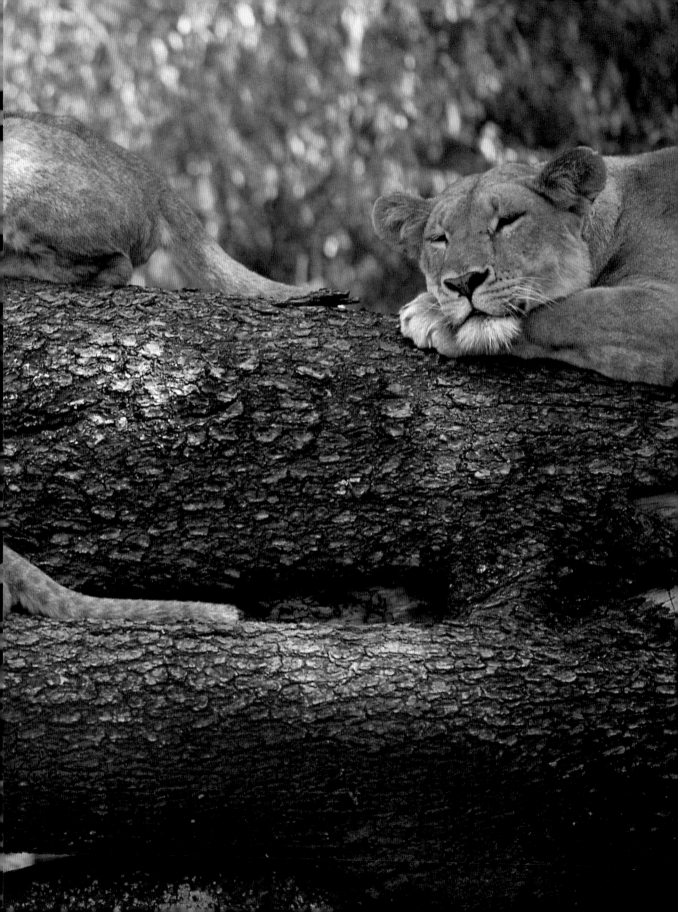

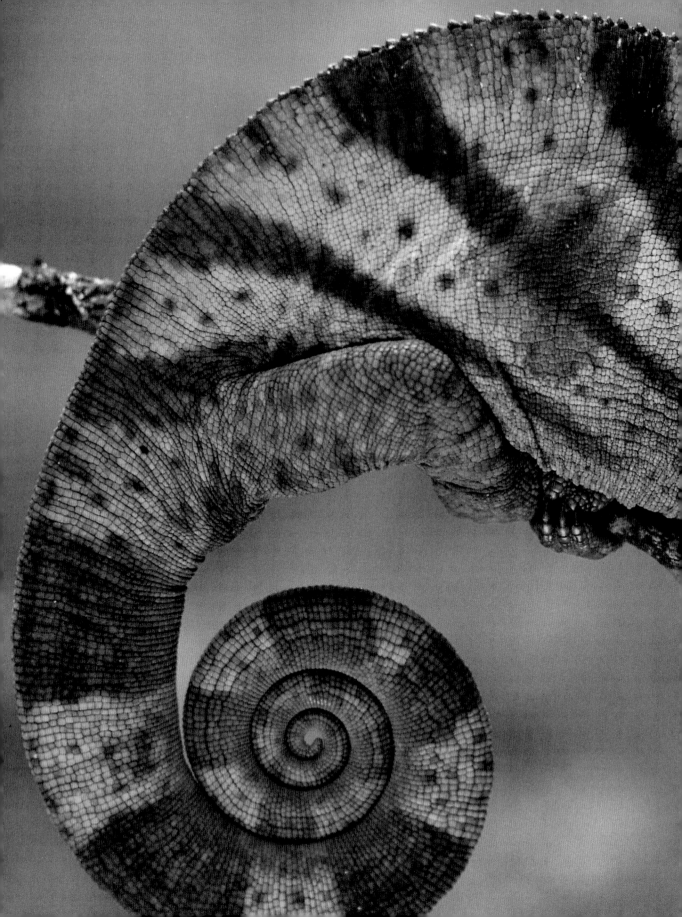

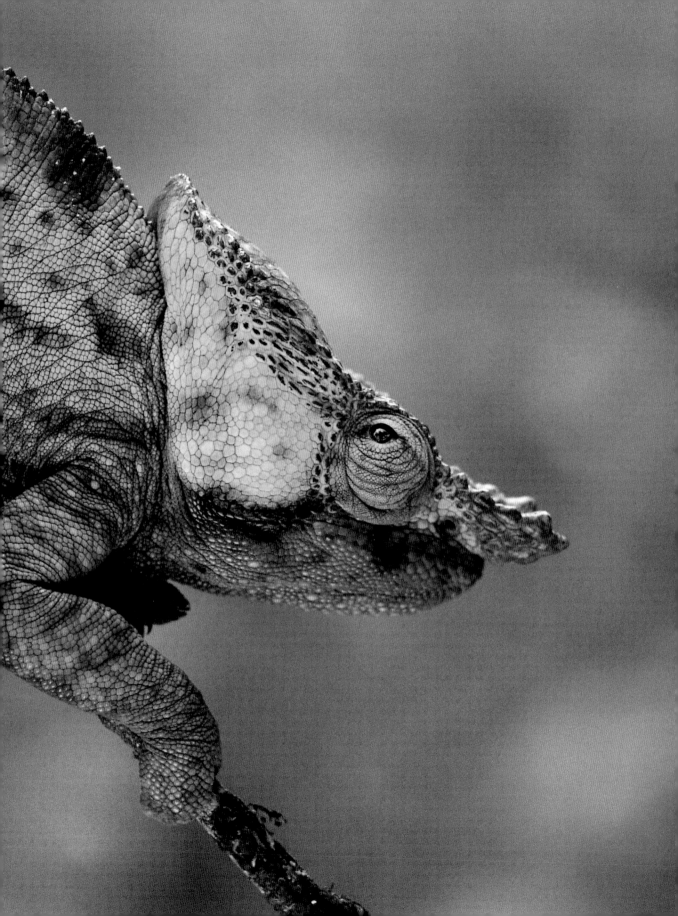

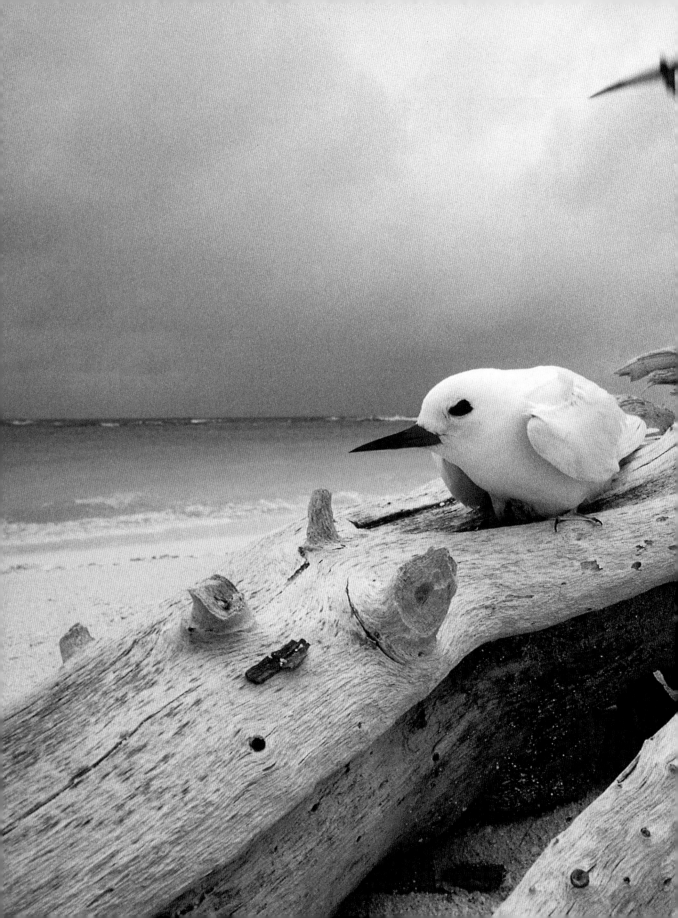

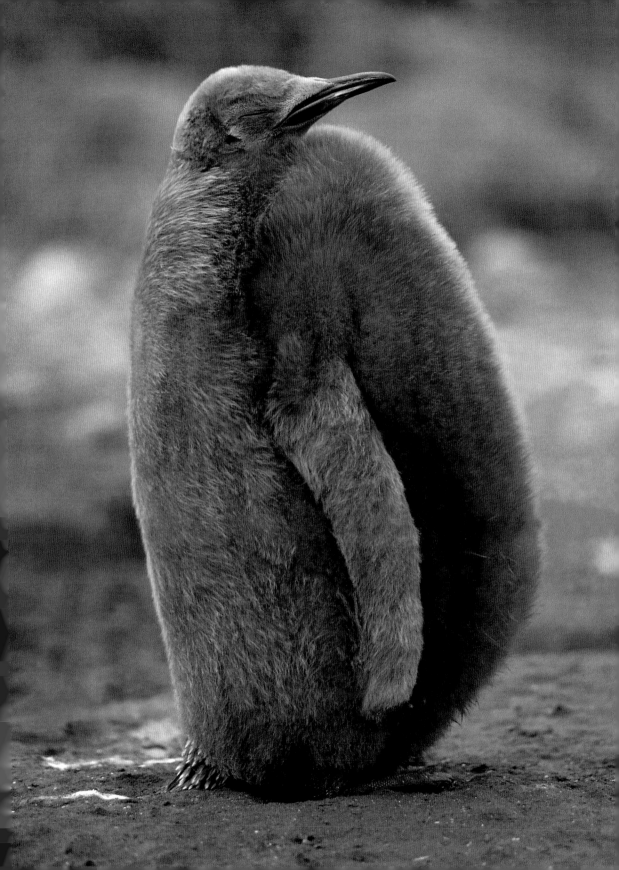

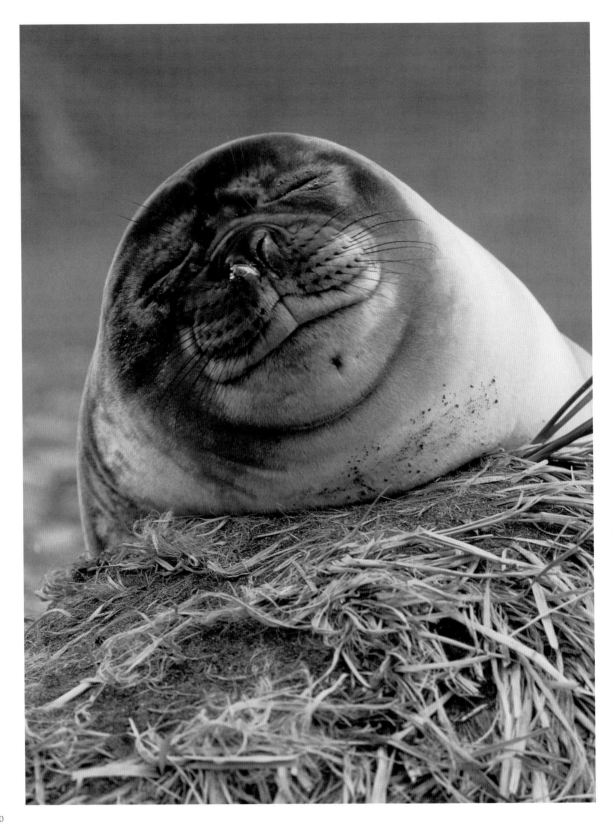

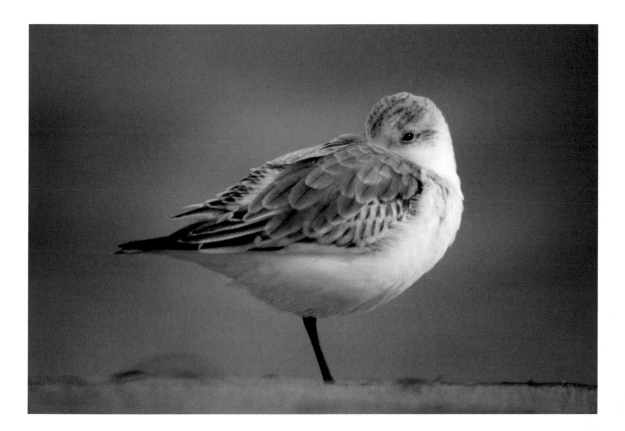

LEFT: *Southern Elephant Seal, South Georgia Island*
ABOVE: *Sanderling, California*
PAGES 106–107: *Fairy Tern, Hawaii*
PAGE 109: *King Penguin, South Georgia Island*
PAGES 112–113: *Leatherback Turtle, Surinam*
PAGES 114–115: *Marbled Godwit and other Shorebirds, Mexico*

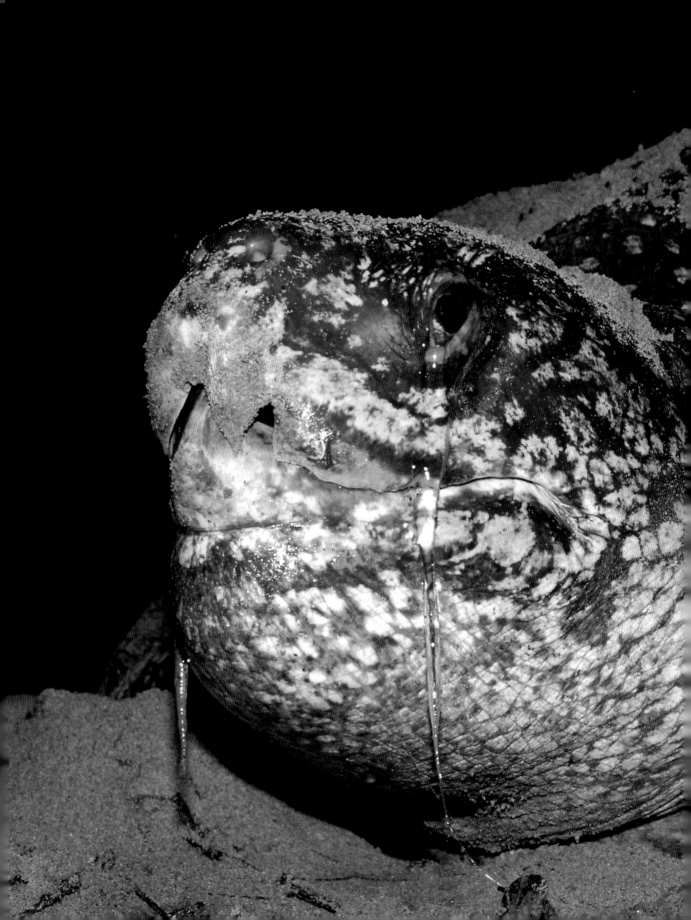

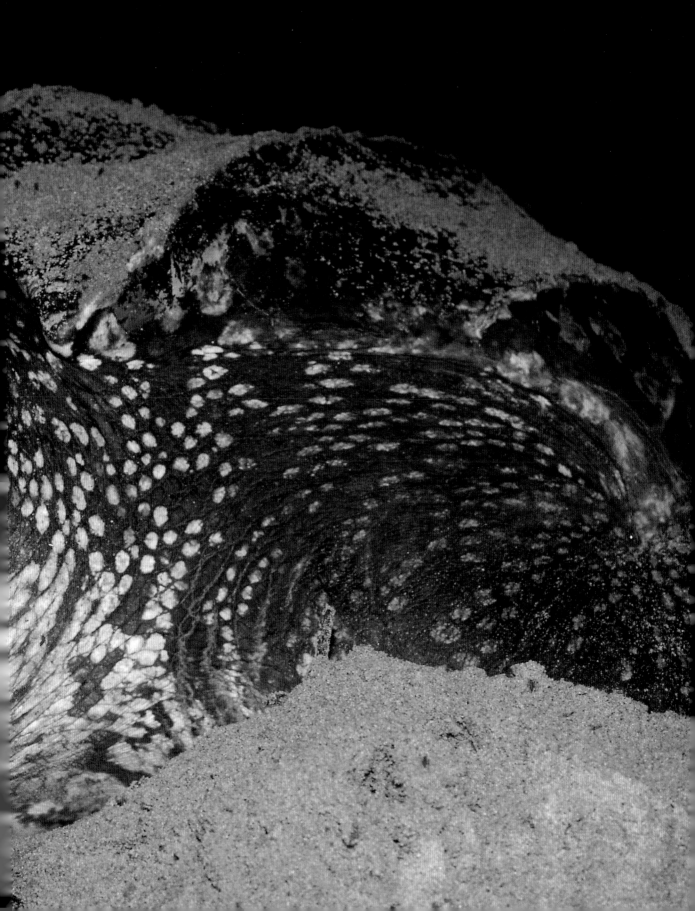

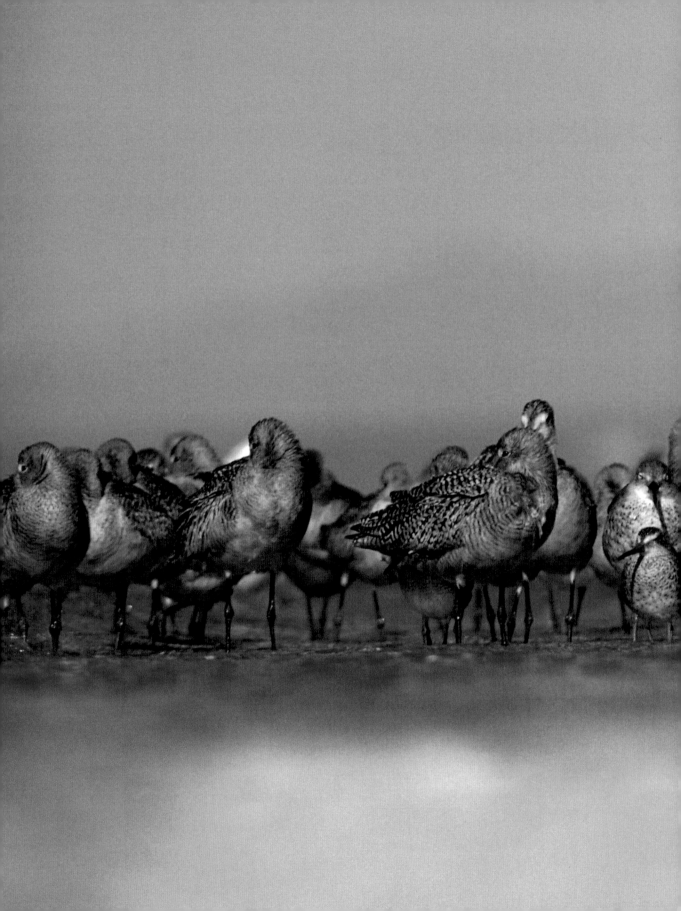

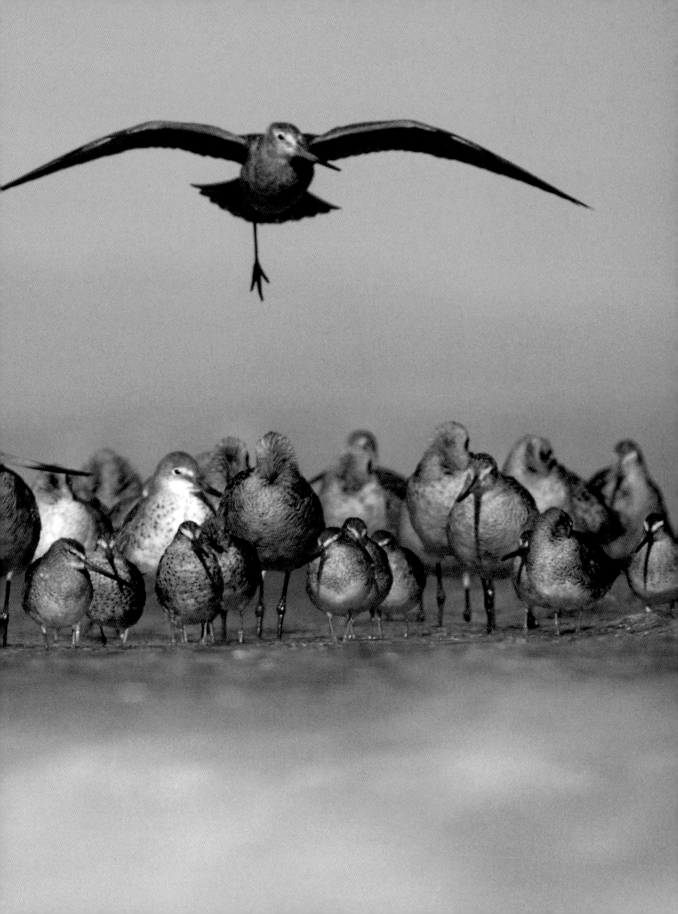

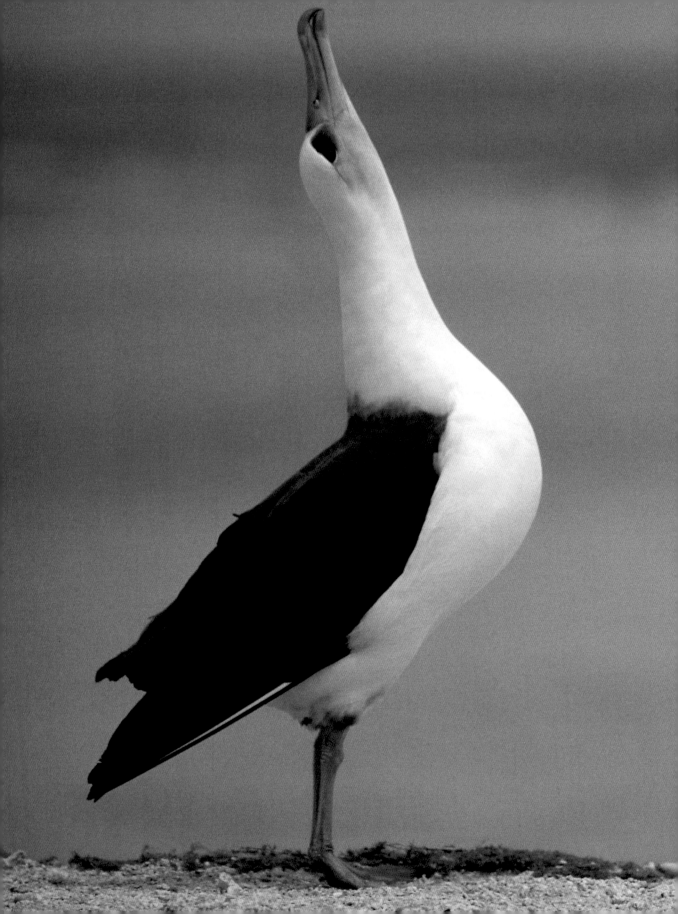

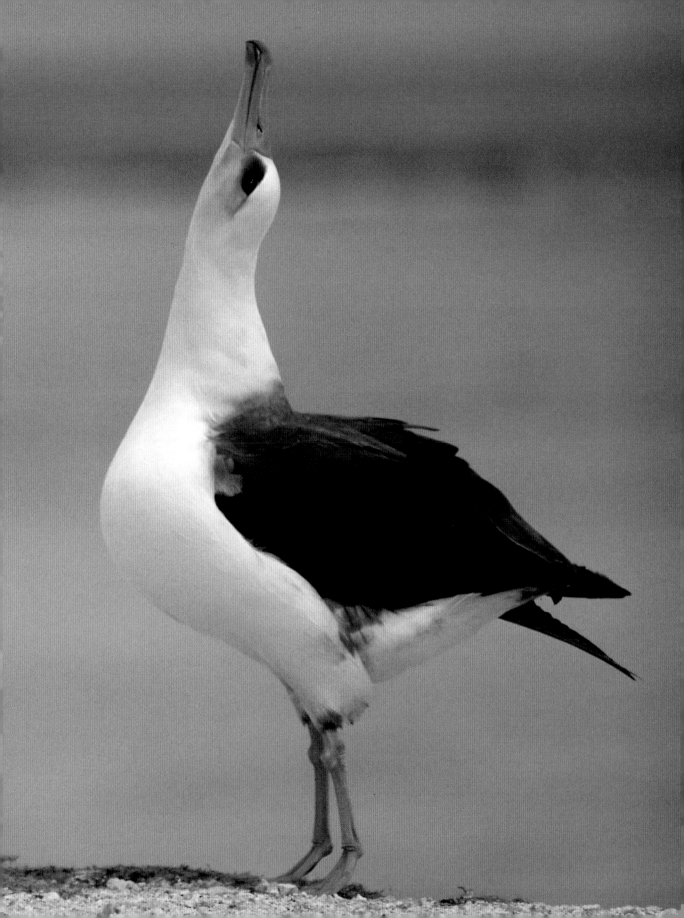

TWO BY TWO

COMING TOGETHER

Many wild animals are wary of physical contact, or even proximity to another of their own kind, and in many species elaborate rituals have evolved to enable two strangers to come together and become partners. To me, no animals demonstrate that notion in a more theatrical fashion than albatrosses. These great seabirds spend their youth at sea as solitary wanderers without ever coming ashore. When they do return to their island of birth, it is to enact a courtship dance that is unrivaled for its complexity. The Leeward Islands of Hawaii, a chain of atolls that stretches for 1,200 miles between Hawaii and Japan, are home to millions of Laysan and blackfooted albatrosses. I traveled there to document their lives, and one day on a sandy beach in the French Frigate Shoals I watched in amazement as a pair of Laysan albatrosses began to court.

Facing his partner, the male fluffed out his breast, stretched himself up on tiptoes, looked vacantly into the air, and let out a moan like a melancholy cow. The female responded by clapping her bill like a castanet. The male then snapped out of his erect stance and nibbled intently at his flank while raising one wing. She let loose a frightening whine and shook her head wildly from side to side. For fifteen minutes the birds carried on, screaming, whinnying, bowing, and tiptoeing, before they finished their performance with the bill claps and soft moans albatross etiquette requires at the end of a dance.

There seemed to be no logic to the sequence of bizarre sounds and motions, yet the birds performed their score as orderly as a Baroque couple doing a minuet. Albatrosses dance to establish pair bonds, a serious matter for birds who often mate for life and may live almost as long as humans. In a manner no scientist has yet explained, the dance serves as a test of compatibility between two prospective partners, and the proper execution of the complex ritual mirrors the cooperative behavior that successful breeding requires. It takes parents seven months to rear a single chick, and during that time they share chores equally, each shuttling in food every few days. After their offspring fledges, the parents separate and return to sea. Months later they reunite for the next cycle, often arriving within a few days of each other at the same nest site. Recognition between mates is instant, even in crowded colonies numbering tens of thousands of birds.

Mastery of the dance is the centerpiece of albatross life, and it requires lengthy practice. Although all albatrosses are born with a basic knowledge of the score, they only succeed in finding a mate after they can perform the ritual with vigor and self-assurance. As the late Duke Ellington once said, "It don't mean a thing if it ain't got that swing." When young birds return to their island of birth to learn to dance, they socialize with others their own age and exchange their first insecure moans and bill claps. At this stage the birds seem eager for partners of any kind: Inquisitive youngsters would sometimes approach me with ceremonial bows or offer more intimate overtures such as nibbling my hair or ears. Although I tried hard, I never produced the proper sound in response.

At the final stage of courtship, a new albatross couple will spend weeks dancing and preening each other. Breeding, however, will not take place until the following season. When they return after months at sea and reunite with a passionate dance, the birds look the same but a change has occurred: The nomads have become partners.

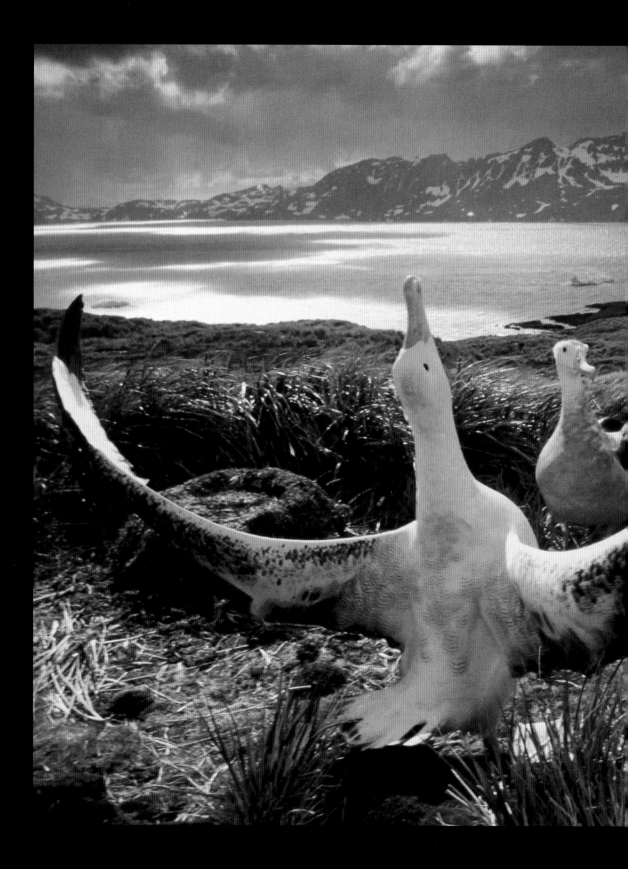

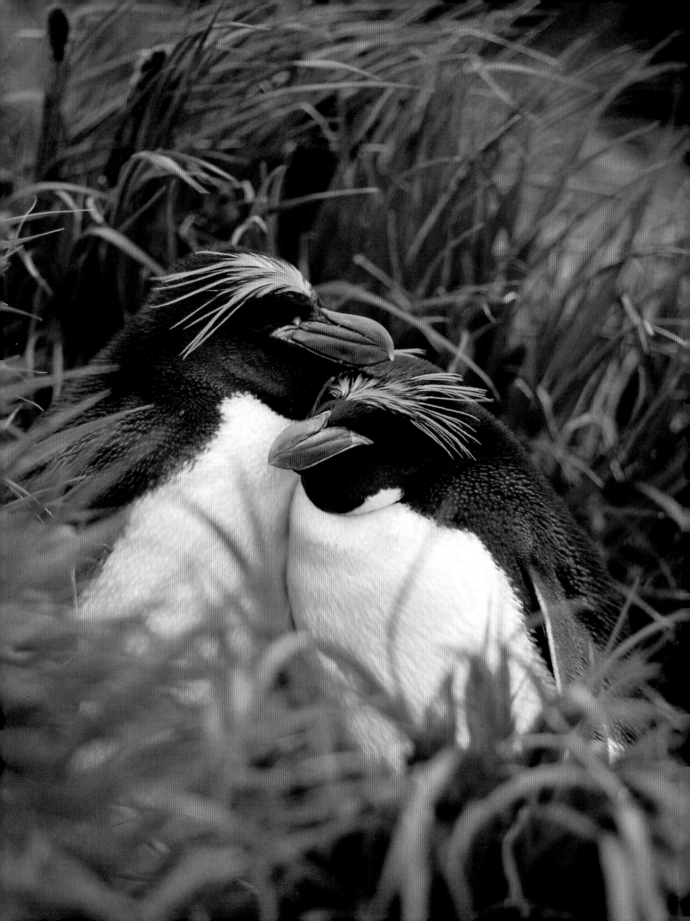

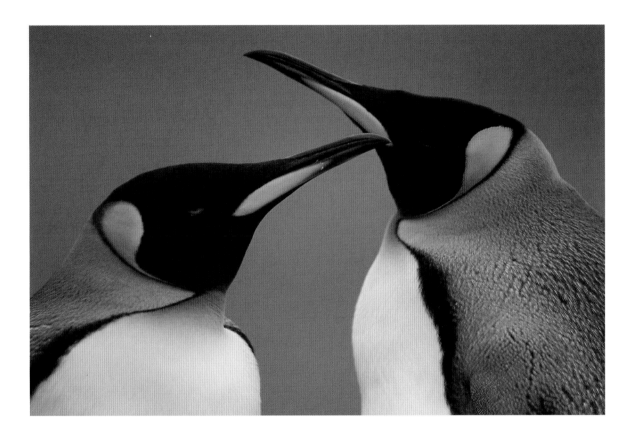

PAGES 120–121: *Wandering Albatrosses, South Georgia Island*
LEFT: *Macaroni Penguins, South Georgia Island*
ABOVE: *King Penguins, Falkland Islands*

RIGHT: *Masai Giraffes, Kenya*

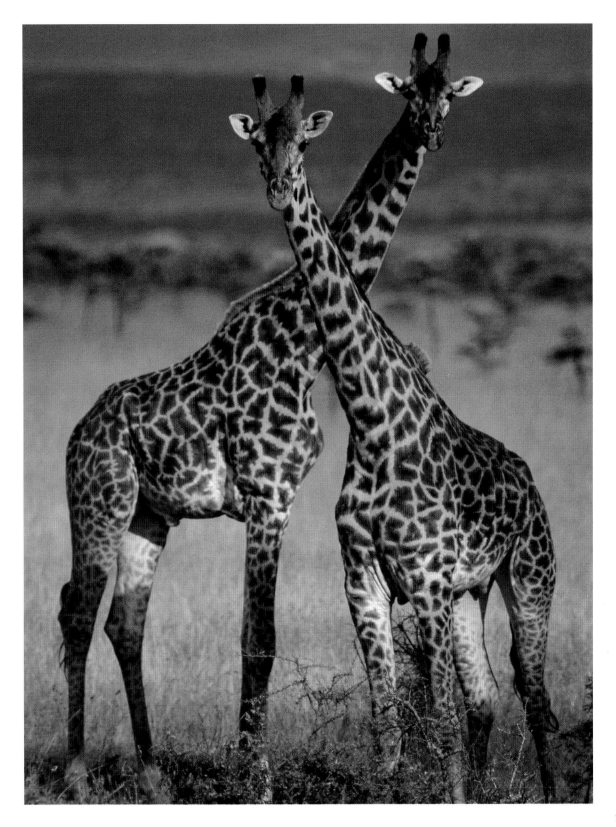

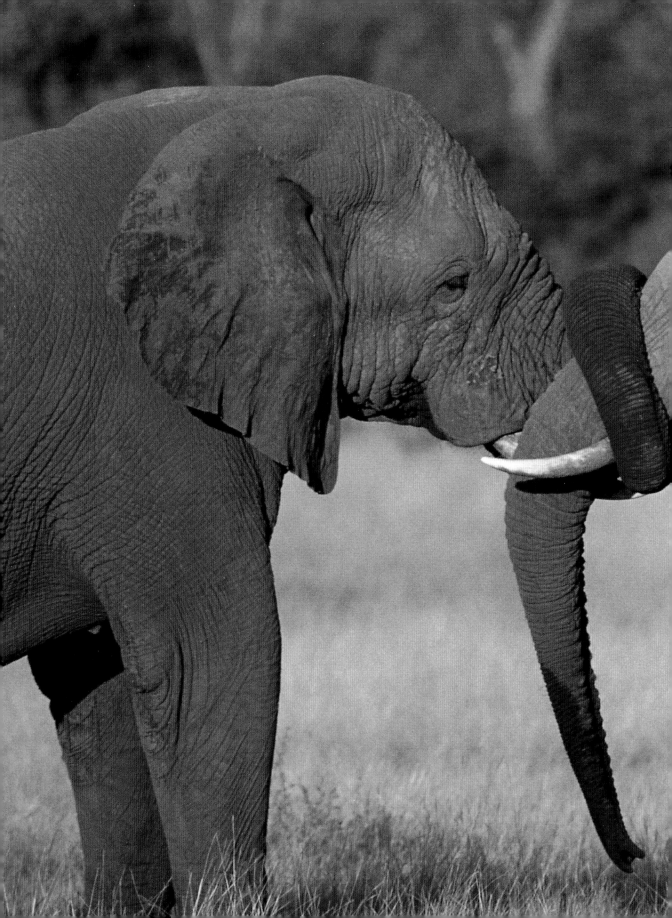

LEFT: *African Elephants, Botswana*
PAGES 128-129: *Oryxes, Namibia*

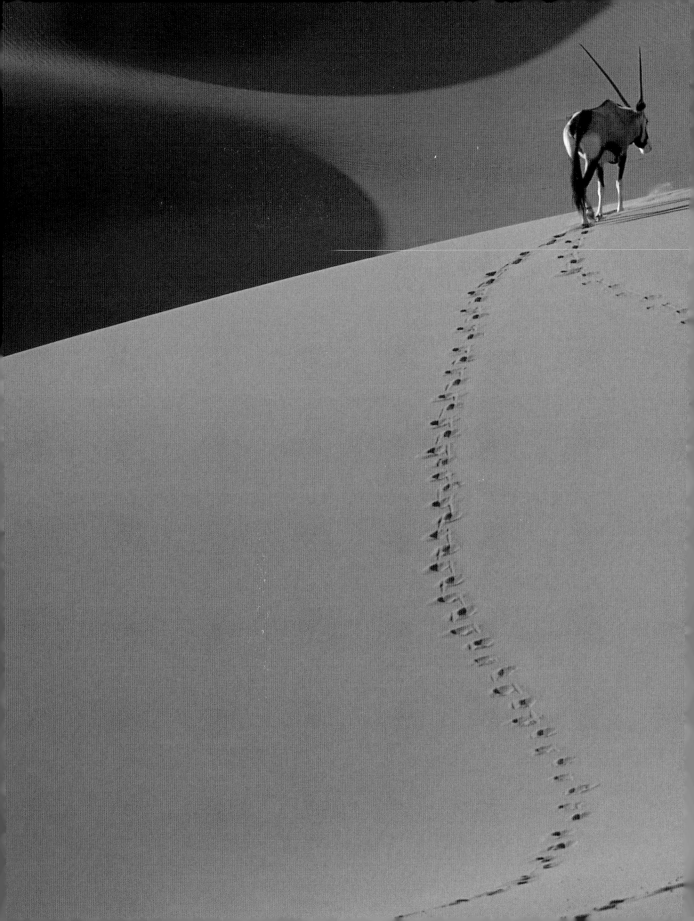

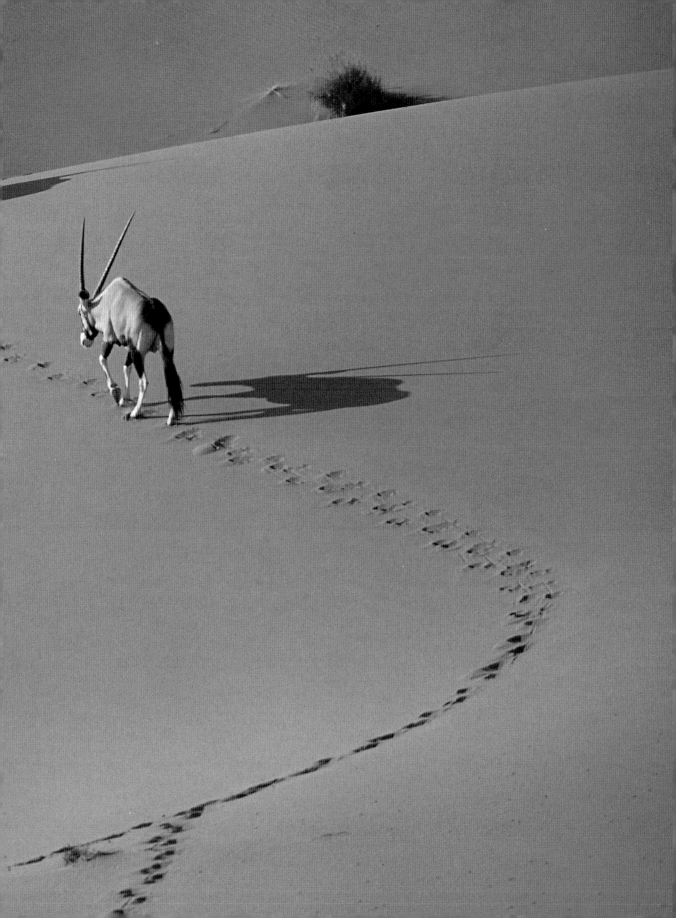

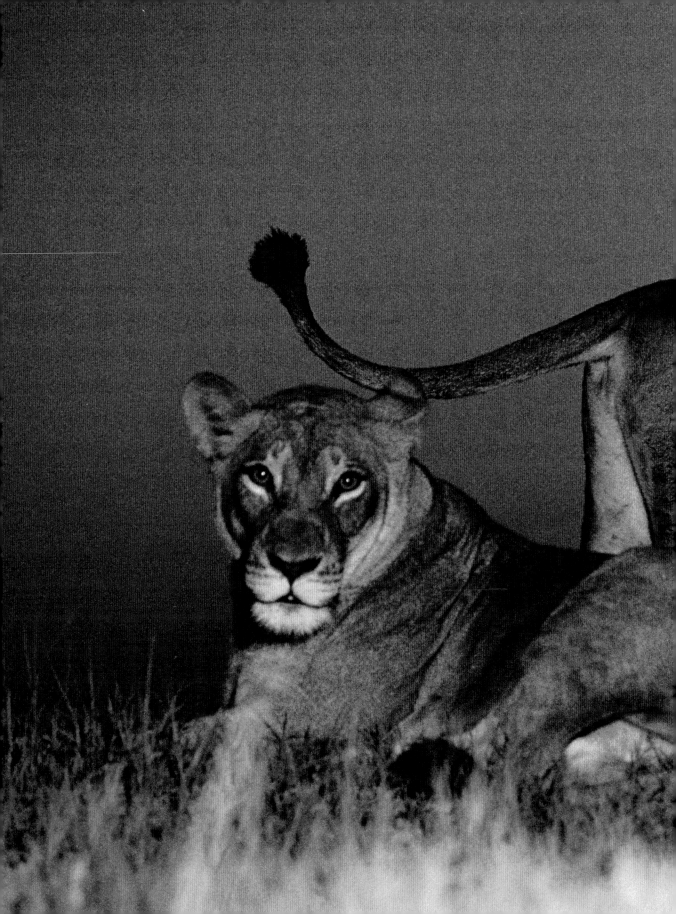

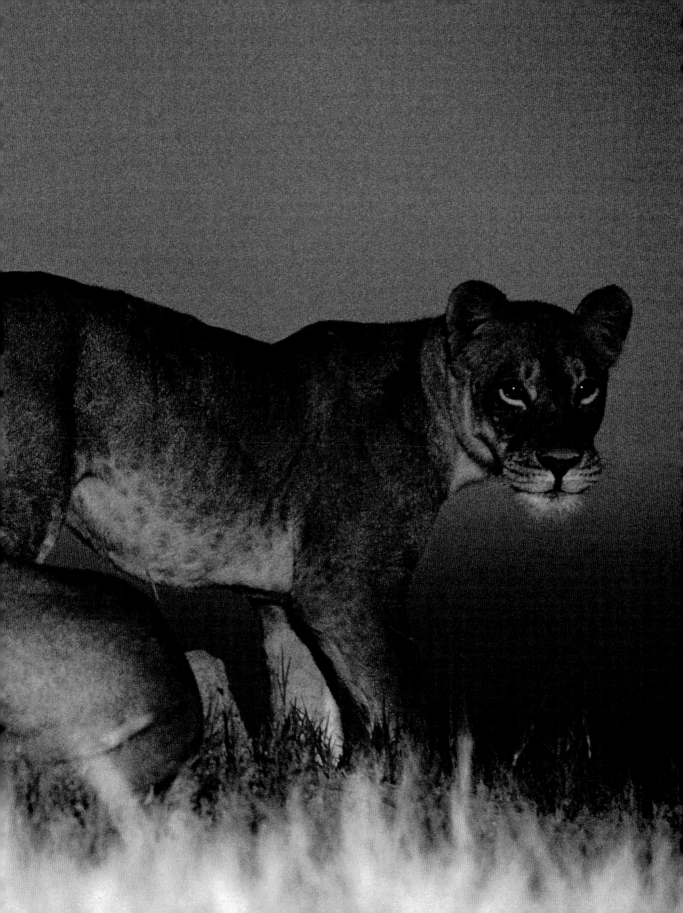

PAGES 130–131: *African Lions, Botswana*
RIGHT: *Verreaux's Sifakas, Madagascar*

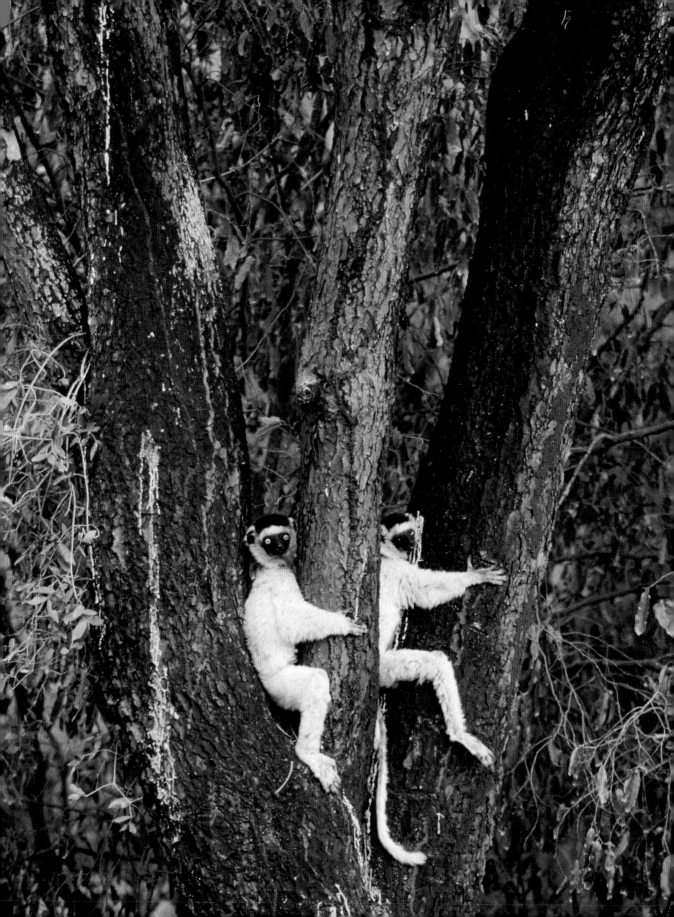

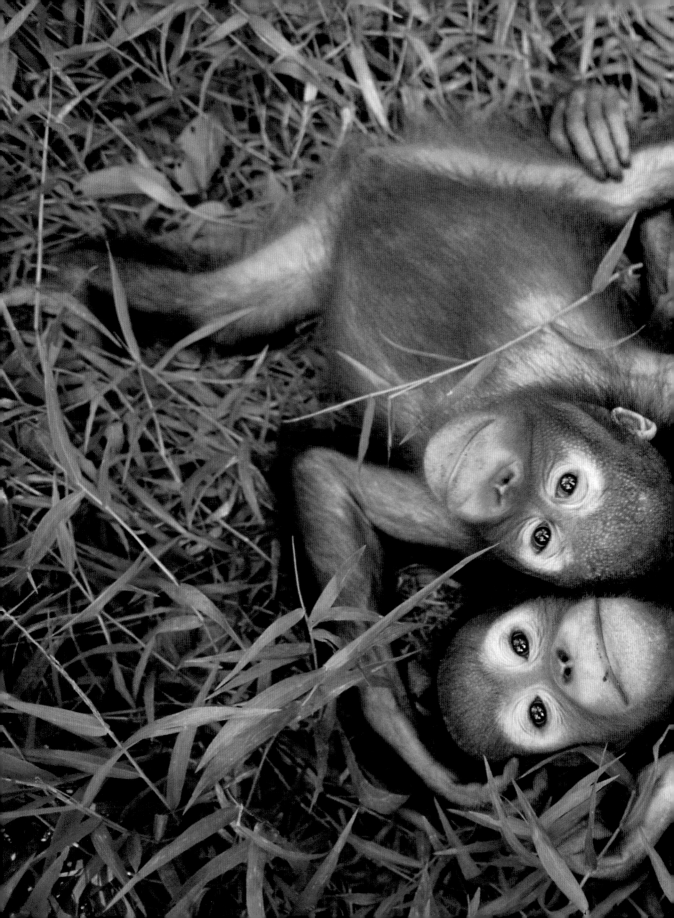

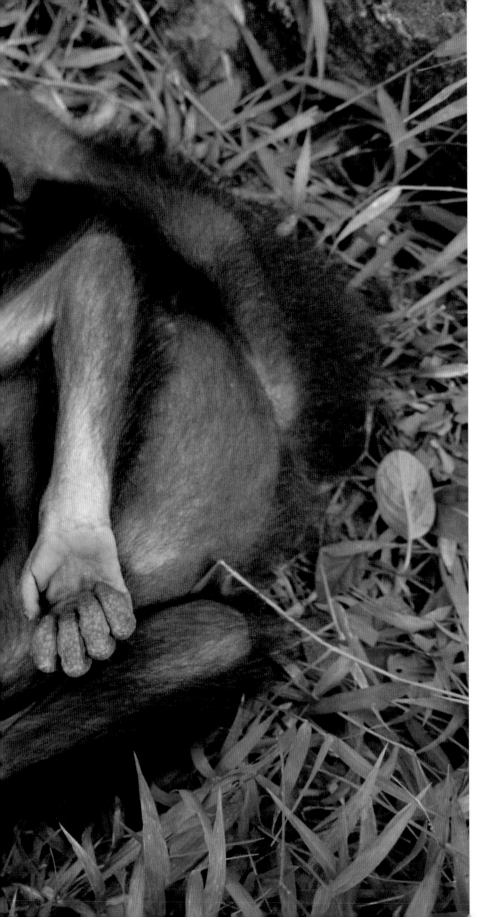

LEFT: *Orangutans, Borneo*
PAGES 136–137: *Warthogs, Botswana*

135

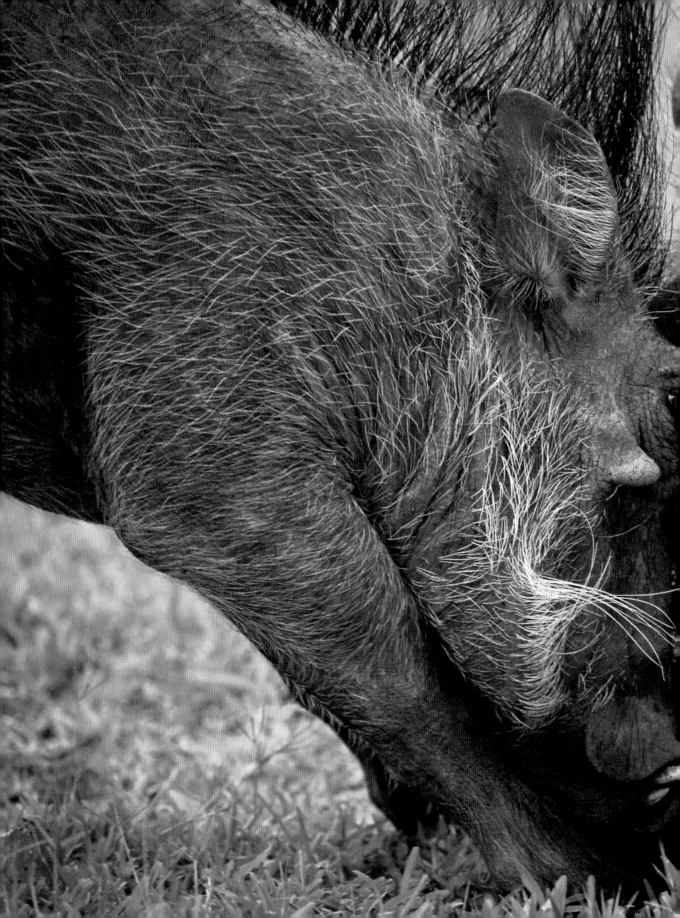

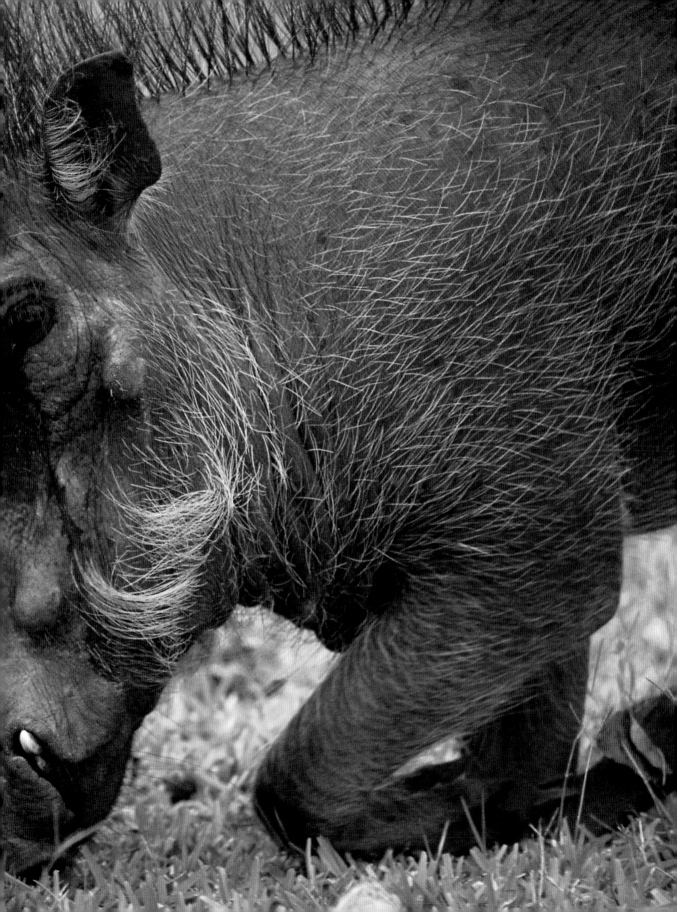

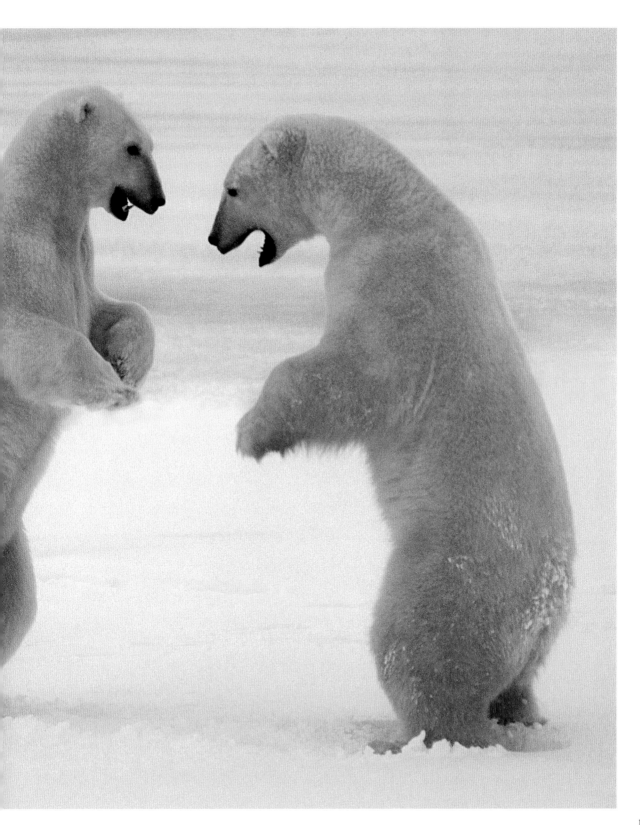

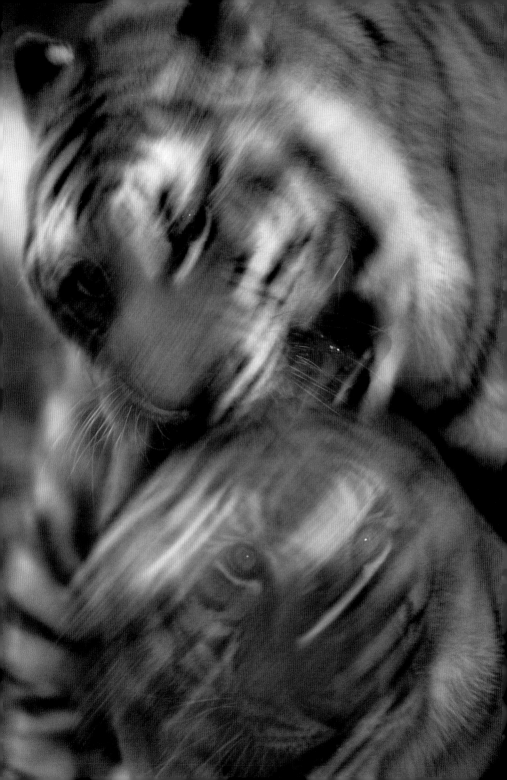

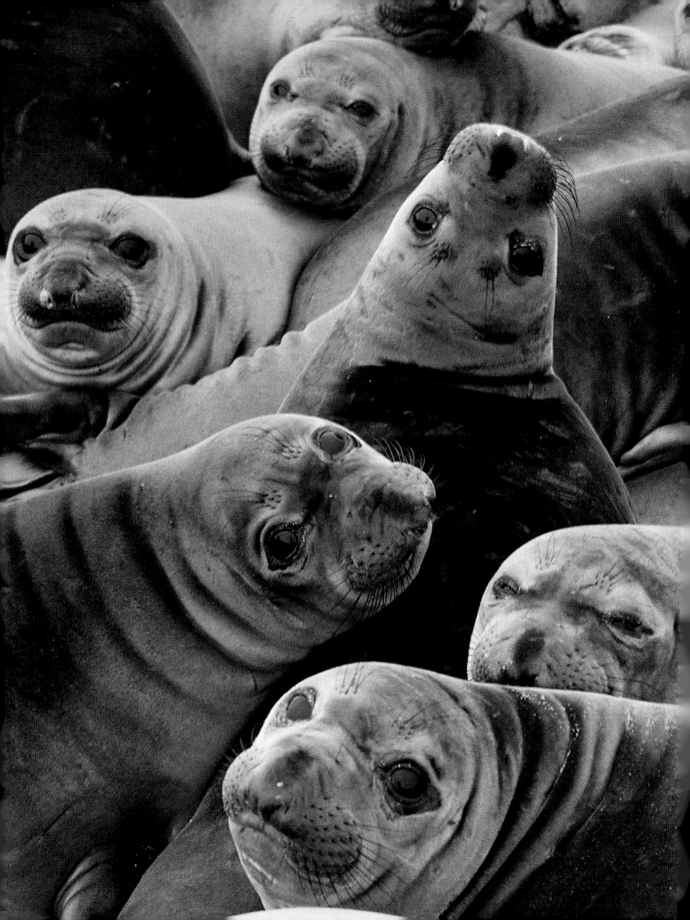

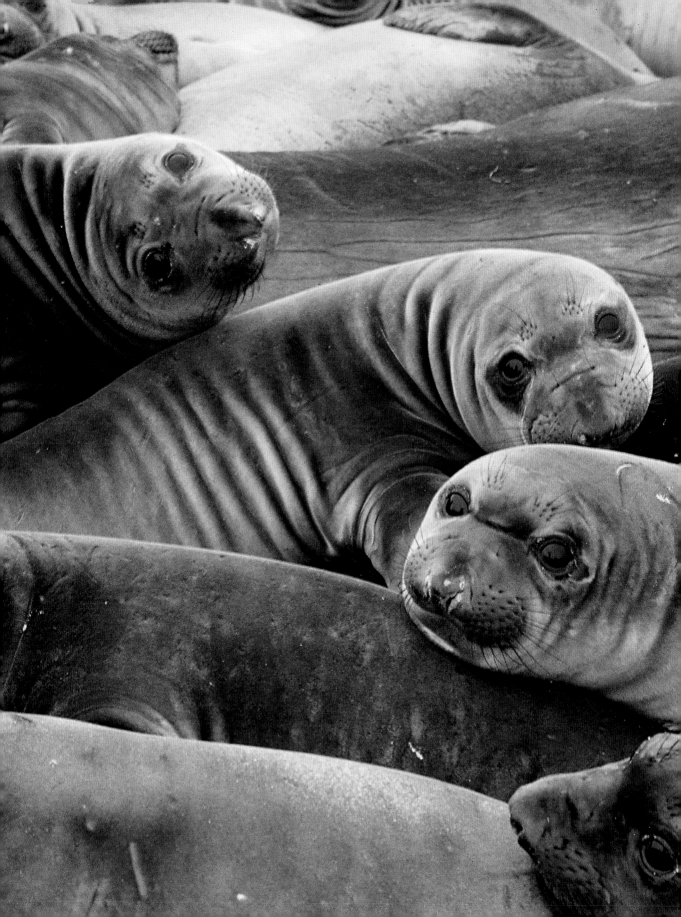

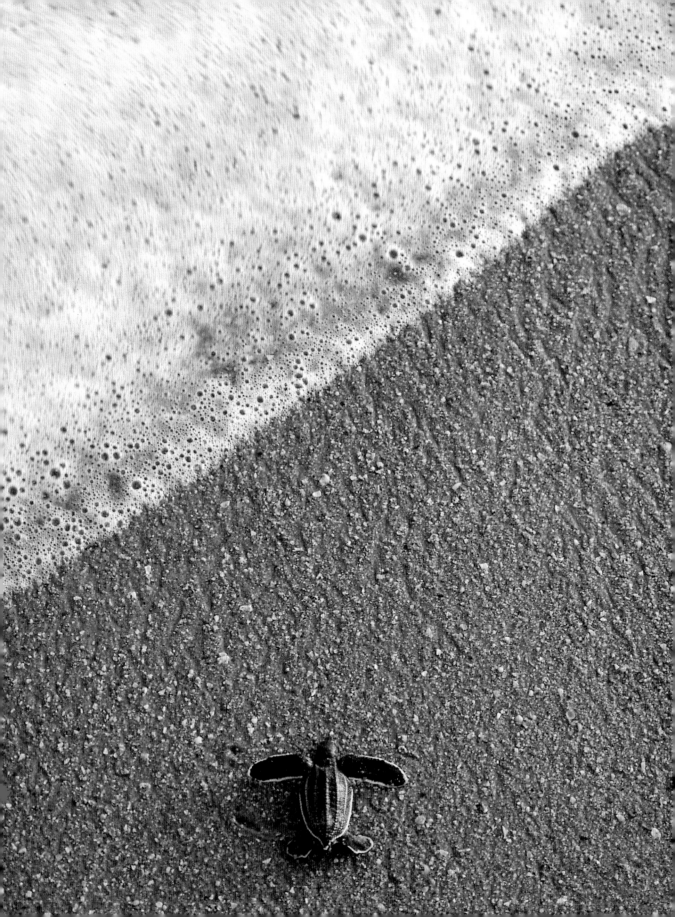

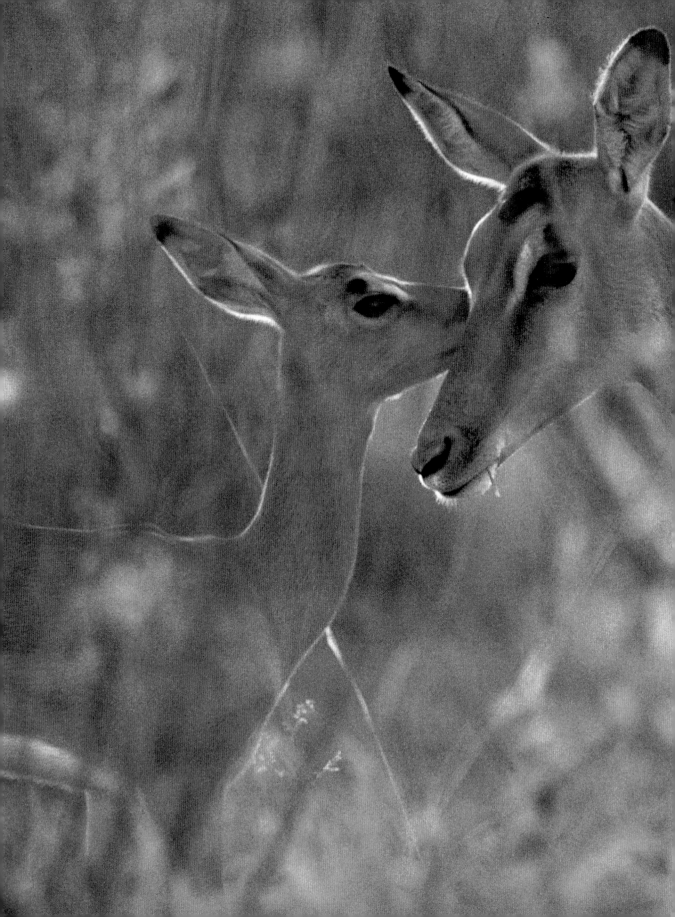

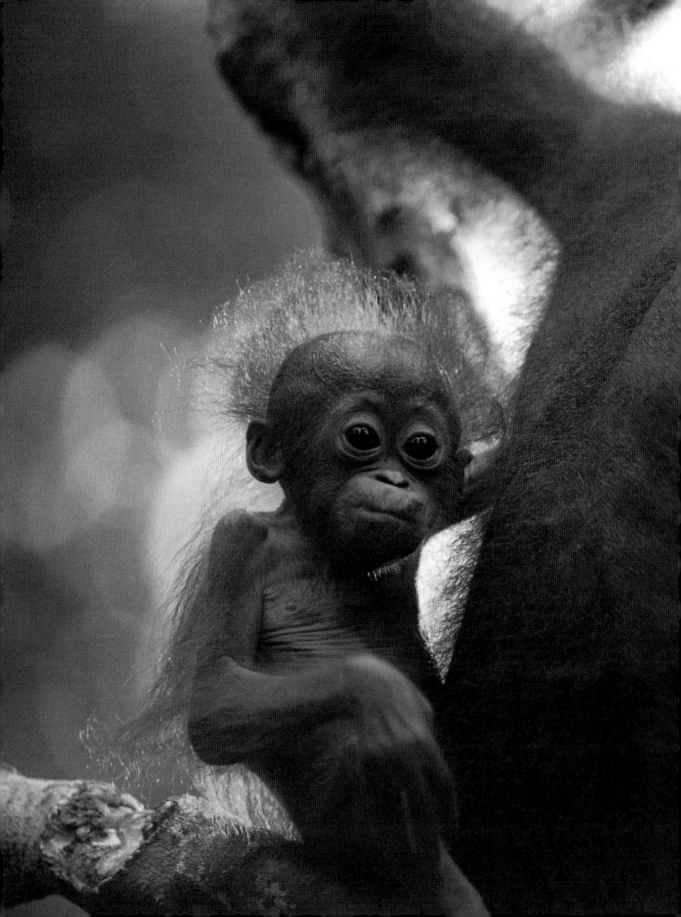

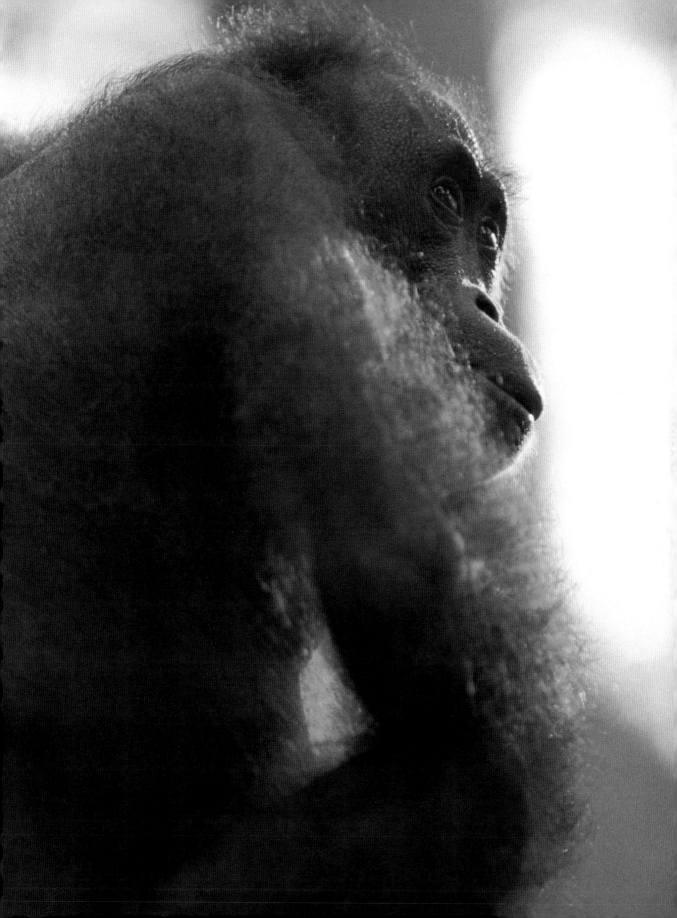

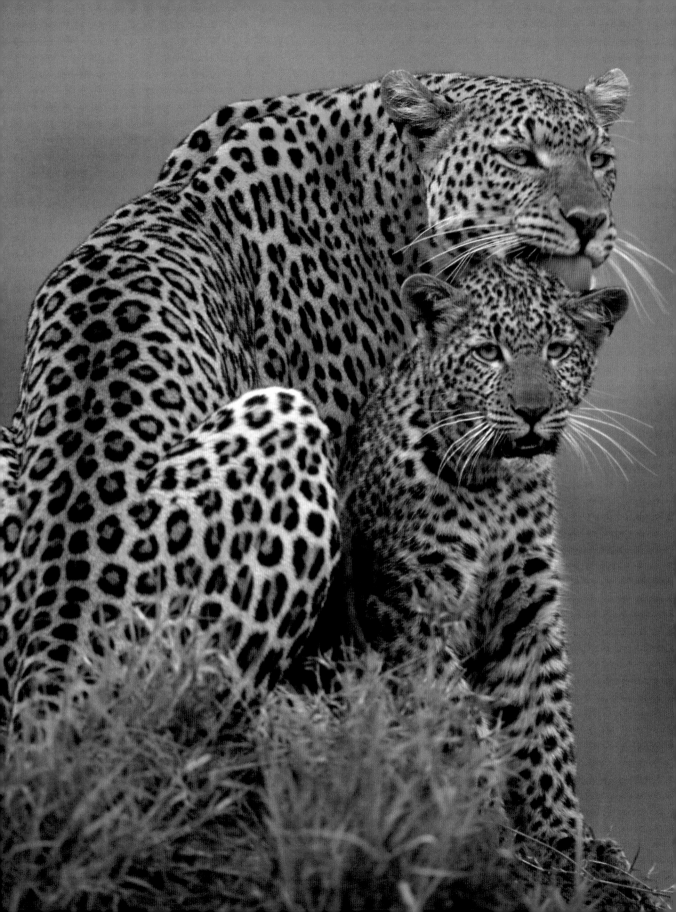

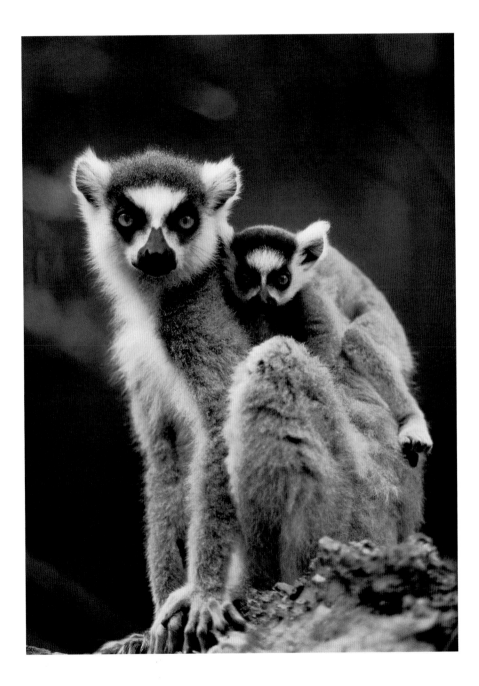

LEFT: *Leopards, Kenya*
ABOVE AND PAGES 152–153:
Ring-Tailed Lemurs, Madagascar

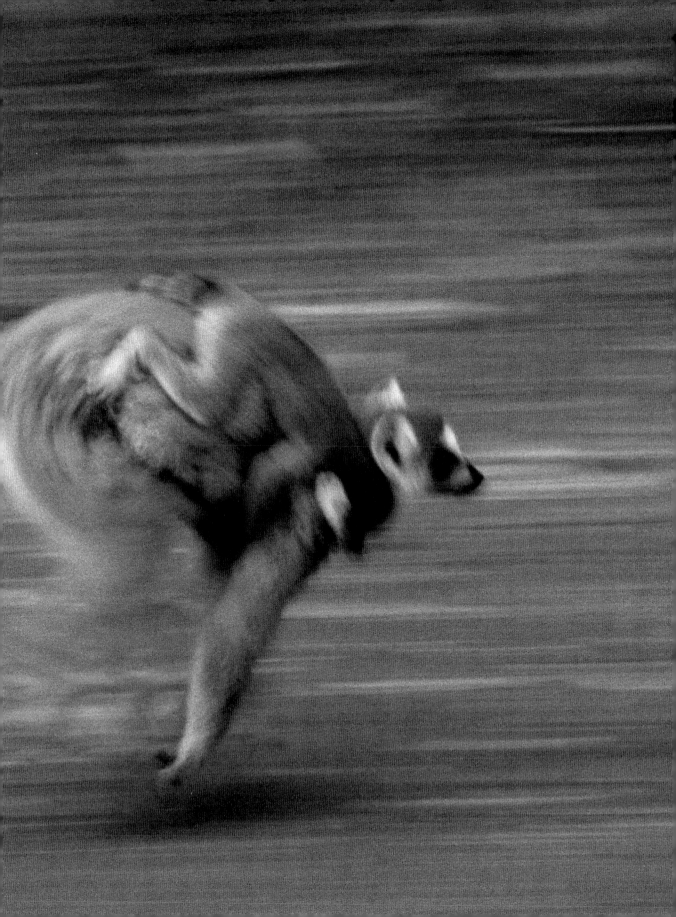

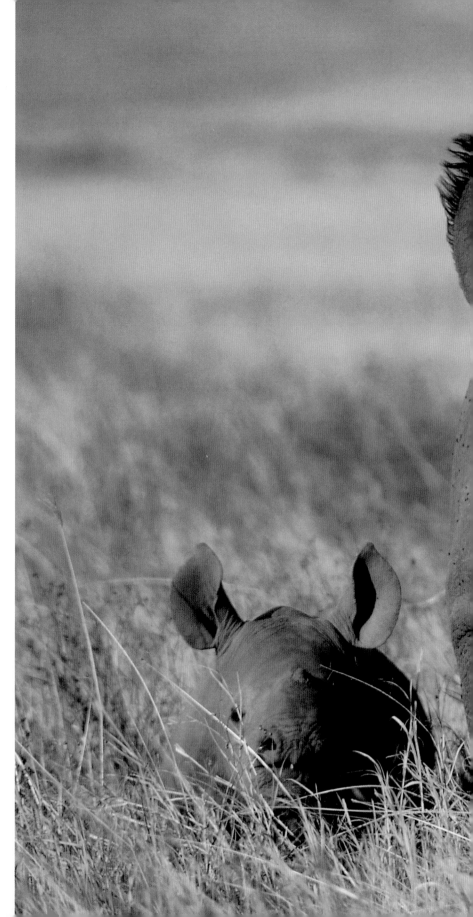

RIGHT: *Black Rhinoceroses,*
Tanzania

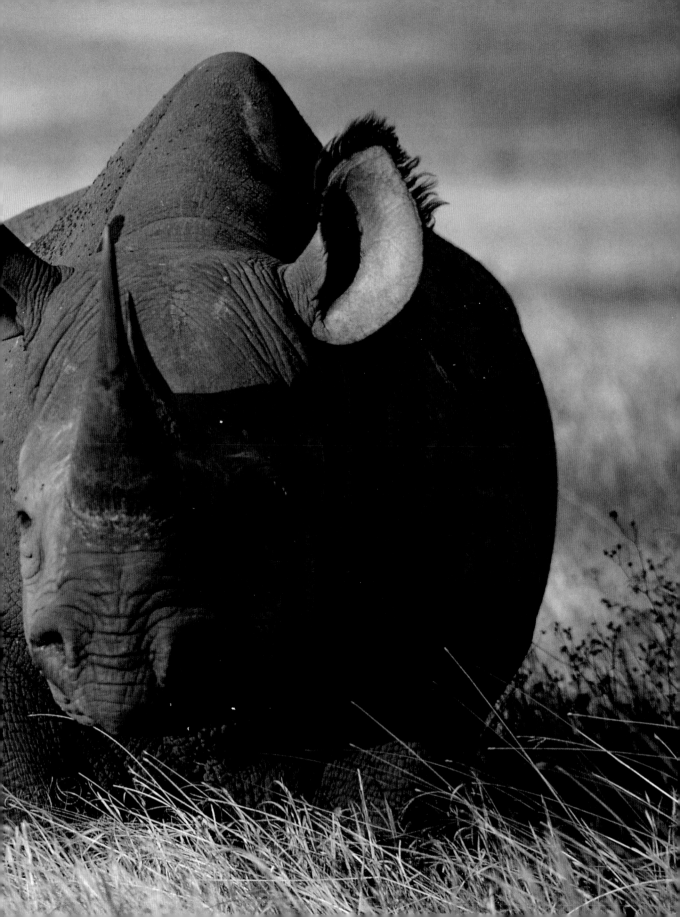

RIGHT: *Gray-Headed Albatrosses, South Georgia Island*
PAGES 158-159: *Polar Bears, Canada*
PAGES 160-161: *Emperor Penguins, Antarctica*

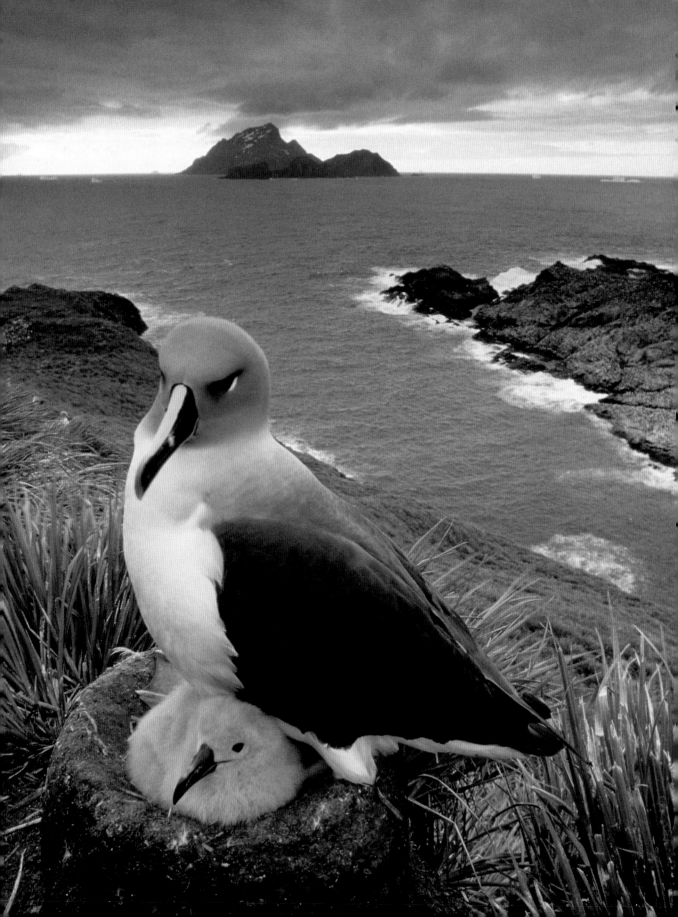

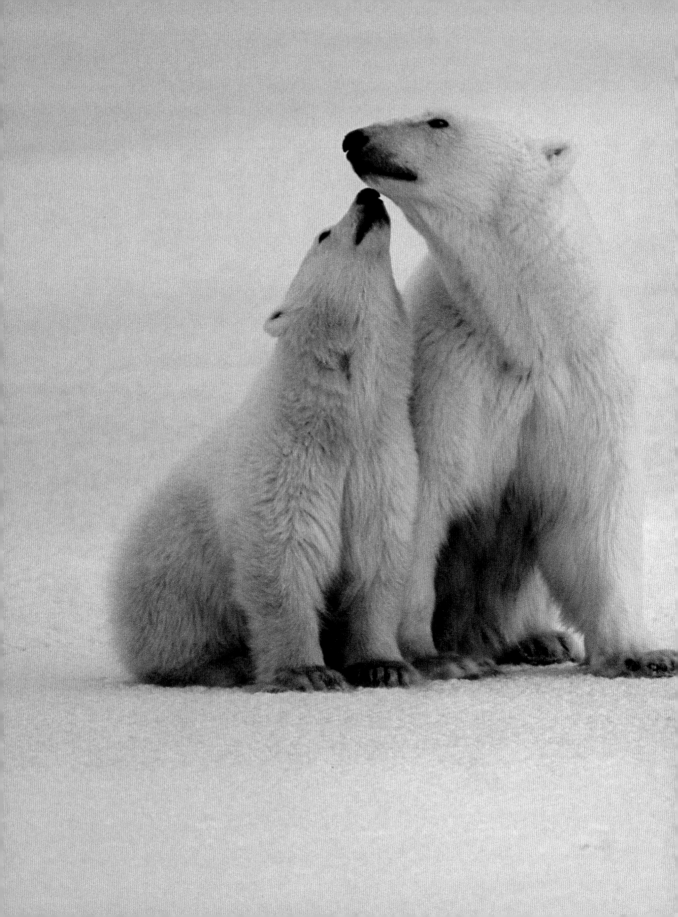

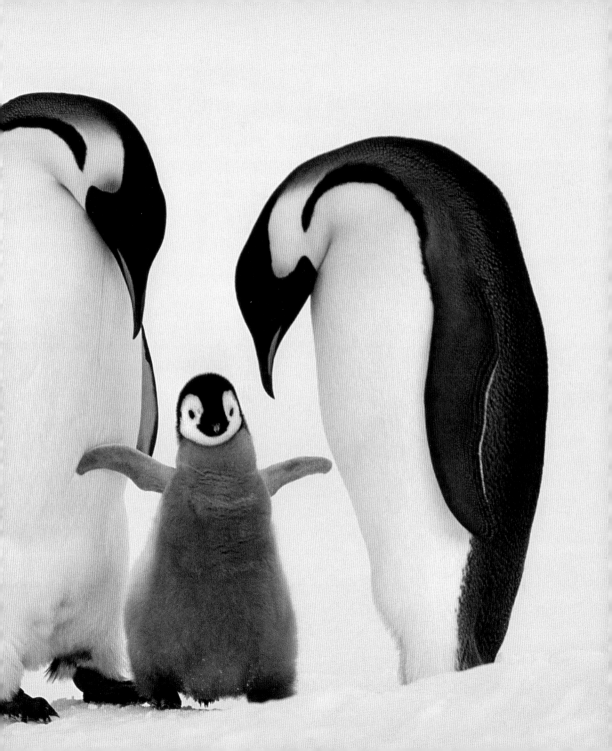

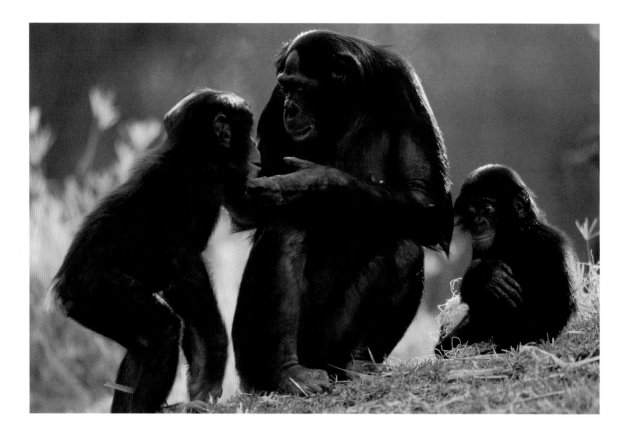

ABOVE AND RIGHT: *Bonobos*
PAGES 164–165: *African Elephants, Botswana*
PAGES 166–167: *Mule Deer, California*

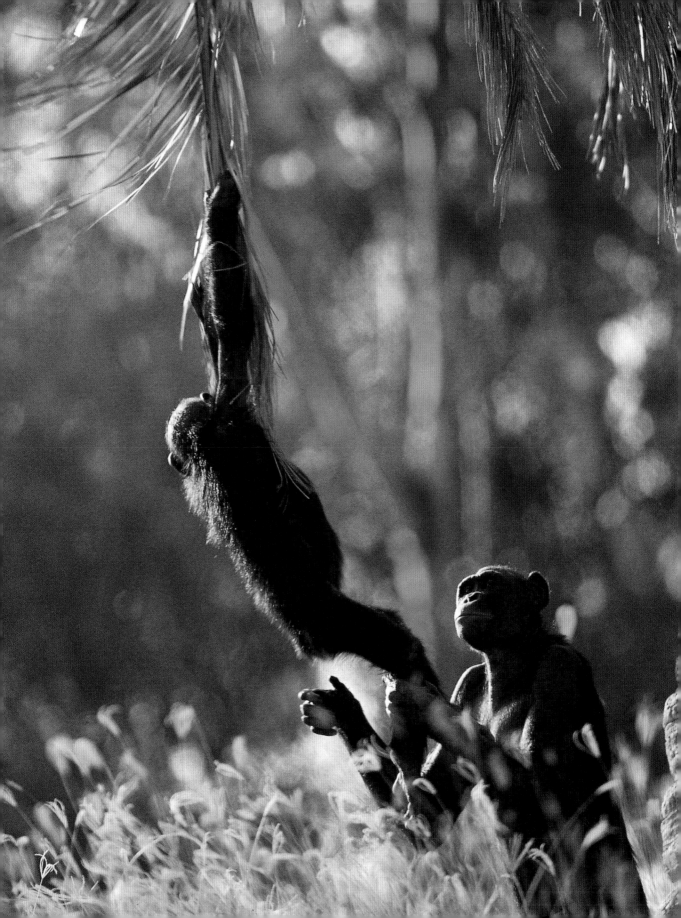

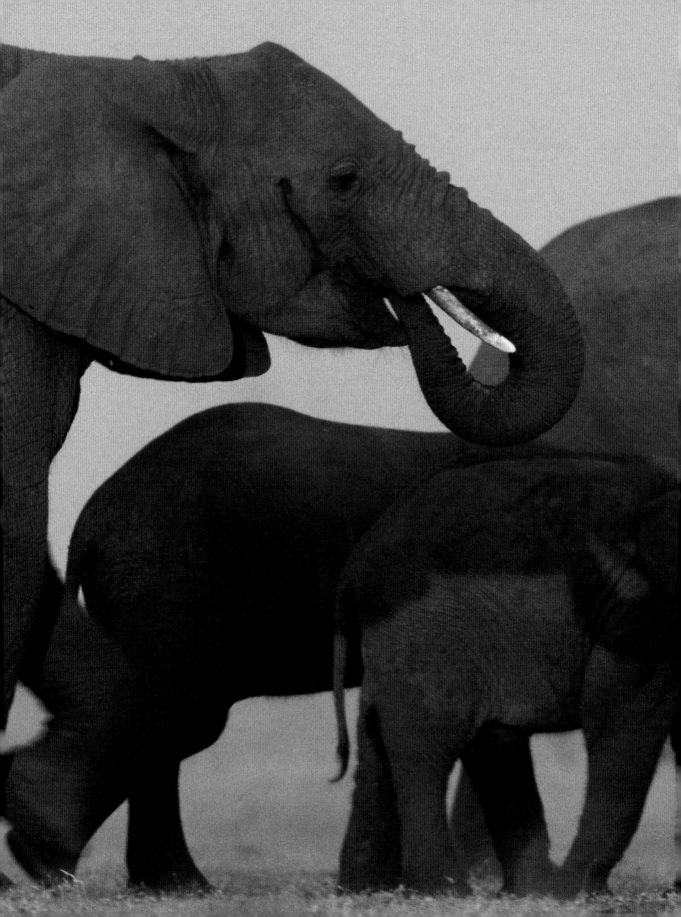

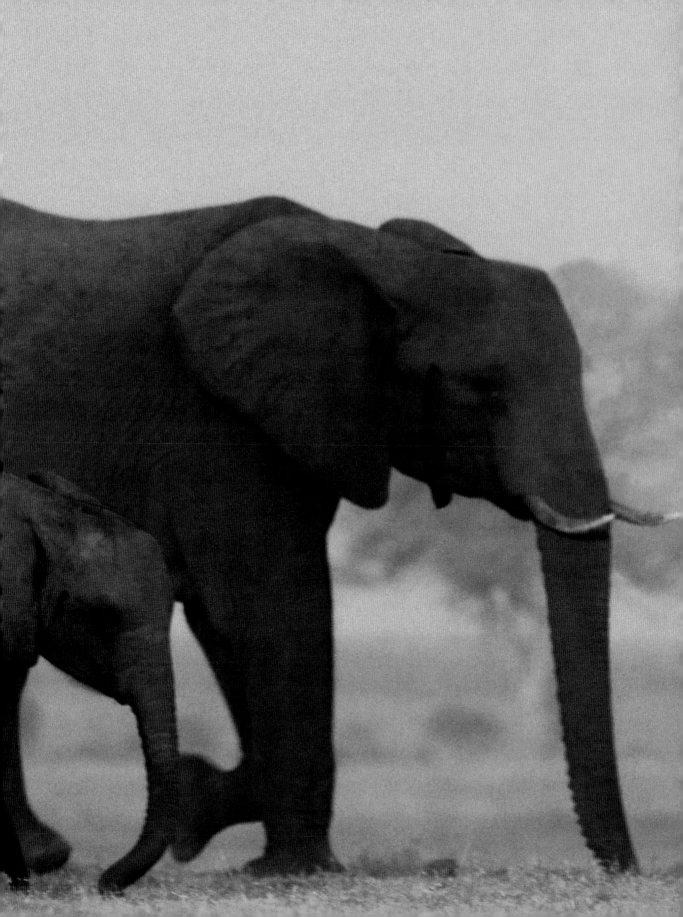

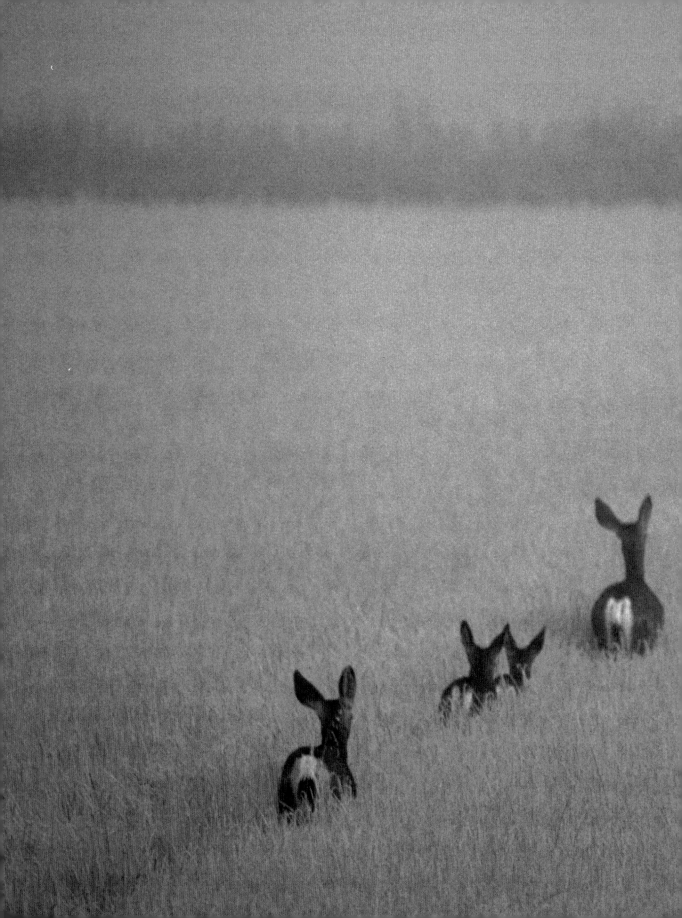

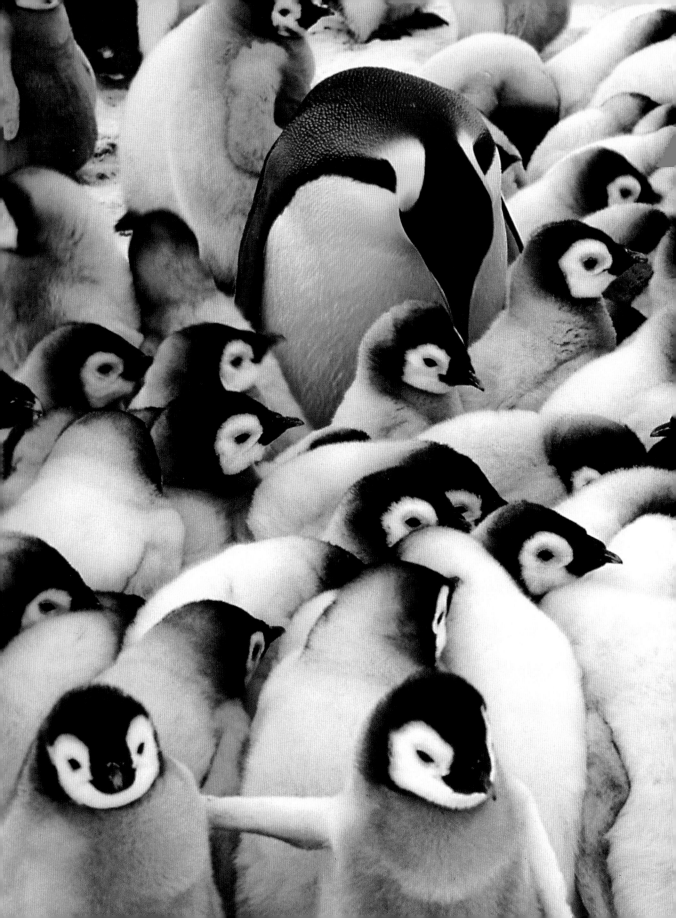

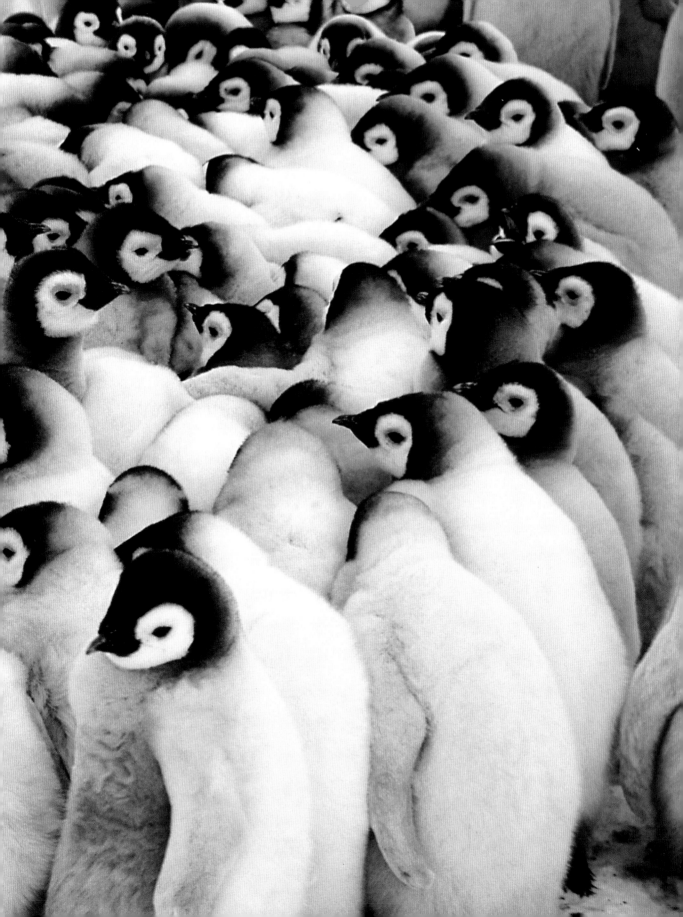

GATHERINGS

Few sights in the natural world are more arresting than animals massed together in great numbers, and few such gatherings are more remarkable than the annual assemblage of emperor penguins at their breeding sites on the frozen seas around Antarctica. It is one of the world's great wildlife spectacles, yet it has been witnessed by a mere handful of people. Emperor colonies form in such remote sites that most Antarctic explorers never see one.

I found my way to this exclusive gathering after a charter flight in a Hercules cargo plane from South America to the interior of Antarctica, where a twin-engine plane took me and a small party a thousand miles across the continent to a colony along the frozen edge of the Weddell Sea. We landed and pitched camp on the sea ice to spend a month among several thousand emperor penguins arrayed against a surreal backdrop of towering icebergs.

Emperor natural history is a tale of superlatives. Each fall, when Antarctica becomes so inhospitable that every other life form flies or swims to warmer haunts, emperors go against the flow. They come out of the water and march up to a hundred miles inland across the sea ice to form colonies at the very edge of the continent. They begin breeding at a time of year and under conditions that seem utterly insane, with temperatures dropping to minus 70°F and winds exceeding a hundred miles an hour. Female emperors transfer newly laid eggs to their mates and head back to sea. Males then stand in place for two months, in the darkness of the Antarctic winter, each one incubating a single egg on top of his feet.

When I arrived at the colony, chicks had already hatched, females had returned, and adults were marching back and forth to the nearest open water in steady processions. The colony was a whirl of activities, ranging from parents cradling newborn chicks on their feet to stately courtship ceremonies between prospective pairs. It was springtime, but the windchill still pushed the temperature to minus 50°F at times. During blizzards, chicks left unguarded by parents huddled in shivering masses. Even adults sought each other's physical protection on occasion, clustering in huddles reminiscent of rugby scrimmages. This unique response to extreme temperatures enables the birds to cut their heat loss in half. Without it they would not survive.

In the course of my stay, gales swept through that flattened my tent and kept me pinned down inside for days, but there were also times of sublime beauty, periods of twenty-four-hour sun with emperors traveling through a landscape of otherworldly light. Unfortunately we had to leave before the chicks were fully grown. The sea ice was beginning to melt under our camp and it became too dangerous to stay. When we took off and circled over the colony, I could see that open water was still many miles away. The chicks were facing a long march to sea.

It is to ensure the survival of their offspring that emperors gather during the Antarctic winter—and walk so far from open water to establish their colonies. If the birds were to breed any closer to the sea, the ice might melt from under their chicks' feet before they were ready to go. If they commenced breeding later, their chicks would not fledge in time before the next winter. For emperors, each breeding season is a gamble between ice and time. That they succeed at all in raising young in an environment which seems more like another planet than a place on earth represents a triumph of life itself.

PAGES 168–169 AND PAGES 172–173:
Emperor Penguins, Antarctica

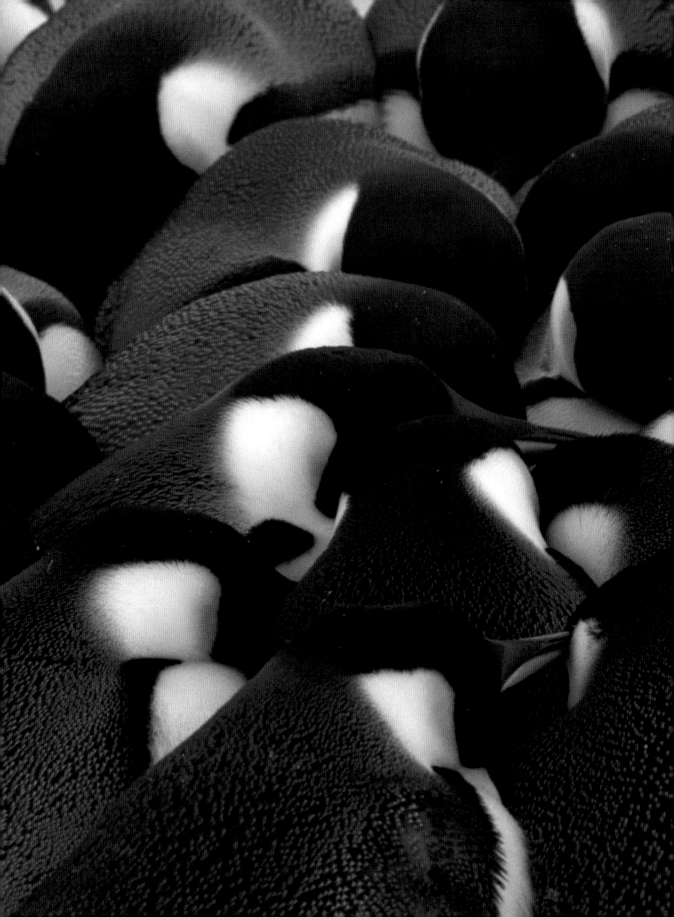

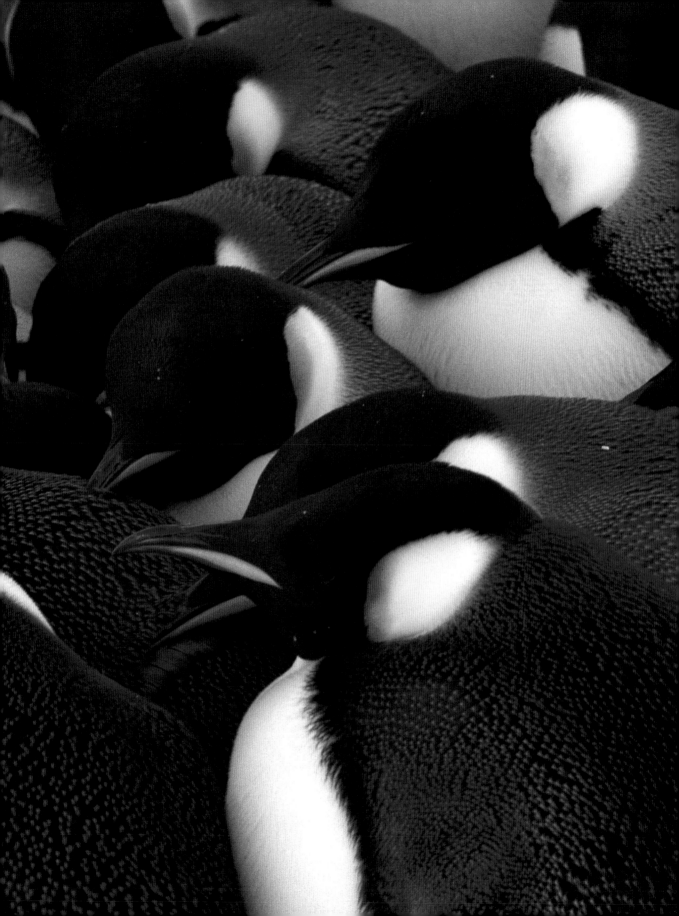

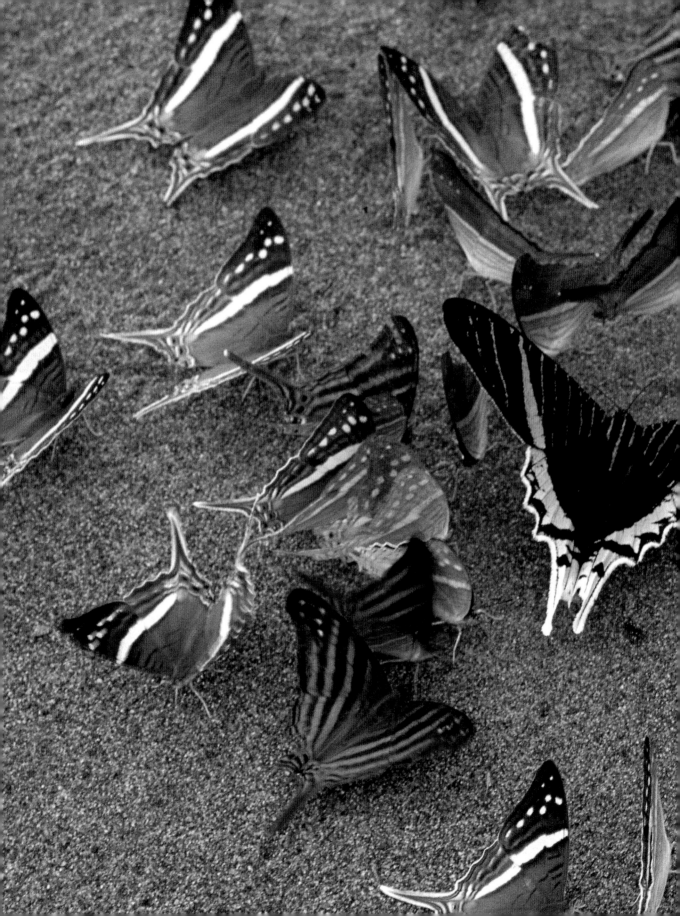

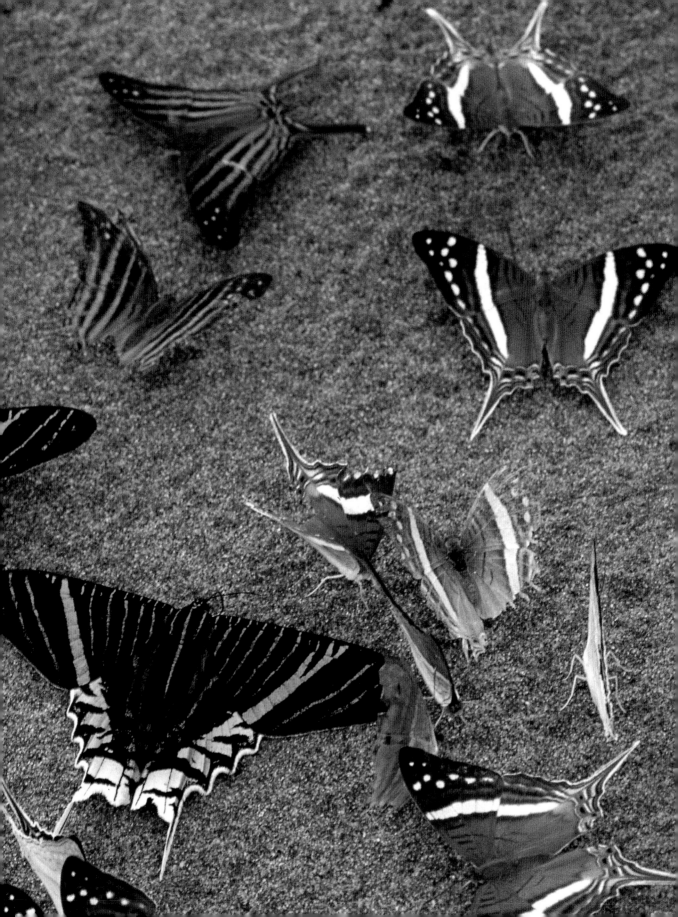

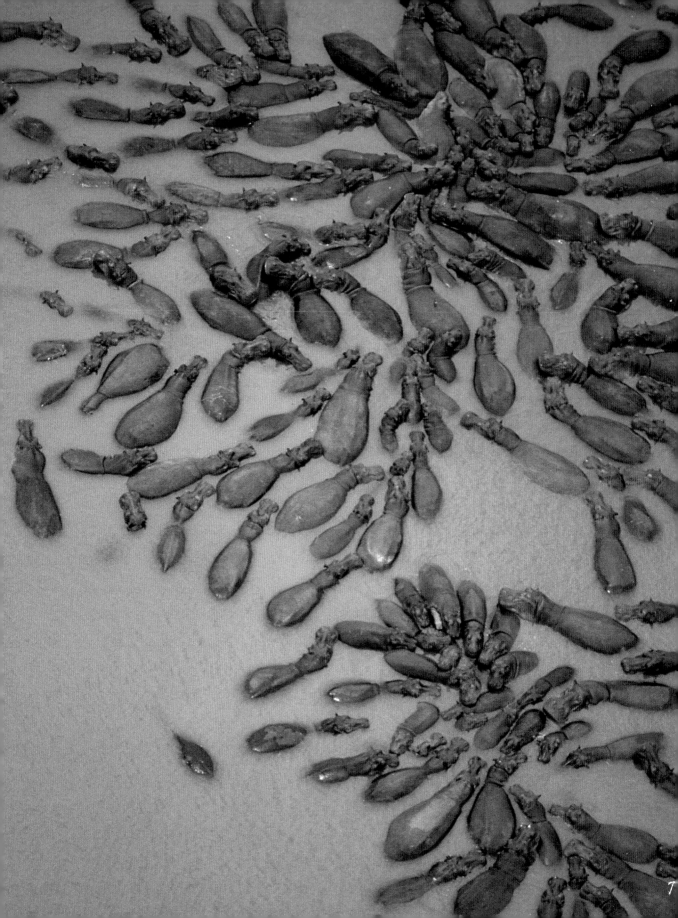

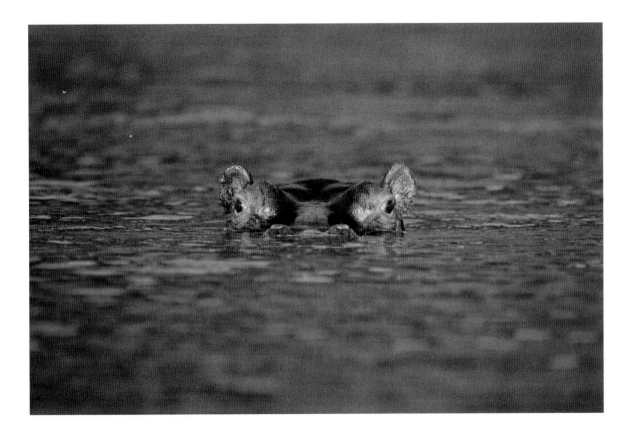

PAGES 174–175: *Moths and Butterflies, Peru*
LEFT: *Hippopotamuses, Congo*
ABOVE: *Hippopotamus, Botswana*

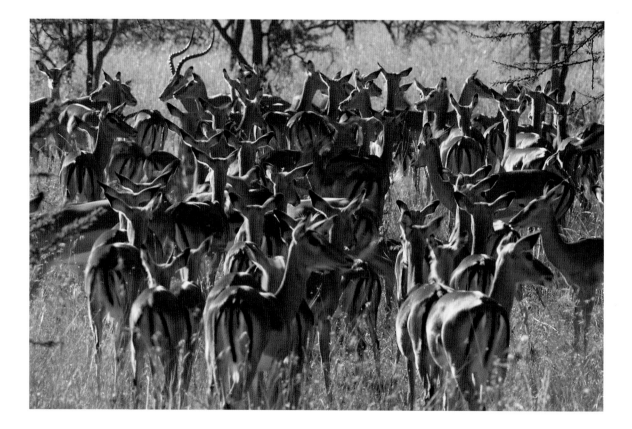

ABOVE: *Impalas, Kenya*
RIGHT: *Impala, Botswana*
PAGES 180–181: *Impalas, Tanzania*

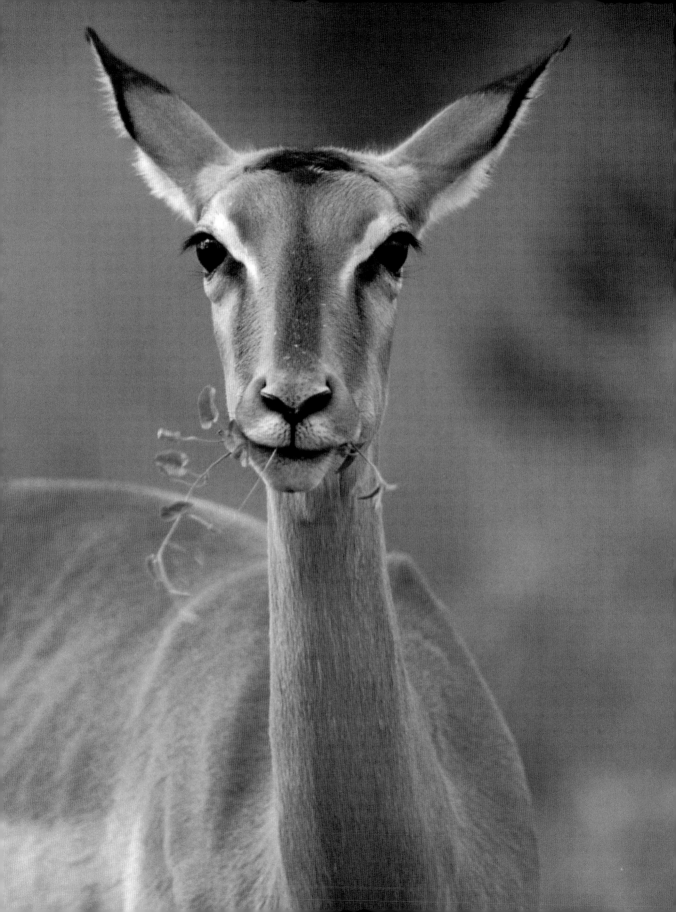

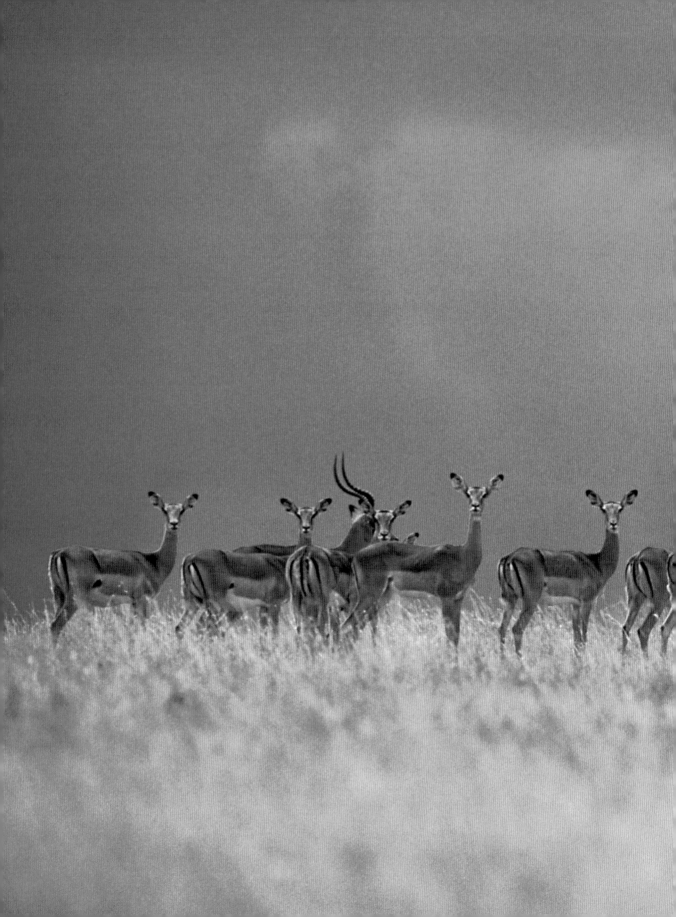

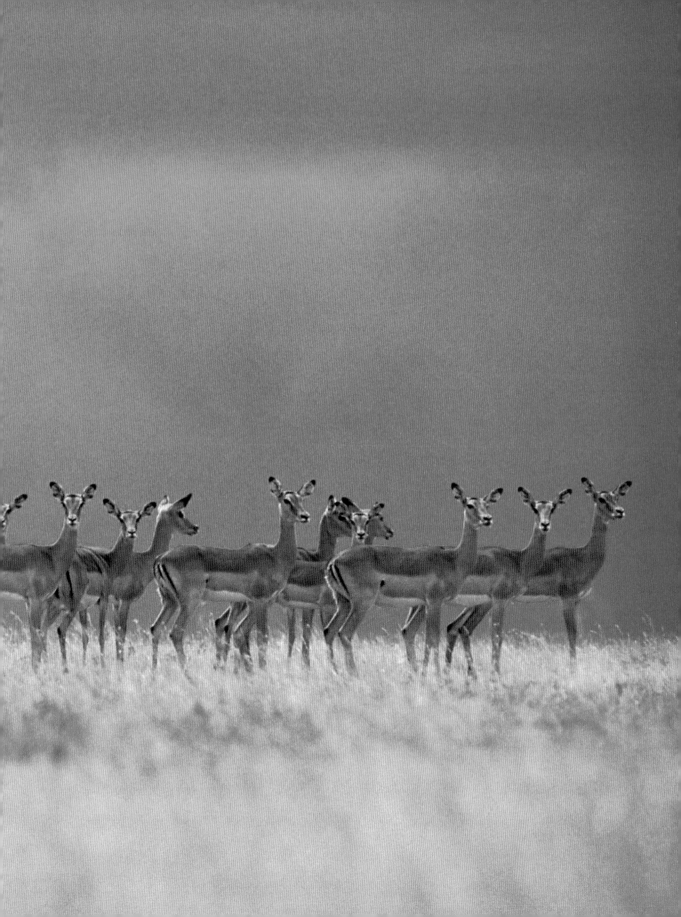

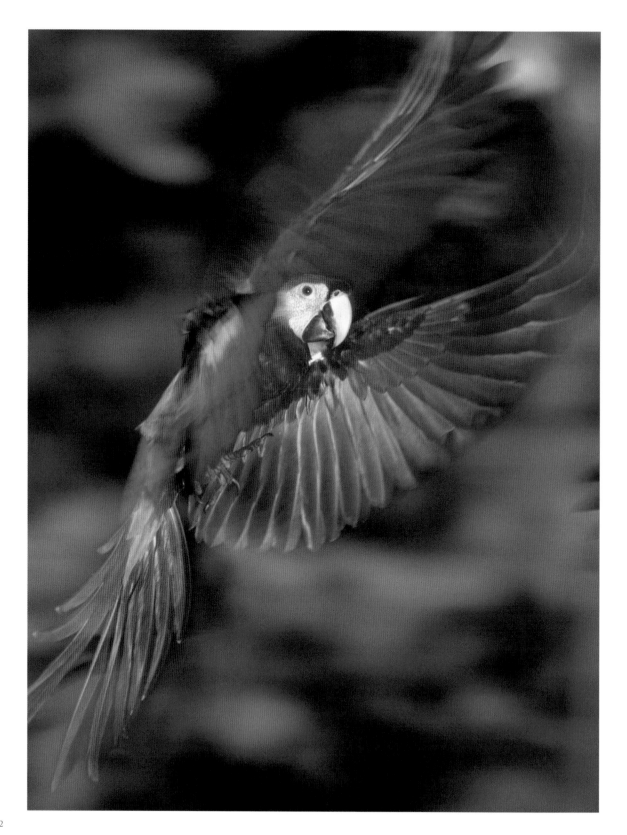

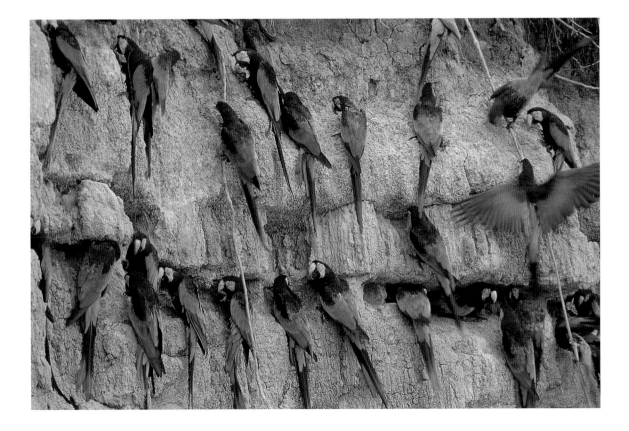

LEFT: *Scarlet Macaw, Peru*
ABOVE: *Red-and-Green Macaws, Peru*

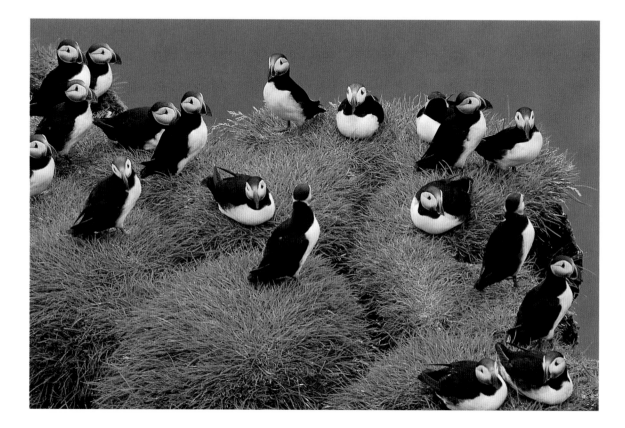

ABOVE: *Atlantic Puffins, Iceland*
RIGHT: *Atlantic Puffin, Scotland*
PAGES 186 AND 187: *Marine Iguanas, Galápagos*
PAGES 188–189: *African Elephants, Botswana*
PAGES 190–191: *Giant Tortoises, Galápagos*

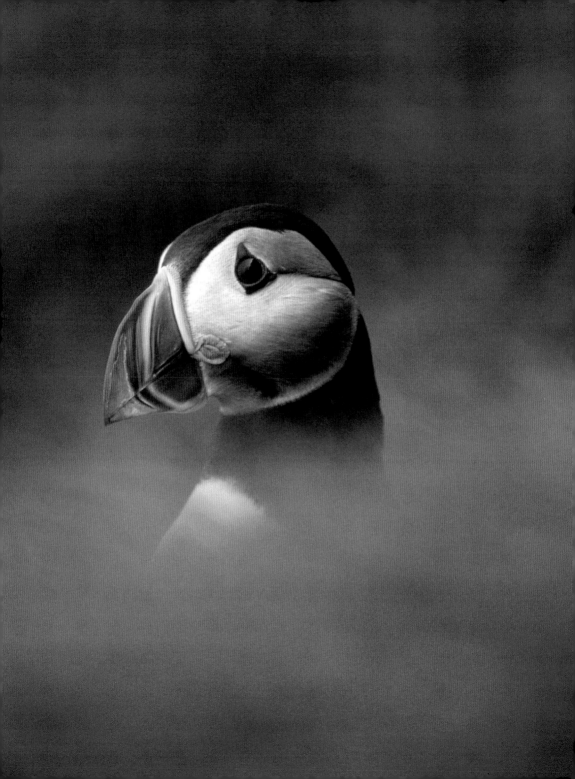

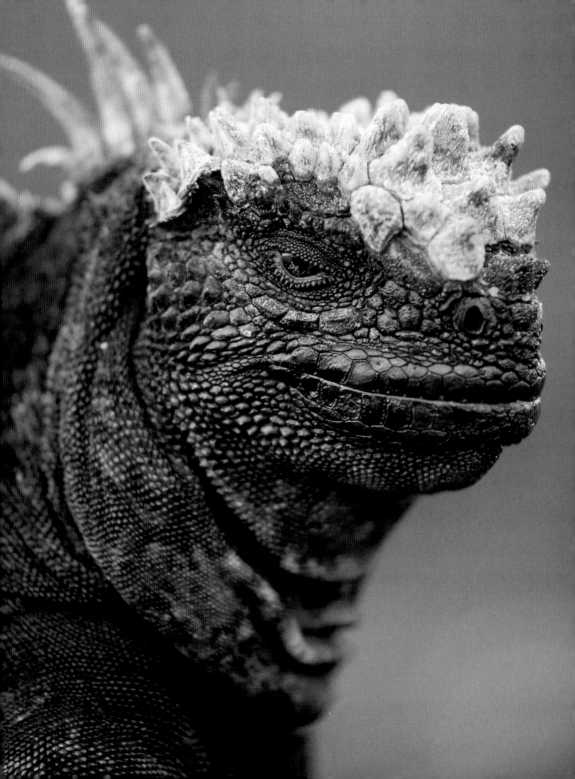

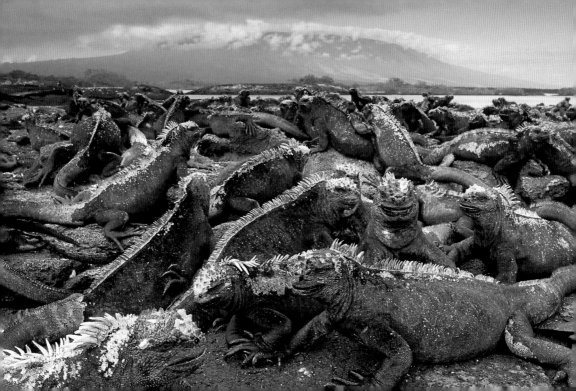

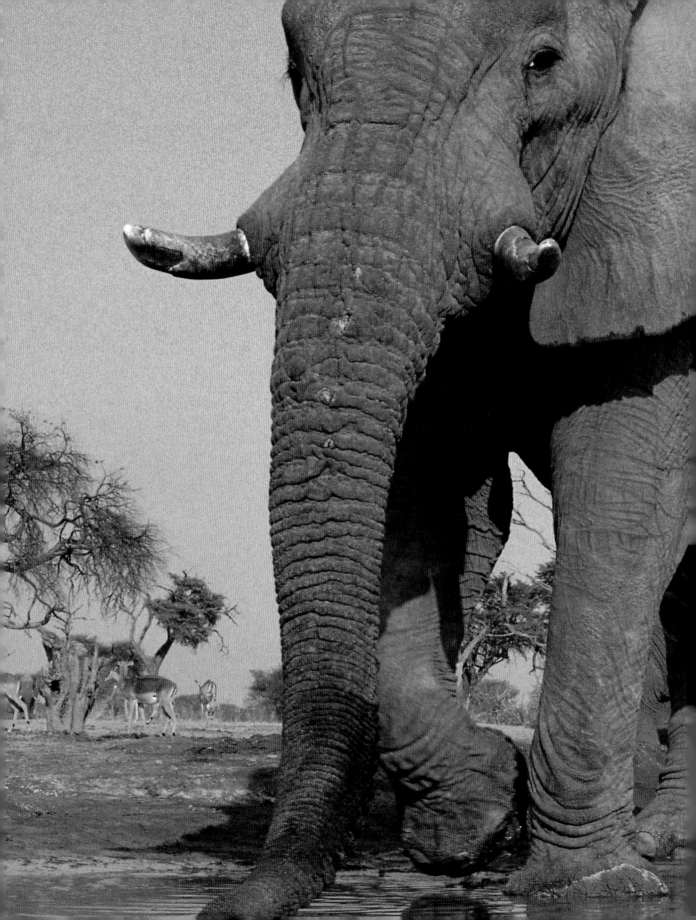

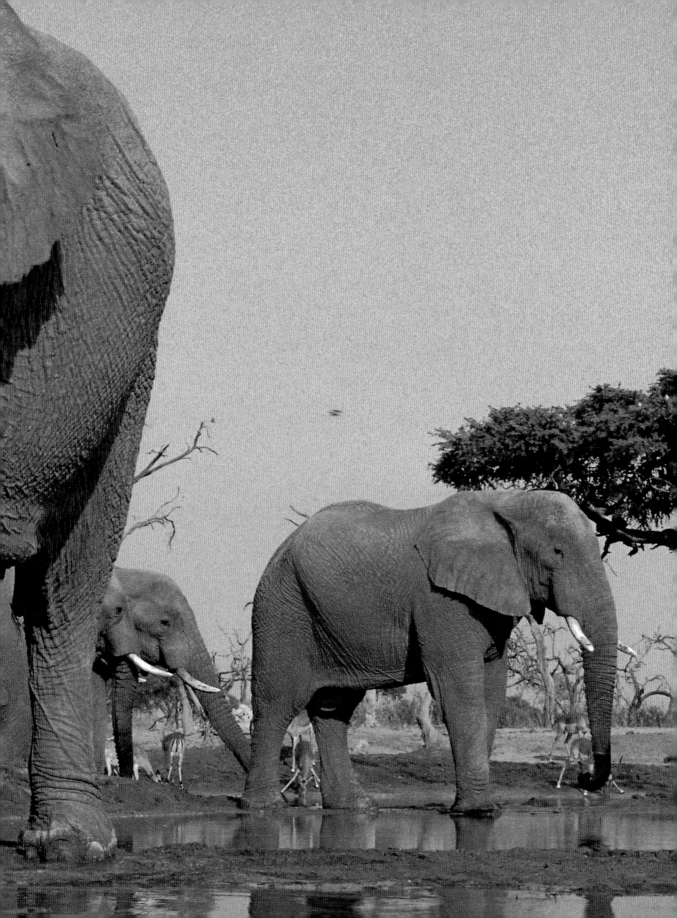

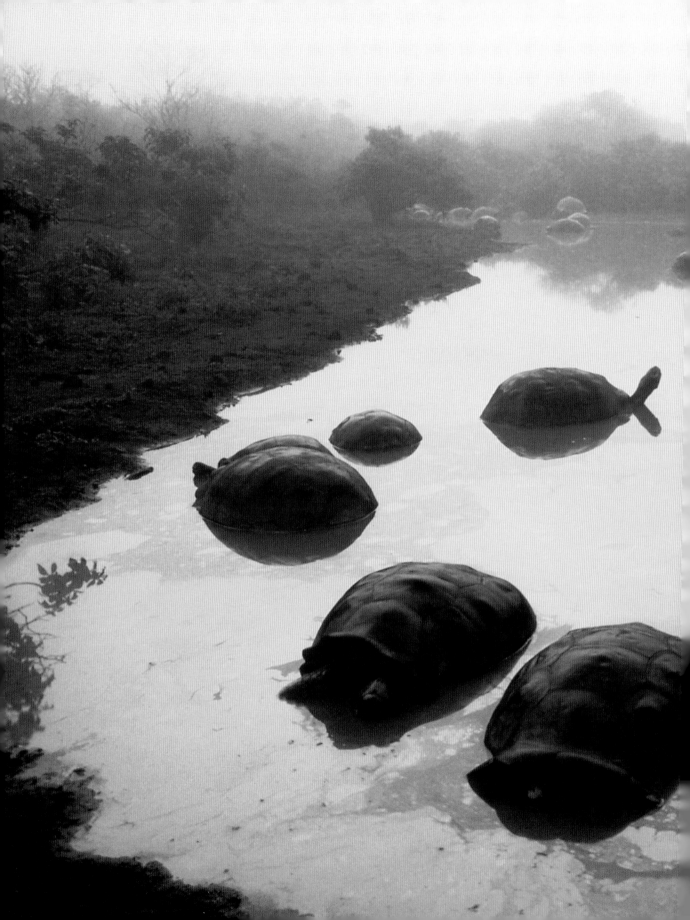

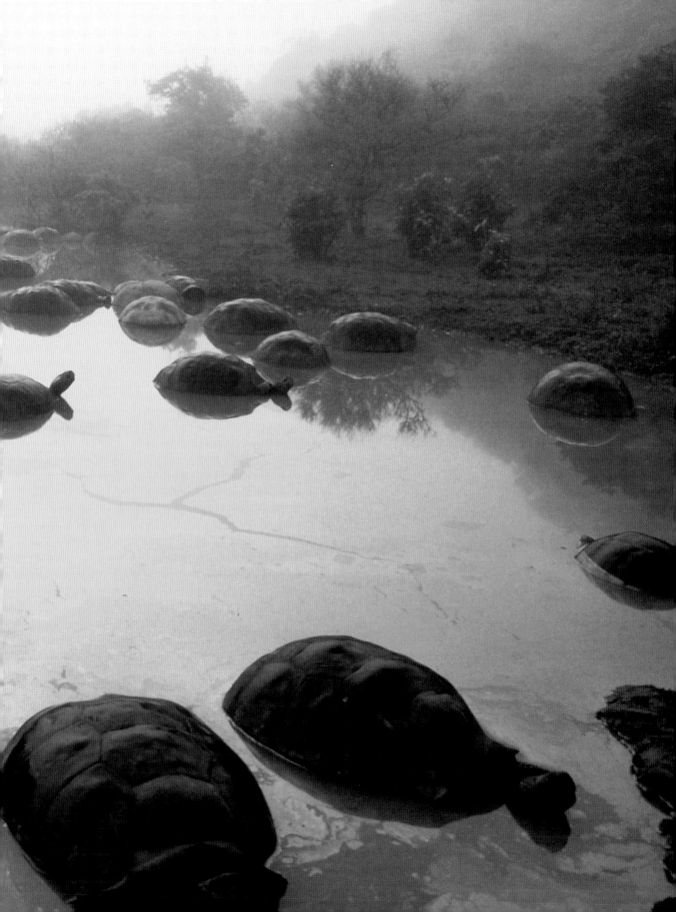

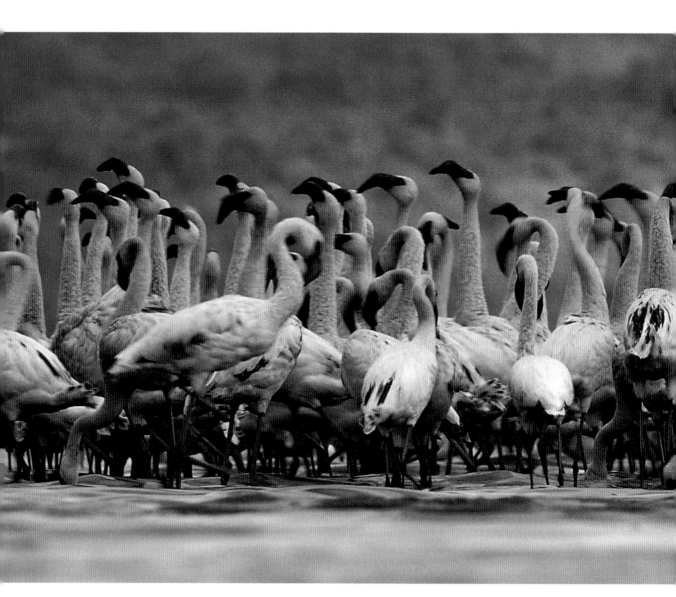

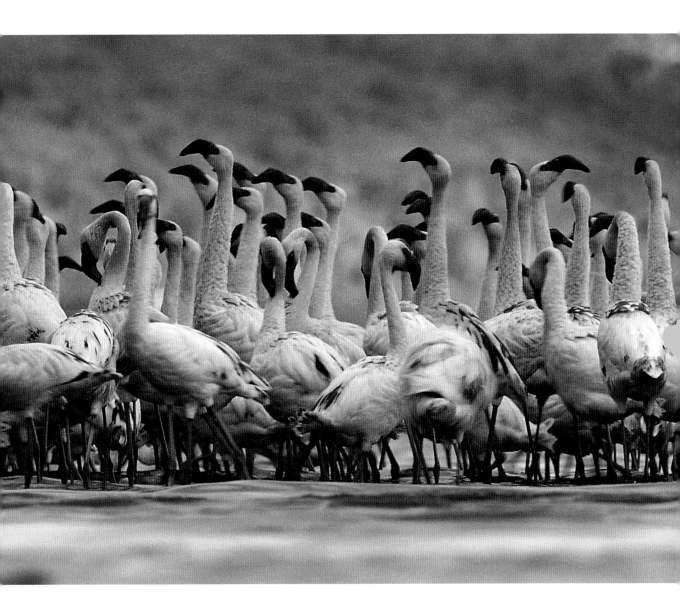

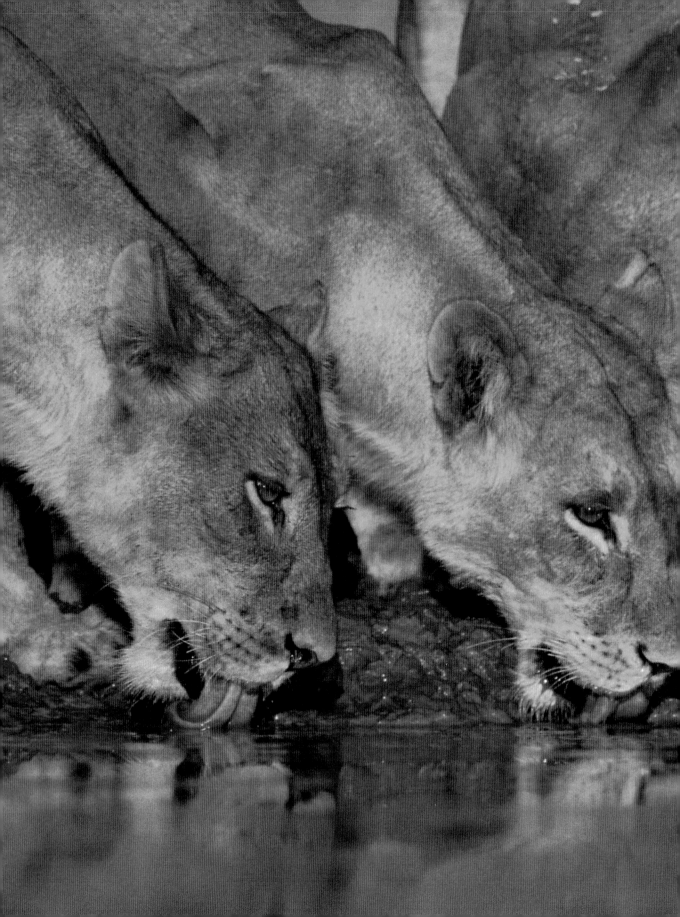

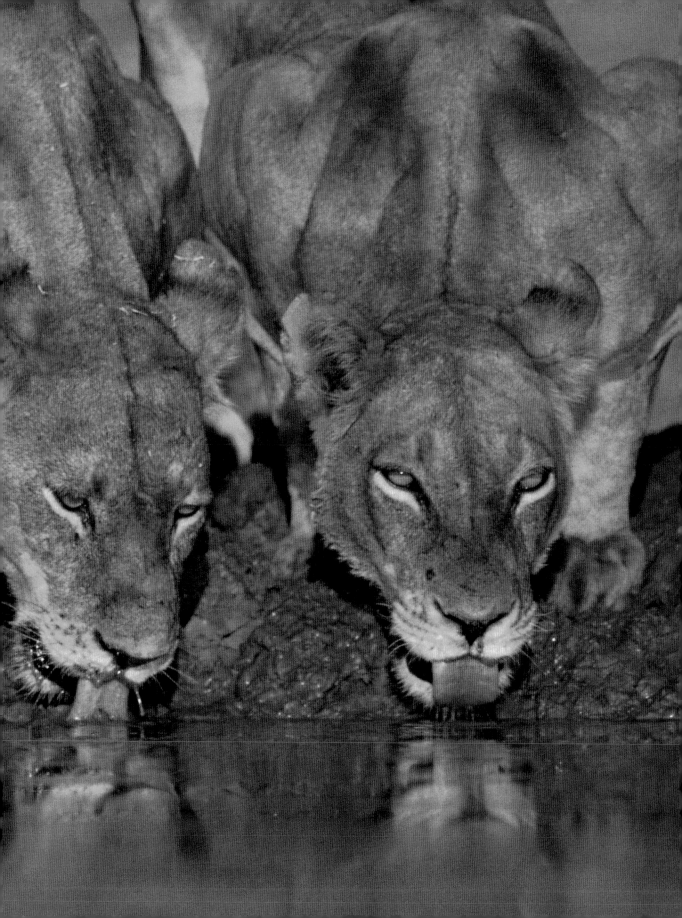

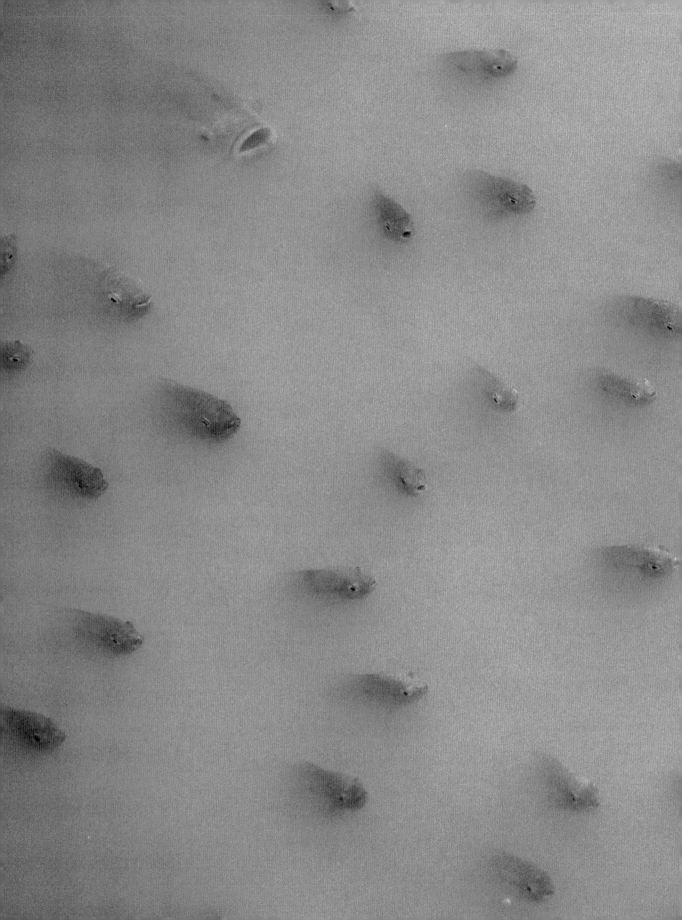

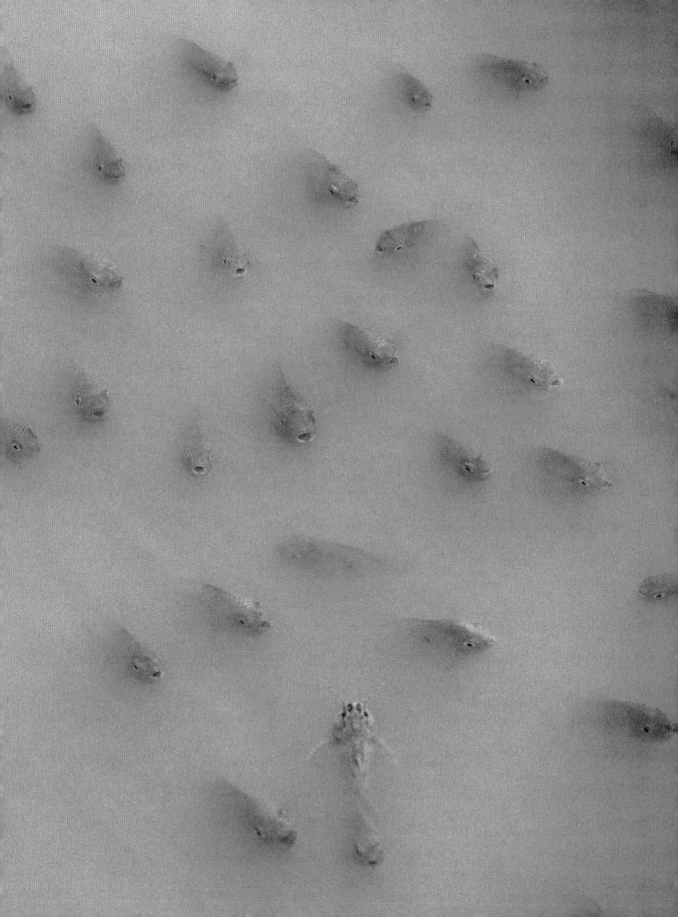

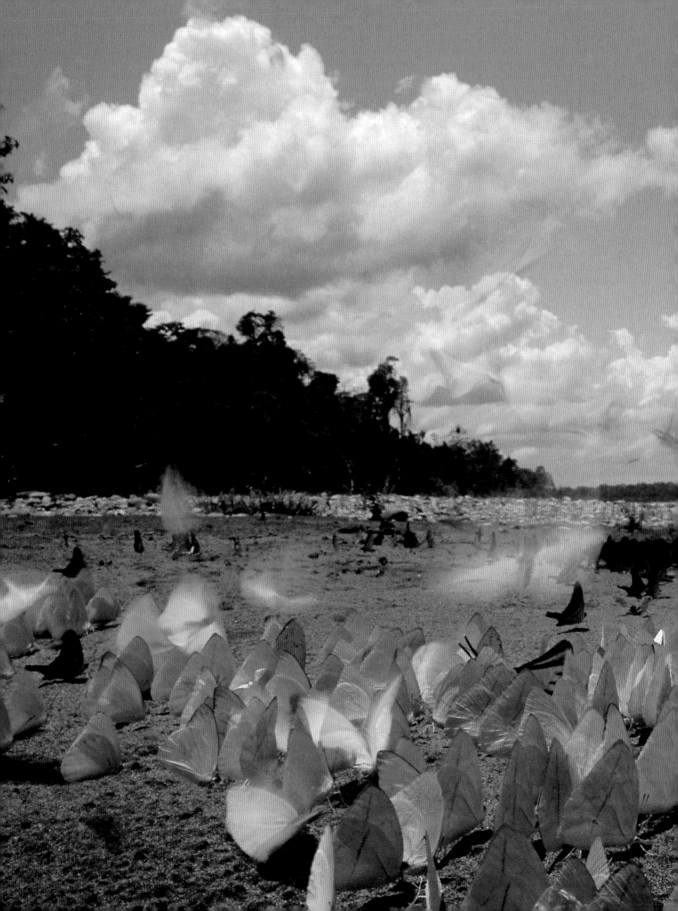

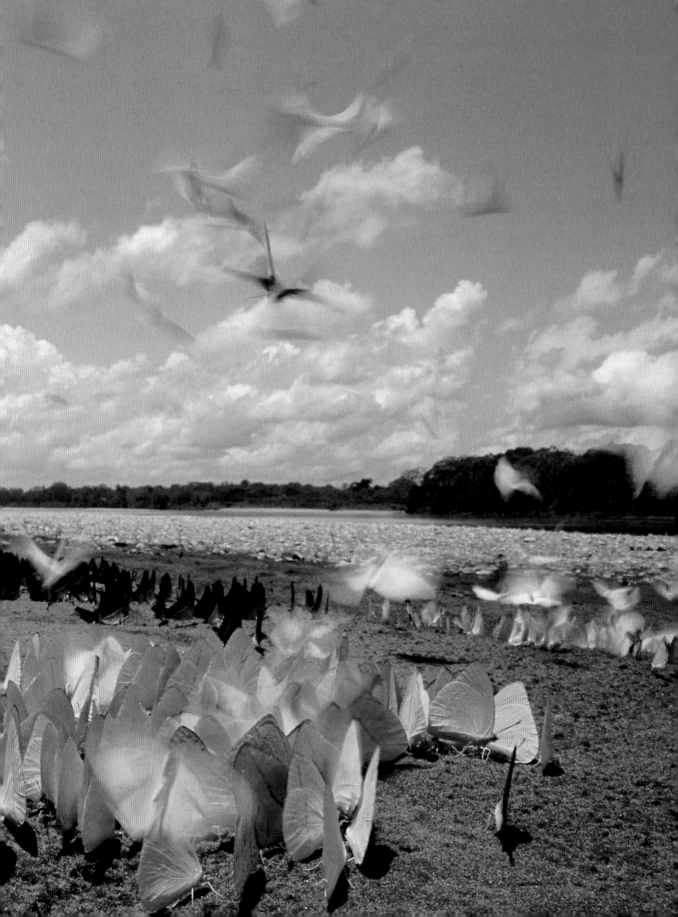

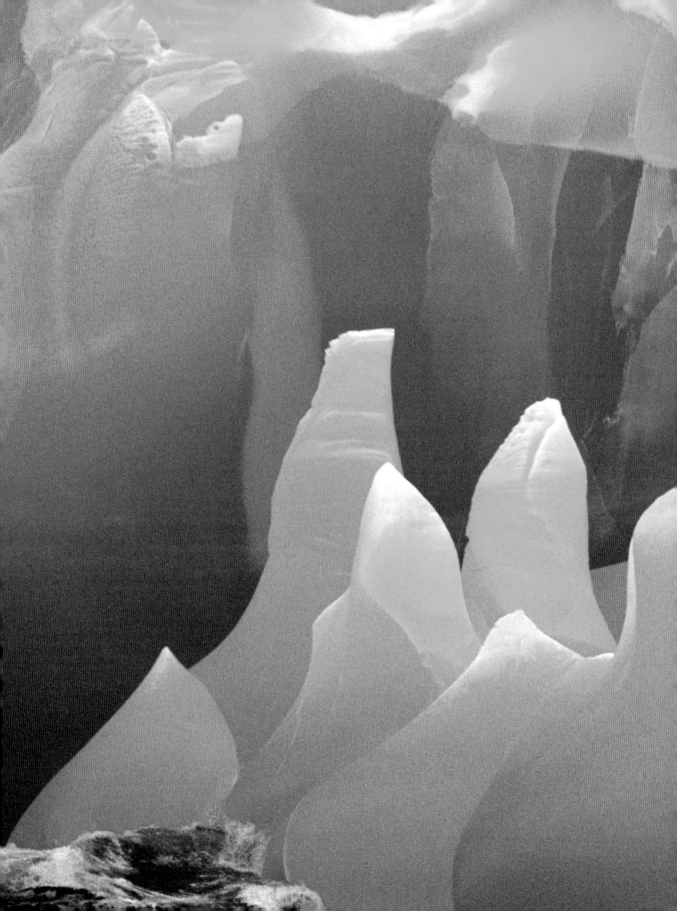

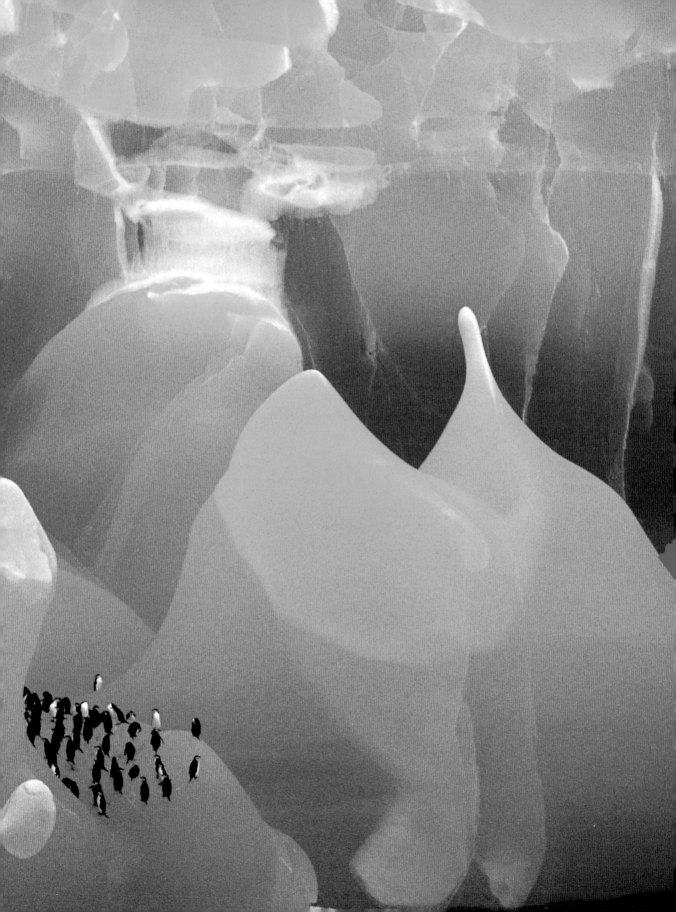

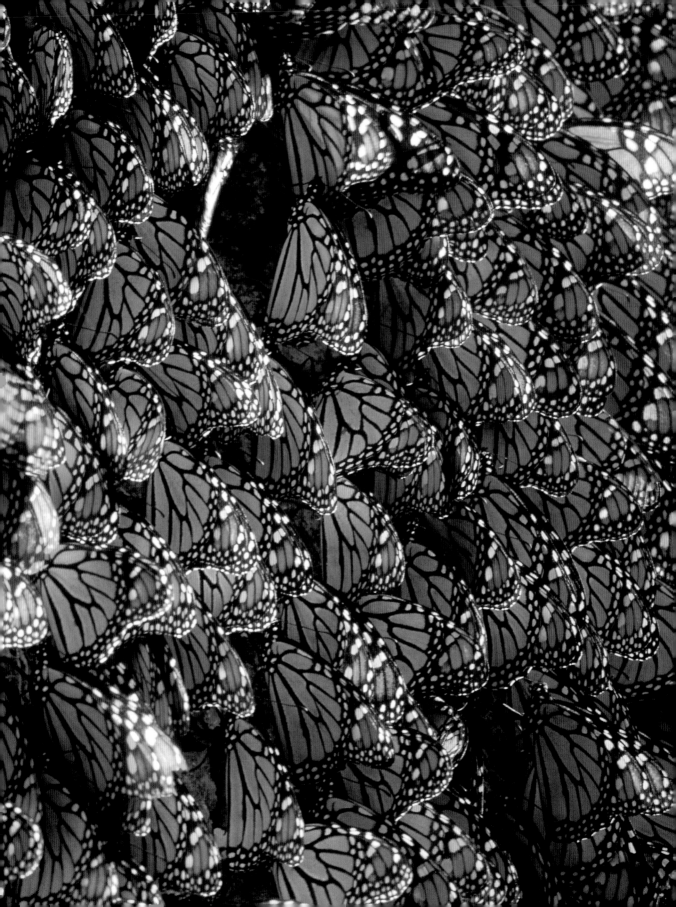

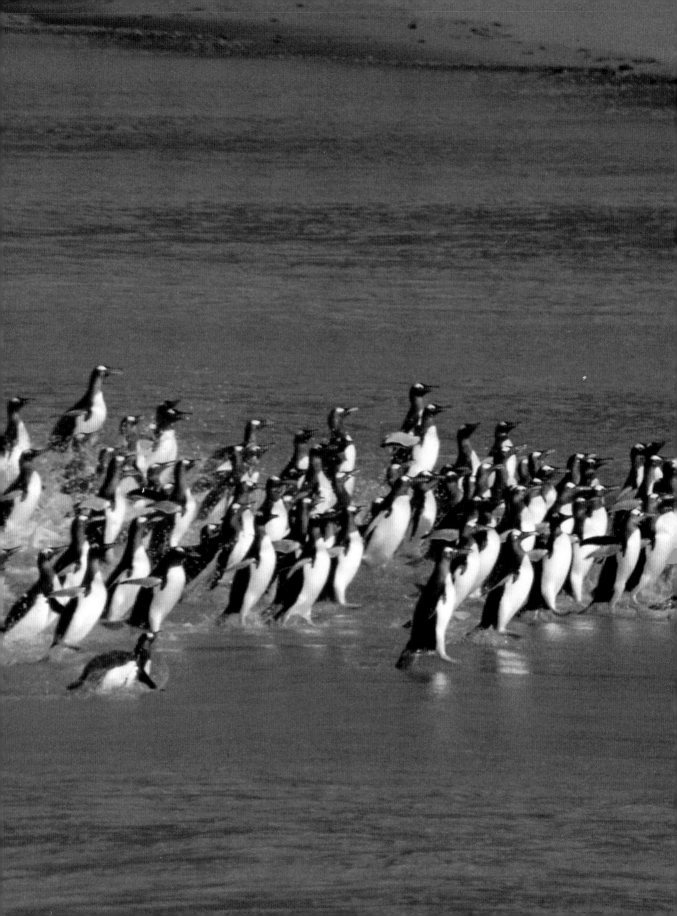

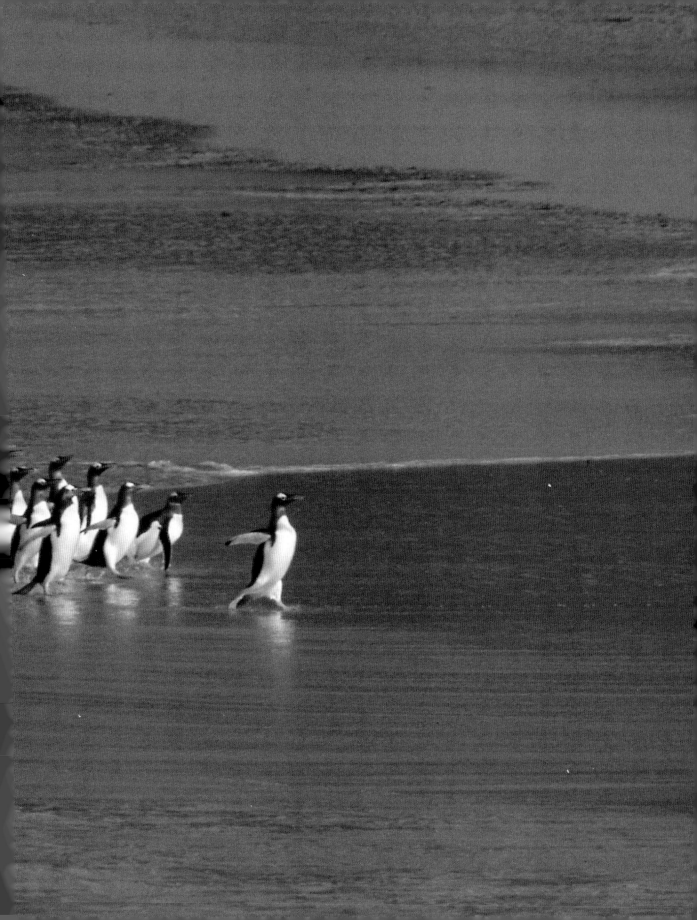

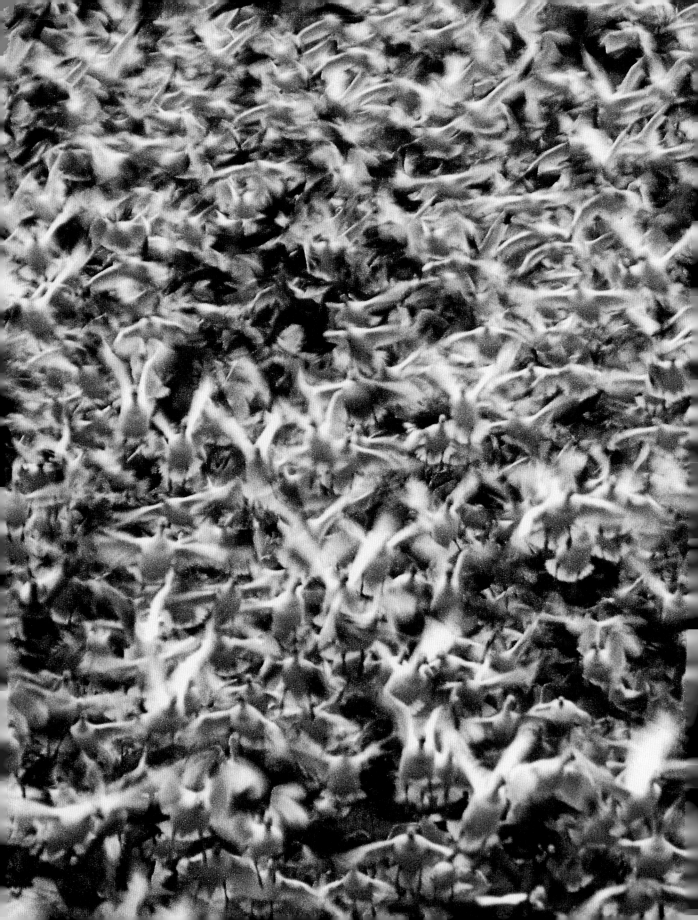

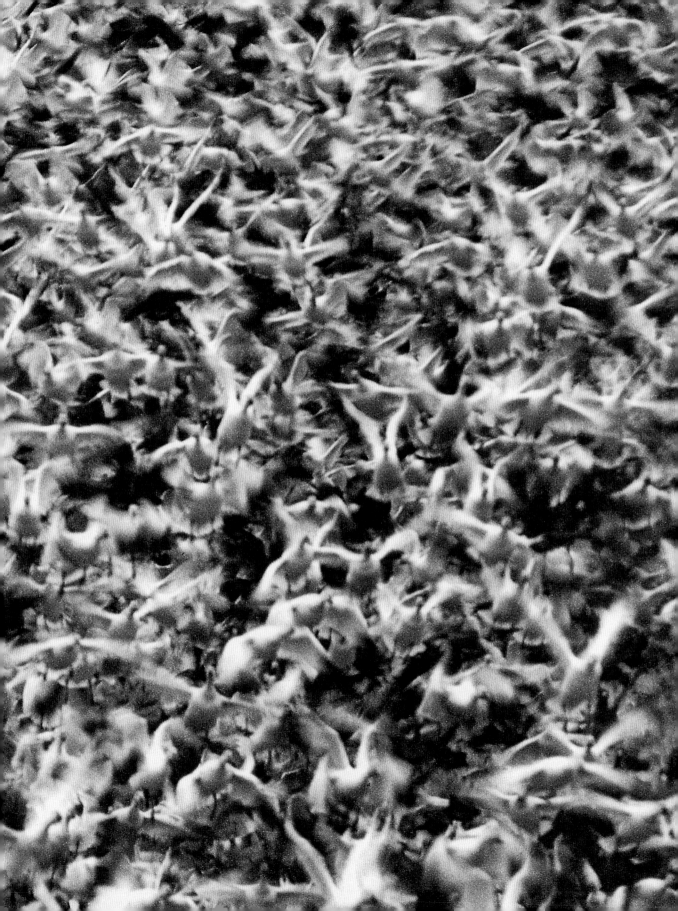

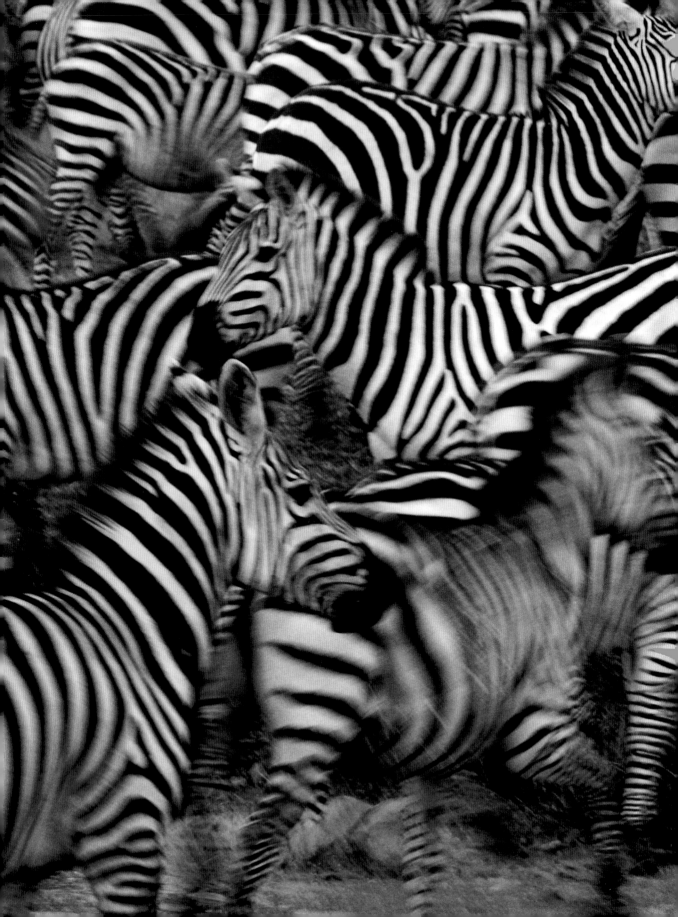

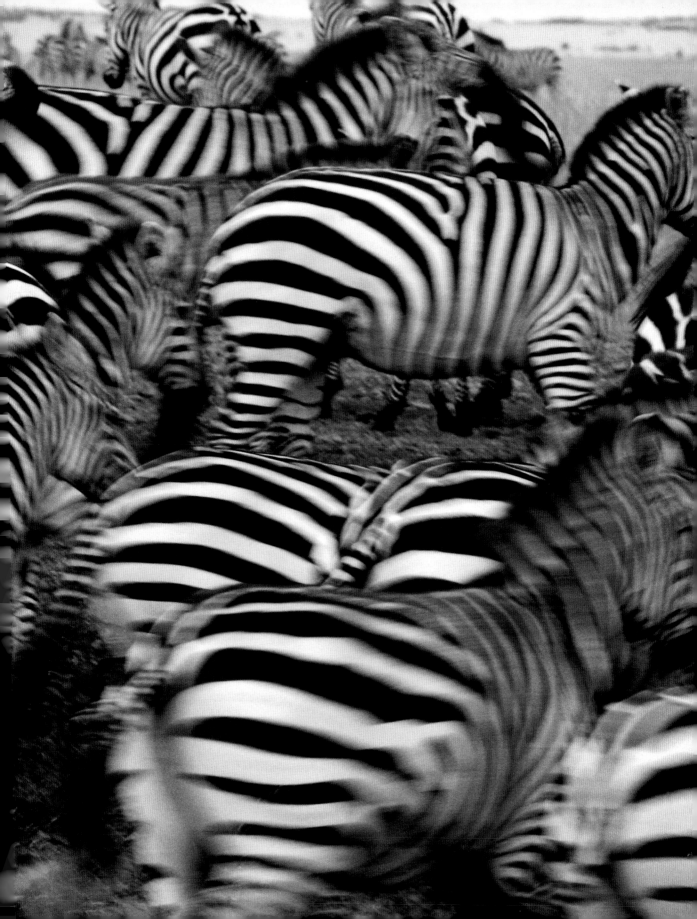

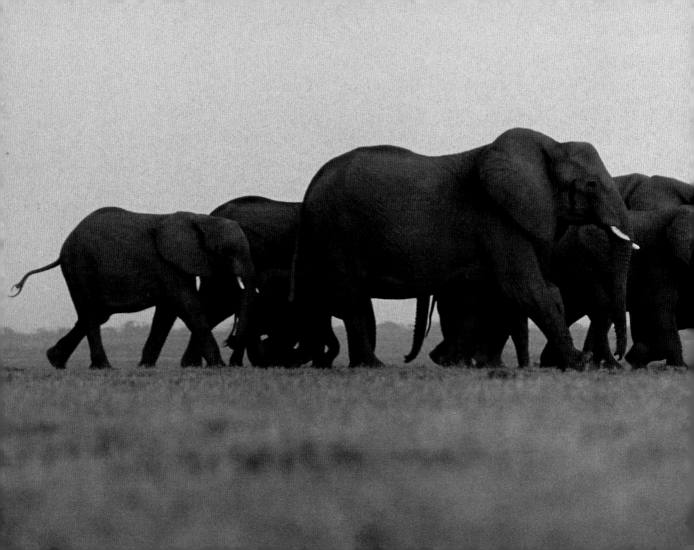

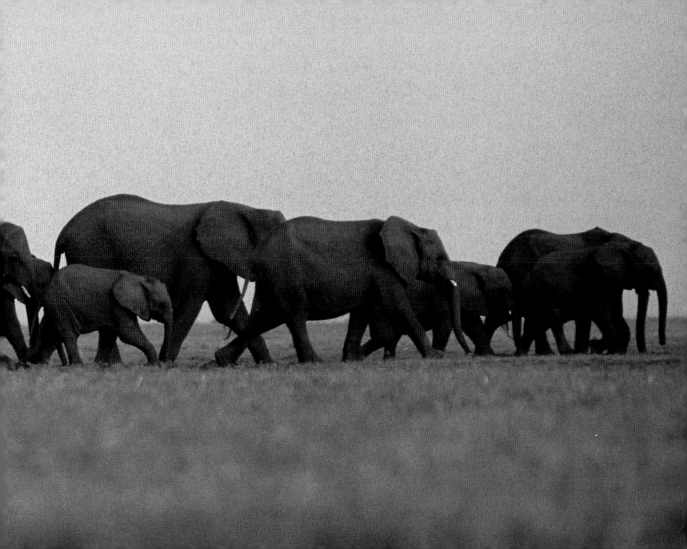

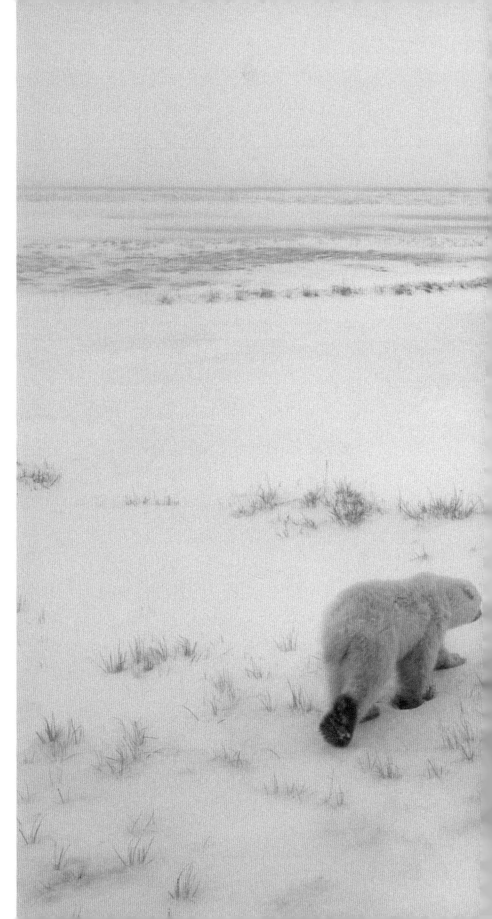

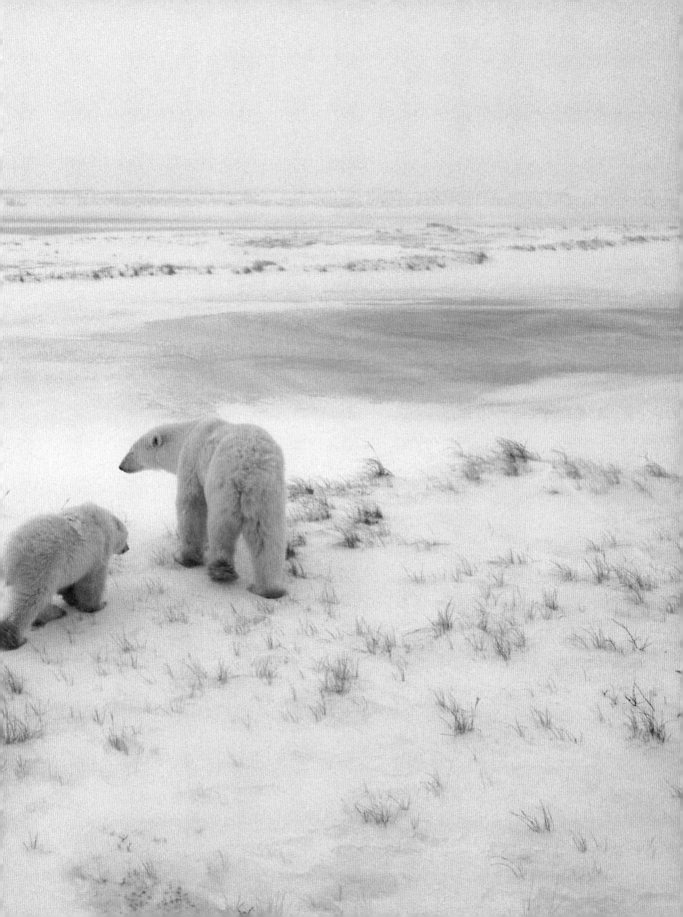

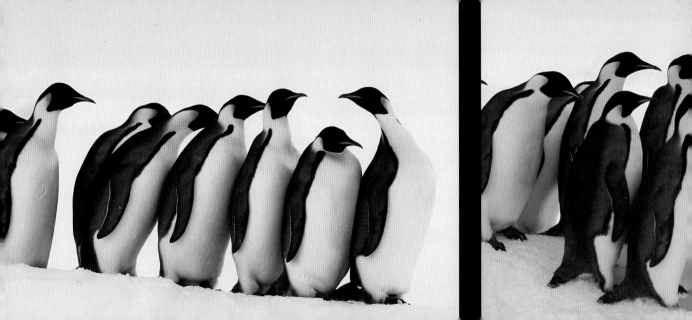

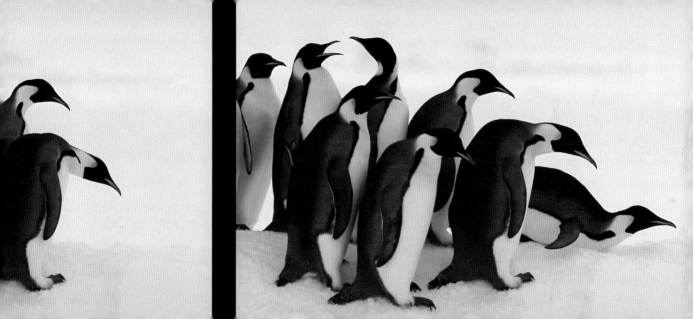

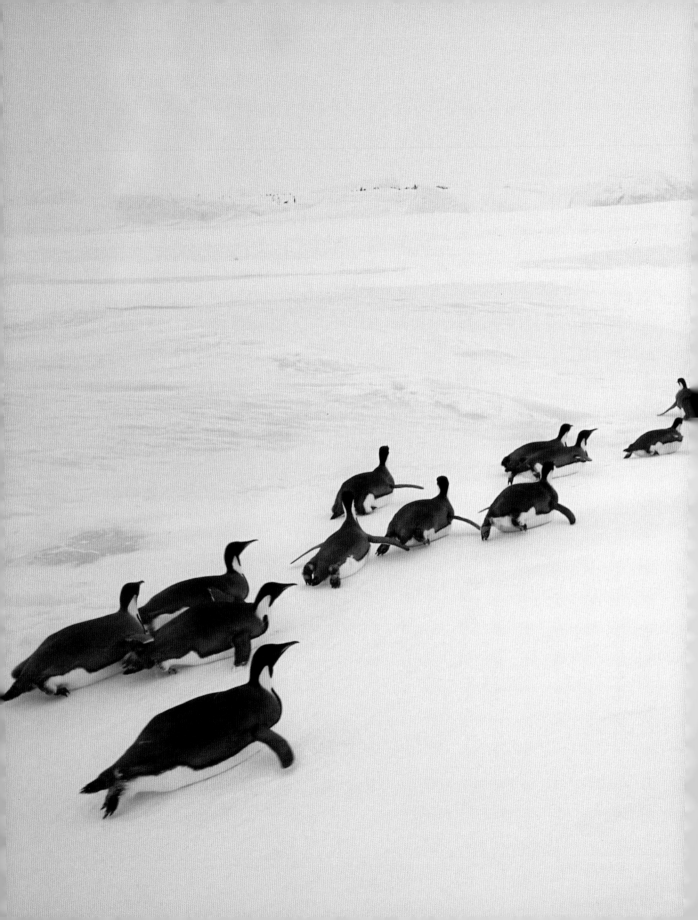

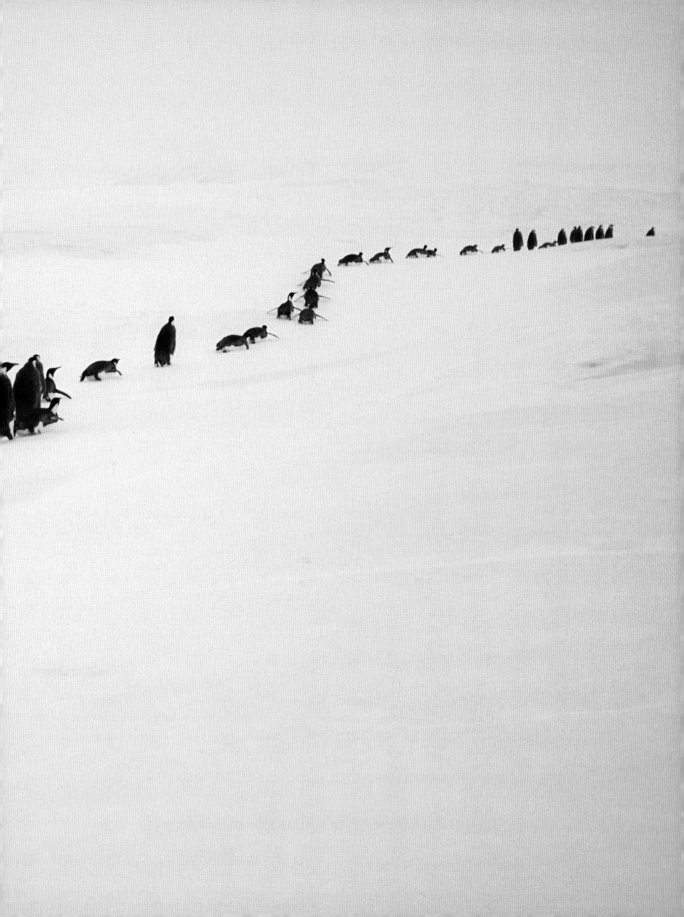

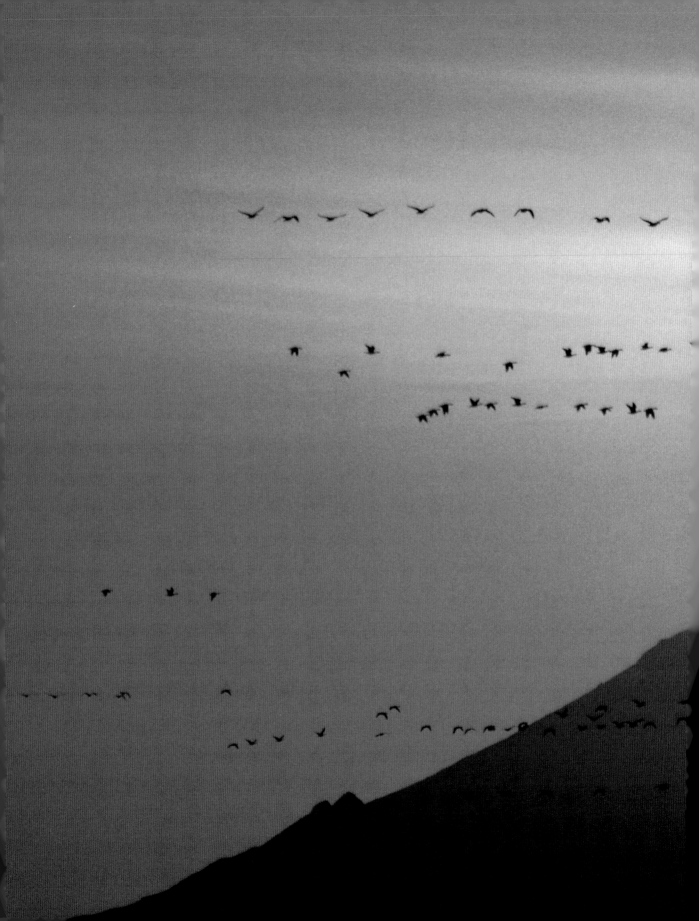

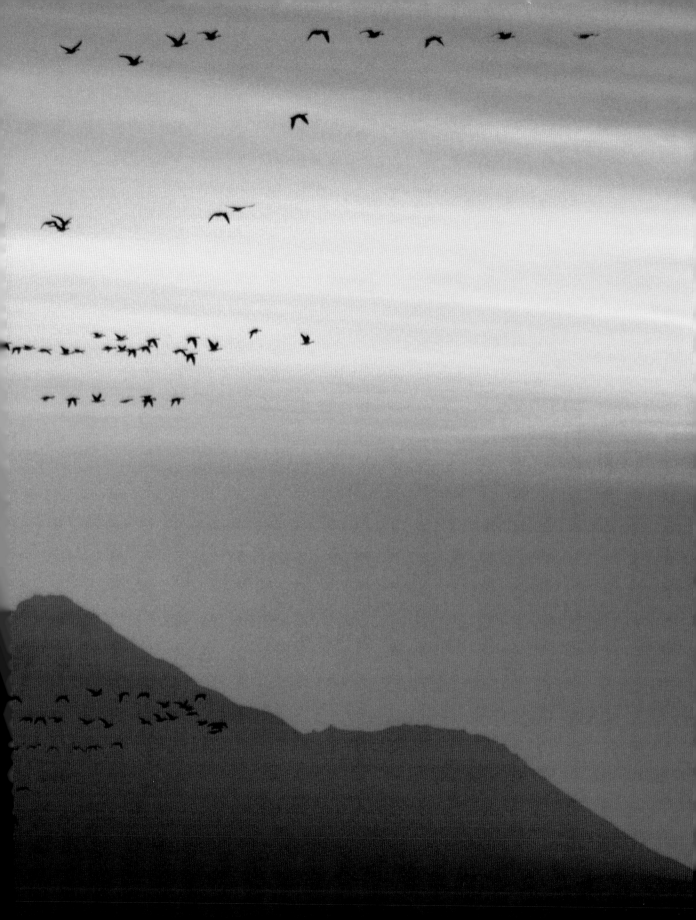

BEHIND THE CAMERA

When I am asked about the methods I use to photograph wildlife, my answers are often not photographic in nature. This is because I believe that in wildlife photography—certainly in the way I practice it—photographic details are sometimes just the tip of the iceberg.

Some images in this book required expeditions into remote areas with a massive amount of gear and logistical support. Others, by contrast, were the result of brief encounters that took little more than being in the right spot at the right time—and having the right attitude.

My success depends on my ability to interpret an animal's attitude, which is usually expressed through its body language. Each animal has its own way to signal comfort or displeasure when it is approached. Most like to maintain a bubble of privacy around themselves. For my work, I often need to ease inside that invisible boundary. Sometimes I use techniques borrowed from hunters, such as constructing blinds and other hiding devices. But my preferred approach is to be open. That requires thinking and moving like an animal, slowly and fluidly, knowing when to avert my eyes and when to watch.

Sometimes I work with animals under captive conditions in order to render details that would be impossible to document in the wild, or when my proximity would be too much of an invasion of a wild creature's privacy. Nothing, however, is a substitute for living with animals in the wild for extended periods.

Botswana

Amazon Basin

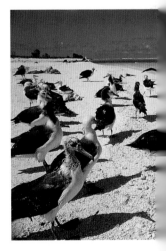

The contents of my camera bags have evolved along with the general development towards electronic cameras. The photographs in this book were made with an array of cameras, from a manual Nikkormat to a computerized Nikon F5. I use Nikkor lenses ranging from 18mm to 600mm, the latter usually mounted on a heavy-duty Gitzo tripod. I apply teleconverters, extension tubes, and a host of other accessories. I like to mix artificial with ambient light in the field, and have experimented with a number of strobe systems. In the last few years, Nikon's SB strobes have enabled me to apply more sophistication to lighting on location than I ever thought possible.

I use a variety of film emulsions, from fine-grained to high-speed, and not just to adapt to changing light levels. Each film has its own strengths and weaknesses that can be used to creative advantage. Many of the images in this book were made with Fuji's Velvia and Provia films, complemented by images shot on traditional Kodachrome and newer Ektachrome films as well.

Most of the equipment I take on location serves as spares or accessories for unusual situations. In the end, after all the research and planning, and moving myself and loads of equipment halfway around the world and into the field, I have to strip things down again. For me, the best way to work creatively and intimately is to simplify an encounter to the point where the only thing between an animal and me is one camera and one lens.

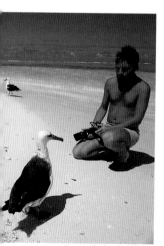

Leeward Islands, Hawaii

Okavango Delta

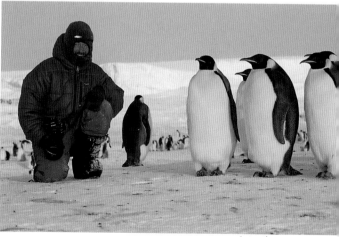

Antarctica

PHOTOGRAPHER'S NOTES

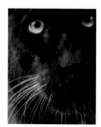

Black Leopard <> *Panthera pardus,* p. 1
Leopards are symbols of stealth, and black leopards seem to embody that elusive quality even more. The black coat is a color variety that occurs especially among leopards that live in dense forest. With selective lighting, I wanted to show the cat peering out of the dark, highlighting only the eyes and whiskers.

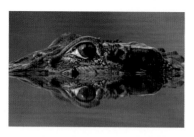

Black Caiman, Peru *Melanosuchus niger,* pp. 2–3
On an oxbow lake along a remote jungle river of the upper Amazon basin, I came quite close to this black caiman, South America's largest, rarest, and most dangerous crocodilian. Although this adult female was placid around me, it was implicated a few months later when a swimmer disappeared from the lake.

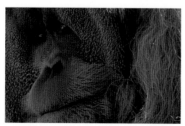

Orangutan <> *Pongo pygmaeus,* pp. 4–5
Of all the great apes, orangutans seem to be the most inscrutable. This full-grown male, with his characteristic bulging cheek pads—an indication of his age and status—had a particularly introspective quality about him.

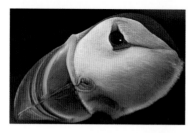

Atlantic Puffin, Iceland *Fratercula arctica,* pp. 6–7
The clownish facial adornments of this male puffin are loaded with social connotations. The ridges on his beak indicate age, and the manner in which his natty head feathers can be flattened down or puffed out reveals emotions and sends out signals to others nearby.

White Rhinoceros <> *Ceratotherium simum,* pp. 8–9
Compared with its testier cousin, the black rhino, the white rhinoceros is relatively mild-tempered. This enabled me to ease up to this adult female, nurtured for a captive breeding program, and focus on one staring eye encased in her massive head.

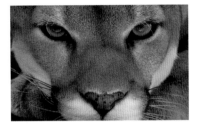

Cougar, Belize <> *Felis concolor,* pp. 16–17 and cover
The American cat called cougar is also known as mountain lion, puma, or panther. It has the greatest distribution of any large feline, yet it is rarely seen wherever it lives. I have seen cougar prints right outside my home in coastal California, but I have never glimpsed one in the wild—yet. Enthralled, I spent hours eye to eye with a captive male in Belize, until he relaxed to a dreamy pose.

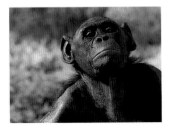

Bonobo <> *Pan paniscus,* pp. 20–21
Bonobos, also known as pygmy chimpanzees, are perhaps the most enigmatic members of the great ape family which includes, besides humans, lowland and mountain gorillas, chimpanzees, and orangutans. Some scientists have called bonobos the closest living relative to human ancestors. This female I photographed in a captive setting so that I could execute portraits and facial expressions impossible to record under the dim conditions of their native forest habitat.

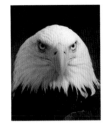

Bald Eagle <> *Haliaeetus leucocephalus,* p. 22
During my early attempts to photograph bald eagles in the wild, I learned firsthand how sharp their eyesight is. No matter how well I concealed myself near dead trees which I knew to be favored perches, they would sense me immediately and take off. In this photograph I tried to highlight that stare that seems to go right through you.

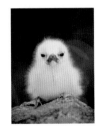

Fairy Tern, Hawaii *Gygis alba,* p. 23
Born on a naked branch of an ironwood tree on a tiny atoll in the middle of the Pacific Ocean, this fairy tern chick, the size of a tennis ball covered with fluff, stared at me with all the ferocity it could muster, not the least intimidated by my size.

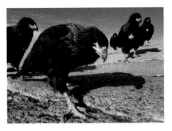

Striated Caracaras, Falkland Islands *Phalcoboenus australis,* pp. 24–25
It is quite possible that these birds had never seen a human being before when I landed on a seldom visited seabird island near the Falklands in the South Atlantic Ocean, where caracaras thrive on the eggs and helpless young they scavenge from penguin colonies. There was something eerie about the way a dozen of these predatory birds closed in on me without fear. I had the distinct feeling I was being sized up as potential prey. Birds are now believed to be living descendants of dinosaurs, and from my ground-level perspective, it was not difficult to imagine the position of a small dinosaur trapped by a flock of *Velociraptors.*

Black Lemur, Madagascar *Lemur macaco,* pp. 26–27
Black lemurs are sexually dimorphic—males are jet black, while females are brown with a white facial ruff. They are restricted to Madagascar—home to virtually all lemurs, a branch of the primate family long ago driven into oblivion elsewhere in the world by later-evolving monkeys. I caught up with these black lemurs on a small offshore island where villagers had habituated an entire troop, declared their forest a reserve, and turned the lemurs into an attraction for tourists from nearby resorts. The entry fees help finance a local school.

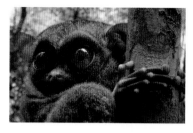

Tarsier, Borneo *Tarsius bancanus,* pp. 28–29
Tarsiers use their oversize eyes to hunt for insects in the dark understory of the Borneo rain forest, but when faced with these tiny primates—small enough to fit in a human hand, I found it hard to refrain from anthropomorphizing. With their giant ears and eyes, they seem to live in a constant state of sensory overkill, wearing expressions that seem to vacillate between outrage and scandalous surprise.

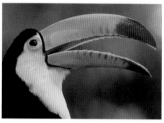

Keel-Billed Toucan, Belize <> *Ramphastos sulfuratus,* p. 30
The keel-billed toucan of Belize, which has been described as a crow pushing a banana, looks off-balance with its enormous appendage. The bill is actually hollow and light, enabling the bird to deftly manipulate fruit and nuts. Despite their beguiling appearance, toucans are known as nest robbers who eat the young of other birds such as parrots.

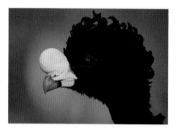

Great Curassow, Belize <> *Crax rubra,* p. 31
Curassows are noisy birds that inhabit the forests of Central and South America. Many of the 44 species in this family make up for their drab plumage with colorful wattles, horns, and knobs on their faces that are striking indications of sex, age, and condition. This male's peculiar curly head feathers accentuate his dandy image.

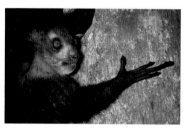

Aye Aye, Madagascar *Daubentonia madagascariensis,* pp. 32–33
The aye aye is an animal like no other on the planet, so different, in fact, that it took scientists a century to decide that it was a lemur. This nocturnal primate has evolved to fill the niche of the woodpecker, absent from Madagascar's forests. With big bat ears it listens for sounds of grubs in dead wood, then chisels through the bark with ever-growing beaver teeth and pries out the larvae with elongated, skeletal middle fingers. When I began my search for aye aye it was considered nearly extinct. As I traveled through the forested northeast to ask about sightings, word of my interest spread faster than my movements. One day when I walked into a village, I learned that I was already known locally as "the man who searches for aye aye."

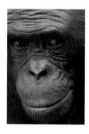

Bonobo <> *Pan paniscus,* p. 34
Sometimes individual animals can influence the perception people have of a species as a whole. Flo, a common chimpanzee, became famous through Jane Goodall's publications. Now Kanzi, a bonobo in the care of Dr. Sue Savage-Rumbaugh at Atlanta's Language Research Center, is changing perceptions about the way apes can learn language. I was a new visitor to his home, and he cast me quizzical glances and tested me in various ways to get a sense of my personality.

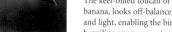

Orangutan <> *Pongo pygmaeus,* p. 35
Orangutans are close cousins to humans, yet we have not treated them particularly like relatives. Their name means "man of the forest" in Borneo and Sumatra, where they live in the wild. Over the centuries, thousands have been taken from the forest as pets, for medical research, and for zoos, but now the greatest danger to their existence has become habitat destruction.

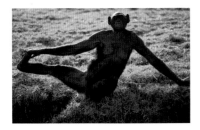

Bonobo <> *Pan paniscus*, pp. 36–37
One of the unique features of bonobos is their longer, more gracile limbs that mirror, in proportion, those of human ancestors of three million years ago such as Lucy, the famous Australopithecine fossil found in the mid-1970s.

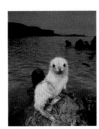

Antarctic Fur Seal, South Georgia Island *Arctocephalus gazella*, p. 39
Blond fur seals are a rare color phase among the hundreds of thousands of black seals that are born on the beaches of frigid South Georgia in the sub-Antarctic. This young pup stood out so much from its neighbors that I easily returned to it day after day to follow it on its wanderings through the crowded colony.

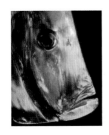

Lookdown Fish <> *Selene vomer*, p. 40
Face it head on, and there is not much to a lookdown fish. It is razor thin. But as a side profile, it presents a face as alien as any I have encountered.

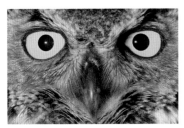

Great Horned Owl, California <> *Bubo virginianus*, p. 42
The eyes of a great horned owl are bigger than its brain, and in size, comparable to the eyes of a human. Yet their resolving power is far superior due to special depressions inside that help magnify images.

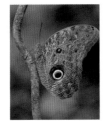

Owl Butterfly, Peru *Caligo memnon*, p. 43
The outer wings of this rain forest butterfly feature spots that mimic eyes. Whether they are designed to divert attacks away from the head of the butterfly, or to startle a would-be predator is still a source of debate, but one thing is certain: They resemble, in a striking fashion, the eyes of a large bird like an owl.

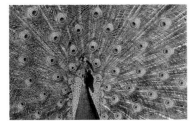

Peacock <> *Pavo cristatus*, pp. 44–45
One of the most outrageous displays in nature is performed by peacocks, jungle fowl originally from the forests of the Indian subcontinent. The more and the brighter the eye spots on the male's modified tail, the more impressed is his potential mate. As if that is not enough, he will actually quiver the whole feathery contraption for a drab-colored female in a kaleidoscopic extravaganza of male excess.

Paraguay Caimans, Brazil *Caiman crocodilus yacare,* p. 46
The light of my strobe bounces back from the eyes of a flotilla of caimans in a backwater of the Pantanal, one of the world's great wetlands. During the dry season, hundreds of these South American crocodilians gather in shrinking ponds.

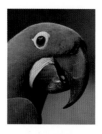

Paraguay Caiman, Brazil *Caiman crocodilus yacare,* p. 47
A caiman keeps a low profile in a quiet river that reflects a glowing sunset.

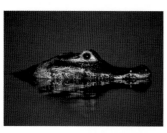

Hyacinth Macaw, Brazil *Anodorhynchus hyacinthinus,* p. 48
Naked yellow skin trimmed by azure feathers create the illusion of a much bigger eye on a hyacinth macaw. This spectacular bird, the world's largest parrot, has a beak designed to crack palm nuts that is strong enough to snap broomsticks.

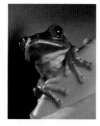

Red-Eyed Tree Frog, Belize *Agalychnis callidryas,* p. 49
This nocturnal tree frog of Central America is tiny enough to fit on a thumbnail. It journeys from the rain forest canopy down to the ground where I found females depositing eggs on leaves hanging over pools of water after several days of drenching rain in the jungle of the Cockscomb Basin. The hatching tadpoles drop into the water and become fully grown tree frogs 80 days later, which make their way up to treetops where they feed on small insects.

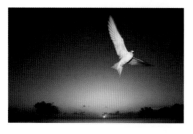

Fairy Tern, Hawaii *Gygis alba,* pp. 50–51
Ethereal in appearance, the fairy tern of tropical oceans around the world has no fear of humans. This adult hovered overhead long enough for me to mount a fill flash on my camera to execute an environmental portrait that included waning light over the lagoon of Midway Island.

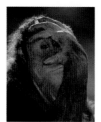

Orangutan <> *Pongo pygmaeus,* p. 52
Making faces, playing hand games, and covering themselves with all kinds of objects are common activities among socialized orangutans. This juvenile tried to get my attention by pretending not to look.

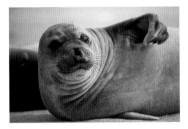

Northern Elephant Seal, California *Mirounga angustirostris,* p. 53
I was crawling through a crowded elephant seal colony on my hands and knees, keeping a low profile so I would not be seen and chased by territorial bulls, when I came upon this juvenile whose blubber ripples under its silky outer fur.

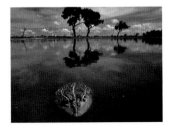

African Bullfrog, Botswana *Pyxicephalus adspersus,* pp. 54–55
Lying flat on my stomach at the edge of a rain-filled pond in the Kalahari and staring into the face of a male bullfrog defending his territory, I marveled at his strange existence. For only a few weeks in the year is he active and above ground. When seasonal water disappears, he digs himself into the ground and goes into a slumber inside a cocoon that helps to preserve moisture.

African Lion, Tanzania *Panthera leo,* pp. 56–57
Looking straight into the eyes of a male lion as he is getting up to hunt at twilight can be a chilling experience. The white fur trimming under his eyes is believed to act like a reflector to help with night vision.

African Lion, Kenya *Panthera leo,* pp. 58–59
Checking out his surroundings without revealing himself, knowing his outline will send word over the plains that danger is coming, a male lion slinks through tall grass in the Masai Mara at the end of the day.

Eastern Lowland Gorilla, Congo *Gorilla gorilla,* p. 60
Making contact with a lowland gorilla silverback is a humbling experience. Gorilla custom requires meekly bowing your head as a submissive pose when you are challenged by a 400-pound male rather than fleeing, as instinct tells you. This colossal ape lived on the slopes of Mount Kahuzi in eastern Congo. I spent a day with him, acutely aware of the political upheaval that has brought hundreds of thousands of refugees within a few miles of his home.

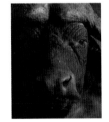

Cape Buffalo, Botswana *Syncerus caffer caffer,* p. 62
The legendary reputation of the Cape buffalo as a foul-tempered bovine has been shaped by the tales of big game hunters in confrontations with wounded bulls. Unprovoked buffaloes are not nearly as nasty, in my experience. However when you get this close, staring a bull straight in the eyes from the wobbly platform of a dugout canoe, you don't test his limits.

231

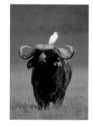

Cape Buffalo and Cattle Egret, Tanzania *Syncerus caffer caffer* and *Bubulcus ibis*, p. 63
Horns growing to trophy size are a reflection of a male's rank, but are no deterrent to a cattle egret who is picking off insects stirred up by the buffalo as it grazes inside Ngorongoro Crater.

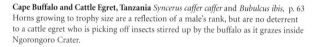

African Elephant, Botswana *Loxodonta africana*, pp. 64–65
In a test of wills, a bull elephant meets my gaze and raises himself in a show of dominance. Yet he refrained from the next step—a rush towards me, lying prone in the sand. Other times this same bull had gone farther, giving an angry head toss or blowing a trunk full of water or dust my way. Here he was measuring my resolve, and I gambled on judging his mood.

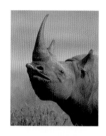

Black Rhinoceros, Tanzania *Diceros bicornis*, p. 67
Sensing but not quite seeing me approach, a black rhino, a notoriously short-sighted character, is testing the air that carries my scent.

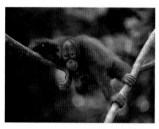

Orangutan, Borneo *Pongo pygmaeus*, pp. 68–69
It is difficult to come face-to-face with primates on their own turf since most of them live in the crowns of tall trees, but on the rare occasions when I was able to get myself into a rain forest canopy, I realized with exhilaration how different their world is from that of earthbound creatures. Primates like this orangutan inhabit a three-dimensional universe for which a fine-tuned sense of space and depth is paramount for survival.

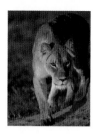

African Lion, Botswana *Panthera leo*, p. 70
Having slept all day under the shade of an acacia, this lioness woke shortly before sundown and used the cover of a termite mound to scan her domain.

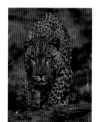

Leopard, Namibia *Panthera pardus*, p. 71
Focused as only a cat intent on prey can be, a leopard's eyes reveal a hunter's calculating stare.

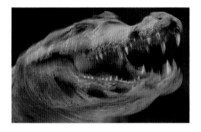

Paraguay Caiman, Brazil *Caiman crocodilus yacare,* pp. 72–73
Paraguay caimans are not nearly as large or as aggressive as Nile crocodiles or black caimans, and this big male allowed me to crawl quite near on a sandbank along the Cuiabá River, when a sudden head shake indicated I had come as close as I should.

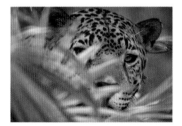

Roseate Spoonbill, Brazil *Ajaia ajaja,* pp. 74–75
Sweltering in a canvas blind set up at the edge of a backwater in the Pantanal, I took sweaty pleasure in watching this spoonbill indulge in a bath, oblivious of the piranhas that riddle these waters.

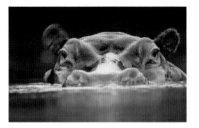

Hippopotamus, Congo *Hippopotamus amphibius,* pp. 76–77
I played a game of hide-and-seek with this hippo in a river near the Sudanese border. When he submerged, I moved in; but when he surfaced with a snort— I held my breath.

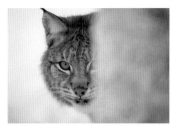

Jaguar, Belize <> *Panthera onca,* p. 78
The largest cat of the Americas is a denizen of rain forests where it uses tremendous strength and stealth to overcome prey like deer and capybara. In every Meso and South American Indian culture—whether Mayan, Incan, or Amazonian—jaguars served as powerful symbols and spirits of the forest.

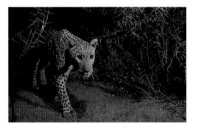

Lynx, Finland <> *Felis lynx,* p. 79
Largest cat of Europe's boreal forest, a lynx is playing peekaboo with me behind a tree on a bitter winter day in Scandinavia.

Leopard, Botswana *Panthera pardus,* pp. 80–81
I had heard this leopard at night and even found its tracks around my tent in the bush of the Kalahari one morning, but I never laid eyes on it. It was captured on film by a robot camera connected to an infrared beam set up along a trail I knew the cat frequented on its way to water.

Katydid, Borneo *Tettigoniidae* family, p. 82
A katydid flattens itself into imperceptibility on a tree trunk in lowland rain forest.

Katydid, Borneo *Tettigoniidae* family, p. 83
After I ran into this perfectly camouflaged katydid in a rain forest in northern Borneo, and photographed it blending in with its surroundings, I wanted to show the organism itself. By holding it on a glass plate, I was able to show the kind of details the creature would rather have kept to itself.

Horned Frog, Borneo *Megophrys monticola nasuta,* p. 84
A horned frog's upper body is patterned after the leaf litter it lives in. In addition, protuberances shield his eyes from predators that might glance at him from above. I had to sink all the way to the ground before I could reveal his face.

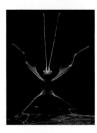

Leaf Insect, Borneo *Phyllium* sp., p. 85
I could not help but admire the courage of this alien insect striking a defensive pose against me in the understory of a lowland rain forest. I was never able to track down its precise name. Many smaller jungle creatures remain unknown or undescribed.

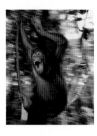

Orangutan, Borneo *Pongo pygmaeus,* p. 87
This young orangutan made maximum use of its hands and feet: Hanging onto a vine with two limbs, it tried to grab my camera as it swung past me, its mouth in a threatening gape to add to its display—which was actually as much bluff as serious charge.

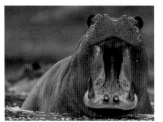

Hippopotamus, Botswana *Hippopotamus amphibius,* pp. 88–89
With bulging eyes and ears aimed forward—but most of all by showing off its cavernous mouth armed with formidable canines—a bull hippo makes his point in a ritualized threat. In Africa more people are killed by hippos than by any other large animal.

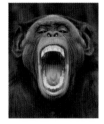

Bonobo <> *Pan paniscus,* p. 91
The facial muscles of great apes allow for expressions as complex as ours. Even more, apes like this bonobo know perfectly well how to feign emotions in order to suit their purposes. This female bonobo was faking rage in order to attract my attention.

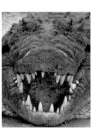

Nile Crocodile, Botswana *Crocodylus niloticus,* p. 92
Even just sunning himself on a sandbar with his mouth agape and no intent to strike or go anywhere, a Nile crocodile presents a fearsome sight.

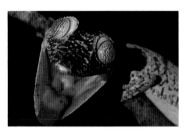

Leaf-Tailed Gecko, Madagascar *Uroplatus fimbriatus,* p. 93
Leaf-tailed geckoes are peculiar lizards indigenous to Madagascar. They have claws on suckered feet, four pupils in each eye, and can change colors like a chameleon. When approached closely by a large mammal such as a photographer, they resort to a defensive posture that includes showing off a gaping mouth with a shocking red lining.

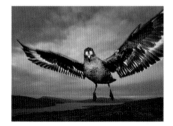

Great Skua, Falkland Islands *Catharacta skua antarctica,* pp. 94–95
During fieldwork in the Falkland Islands, I had to traverse the territories of nesting skuas, who throw themselves at an intruder's face with kamikaze style. They raked my scalp and drew blood on several occasions. The only sensible way through is to wear a helmet. Even so, I was once literally knocked out. Despite this hostility, I am actually fascinated by the keen intelligence and adaptability of these amazing birds, which are regarded as villains by most others.

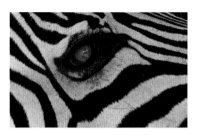

Plains Zebra, Botswana *Equus burchelli,* pp. 96–97
Trophy hunters who have just felled a zebra in the Kalahari Desert are reflected in its eye.

Sportive Lemur, Madagascar *Lepilemur mustelinus,* p. 98
Squirrel-size and nocturnal in habits, lepilemurs spend the day dozing away in tree cavities from which they emerge in the evening to feed on leaves. This particular lepilemur I photographed from a platform so that I could show his perspective on the forest, looking down to the ground.

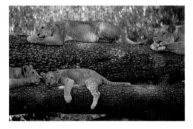

African Lions, Kenya *Panthera leo,* pp. 100–101
Lions are known to sleep 20 out of every 24 hours on average, and the cats in this pride, which included an amazing 15 cubs, were no exception as they lazed away the day on a fallen tree.

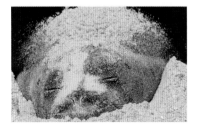

Hawaiian Monk Seal, Hawaii *Monachus schauinslandi,* pp. 102–103
Whale Skate Island is a remote speck of land in the Leeward chain that serves as a sanctuary for the last Hawaiian monk seals, whose entire population numbers less than 1,000. On this treeless islet, I found a monk seal that had flipped sand on its head in a futile attempt to create shade.

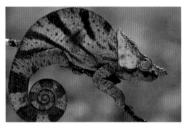

Parson's Chameleon, Madagascar *Chameleo parsonii,* pp. 104–105
Chameleons change color not only to match their surroundings, but according to mood as well. When asleep at night, they may lose almost all color. Masters of ambush, they sit quietly on branches and trap their prey—which for the largest species may include small birds—with a body-length, sticky tongue that strikes out at lightning speed. This one's curled tail indicates relaxation.

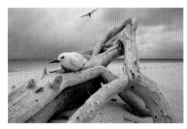

Fairy Tern, Hawaii *Gygis alba,* pp. 106–107
A frail beauty with reckless habits, this delicate sea bird builds no nest to hold its single egg. Instead, the fairy tern balances its fragile egg on bare coral rock, precarious tree forks, or in this instance, a piece of driftwood that has been cast ashore. The incubating bird is crouching down during a winter storm on an uninhabited atoll in the Leeward Islands of Hawaii.

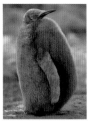

King Penguin, South Georgia Island *Aptenodytes patagonica,* p. 109
A king penguin chick a few months old fluffs out its down coat to stay warm while awaiting the return of parents foraging offshore. At the end of the brief Antarctic summer, king penguin parents abandon their half-grown young who are left to huddle together in crèches to survive the long dark winter by themselves. Not until the following spring do adults return from the sea to rear the surviving young to independence.

Southern Elephant Seal, South Georgia Island *Mirounga leonina,* p. 110
The sleep of an elephant seal approaches a state of torpor. Its metabolism slows down dramatically as an energy conservation adaptation. Sometimes they are so fast asleep that they become oblivious to any outside event. This individual, comfortably resting on a tussock mound was no exception. It never knew I was there.

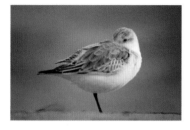

Sanderling, California *Calidris alba,* p. 111
This diminutive shorebird is a featherweight globetrotter that migrates between its summer home in the High Arctic and wintering grounds as far south as Tierra del Fuego. I have found them on beaches of every continent except Antarctica, and whenever I meet up with them, such as here on the beach near my home in California, it is with a sense of appreciation for a fellow traveler.

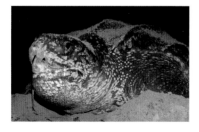

Leatherback Turtle, Surinam *Dermochelys coriacea,* pp. 112–113
Like a vision from an ancient time, a leatherback turtle has come ashore to deposit her eggs on a beach in Surinam, her eyes oozing sticky fluid to keep them moist. These toothless giants who eat nothing but jellyfish have been around virtually unchanged for 100 million years, and their design reflects it.

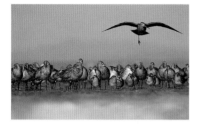

Marbled Godwit and other Shorebirds, Mexico *Limosa fedoa* and other species, pp. 114–115
Knowing that shorebirds like to land into the wind—for reasons every pilot can sympathize with—I had crept on hands and knees through shallow water towards a flock resting at high tide in a coastal lagoon off Baja California. In the stiff breeze, a godwit hovered with part of its landing gear already extended.

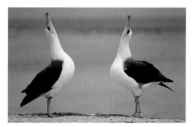

Laysan Albatrosses, Hawaii *Diomedea immutabilis,* pp. 116–117
Albatross courtship is an elaborate affair. It involves a complicated dance ritual that takes young birds years to master before they can apply it to woo a mate for life. A prospective pair of Laysan albatrosses dancing at the edge of a lagoon on Midway atoll toss their heads up in a symmetrical skypointing maneuver.

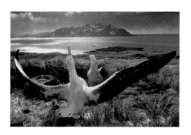

Wandering Albatrosses, South Georgia Island *Diomedea exulans,* pp. 120–121
I had been dropped off on a small island off South Georgia, a lonely outpost of Antarctica, to camp next to a small colony of wandering albatrosses. Cautiously I moved in behind a male spreading ten-foot wings to a dance partner. He was too preoccupied with impressing her to be bothered by my proximity.

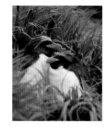

Macaroni Penguins, South Georgia Island *Eudyptes chrysolophus,* p. 122
In a patch of tussock grass, a newly formed pair of macaroni penguins sporting spiky crest feathers is taking time out from nest building for a snooze.

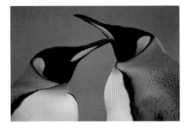

King Penguins, Falkland Islands *Aptenodytes patagonica,* p. 123
Striking head patterns on king penguins become more pronounced with age and serve to communicate breeding condition. Male and female look almost identical and can only be told apart at close distance or by studying behavior. In a prelude to mating, a male will rub the neck of a female. These large penguins—almost three feet tall—form long-lasting pair bonds that yield only one young at a time every two years.

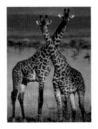

Masai Giraffes, Kenya *Giraffa camelopardalis,* p. 125
Wild enthusiasm greeted the first giraffe to reach France in 1827. A gift from the Pasha of Egypt, she was shipped to Marseilles and marched to Paris with an escort of Nubian attendants. When she strode into the capital after a two-month walk, troops were needed to hold back the cheering crowds. Giraffe fashion was born overnight. Wearing a mantle made for the occasion and crowned with flowers, "Dame Giraffe" was introduced to the King, whom she honored by eating rose petals from his hand.

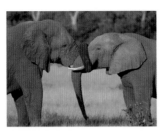

African Elephants, Botswana *Loxodonta africana,* pp. 126–127
Elephants greet with an affectionate twining of trunks. A remarkable fusion of nose and upper lip, an elephant's trunk lacks bones or cartilege but contains some 40,000 muscles. Strong enough to pull down trees, sensitive enough to doodle in the sand, it also serves as hand, arm, taster, trumpet, and spritzer for bathing—or spraying photographers who venture too close.

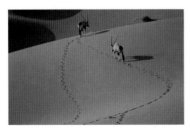

Oryxes, Namibia *Oryx gazella,* pp. 128–129
Superbly adapted to their desert environment, two oryxes, or gemsboks, are plodding through southern Africa's Namib Desert. Whenever they dipped below the crest of a dune, I would scramble closer, making sure, however, that I stayed far enough away not to interrupt their casual progress through this immense sea of sand.

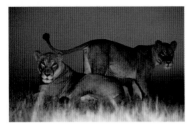

African Lions, Botswana *Panthera leo,* pp. 130–131
As dusk darkens the sky, two lionesses awaken. As I crawled towards them through grass in order to execute an eye-level portrait, I was quite aware of the tension in this encounter, as evidenced by the twitching tail, the taut bellies, and the eyes and ears of two experienced hunters turned towards me.

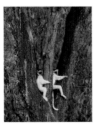

Verreaux's Sifakas, Madagascar *Propithecus verreauxi,* p. 133
The elegant sifaka, a mild-mannered leaf-eater who inhabits arid forests in southern Madagascar, has spindly limbs evolved for an arboreal existence. But it has trouble sitting upright without back support. Against the intense heat of a summer day, these two sifakas have found the best remedy is to laze away the hot hours wedged in the forks of a huge tamarind tree.

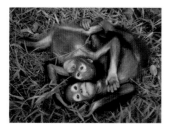

Orangutans, Borneo <> *Pongo pygmaeus*, pp. 134–135
Two orphaned orangutans cling together for mutual support at a rehabilitation center in northern Borneo. Like human babies, they need affection and constant care from their mothers in order to become healthy adults.

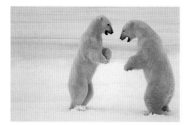

Warthogs, Botswana *Phacochoerus aethiopicus*, pp. 136–137
Two male warthogs are disputing a patch of succulent grass on a floodplain with a head-butting encounter. These pigs of the African savanna often drop to their knees to graze, which gives their oversize heads the perfect angle to meticulously crop blades of grass down to the ground.

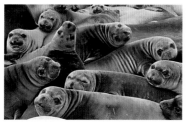

Polar Bears, Canada *Ursus maritimus*, pp. 138–139
Polar bears gather along the shores of Hudson Bay in late fall and bide their time until the bay freezes over and the ice is strong enough to carry them. While onshore, they spend most of their time asleep, conserving precious energy, since they have barely eaten for months. Even so, males periodically engage in bouts of sparring on hind legs.

Bengal Tigers <> *Panthera tigris tigris*, p. 141
In a jostle between two young males, one grabs for the neck of the other, practicing the suffocating bite tigers apply to prey.

Northern Elephant Seals, California *Mirounga angustirostris*, pp. 142–143
Elephant seals have made a miraculous comeback from the brink of extinction. By 1900, relentless hunting along the west coast of North America had reduced the population to a few dozen. The tens of thousands of elephant seals alive today are believed to be direct descendants of one bull and his harem, which makes the youngsters in this pod virtual genetic clones.

Leatherback Turtle, Surinam *Dermochelys coriacea*, p. 145
Running for cover, a newly hatched leatherback runs the gauntlet of frigate birds and vultures on a mangrove-lined beach in Surinam before reaching the foamy edge of the Atlantic, where it will disappear before returning many years later as a 1,000-pound behemoth.

Impalas, Botswana *Aepyceros melampus*, pp. 146–147
In the savannas of southern Africa new life appears with the onset of rain. At that time impalas, like many other species, give birth so that their young can take advantage of sweet green growth. I tried to capture the tenderness of both the season and the encounter in this backlit portrait.

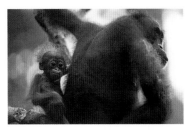

Orangutans, Borneo *Pongo pygmaeus*, pp. 148–149
This infant orangutan was less than two months old and loath to let go of his mother, even for a second.

Leopards, Kenya *Panthera pardus*, p. 150
Most leopards are rarely seen by day, but this female and her young were easy to find during the cub's first months of life, when the mother returned regularly to nurture it near a gorge where she hid the cub while she hunted. After a year or so, when the young leopard becomes independent, both will melt away into the bush.

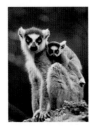

Ring-Tailed Lemurs, Madagascar *Lemur catta*, p. 151
A ring-tailed lemur learns to see the world through its mother's eyes. Clinging to her belly for the first few weeks and riding piggyback thereafter, youngsters are gradually introduced to the ringtail way of life. They learn how to live with other lemurs in the troop, where females form a stable nucleus while males come and go.

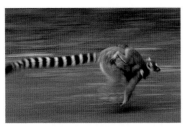

Ring-Tailed Lemurs, Madagascar *Lemur catta*, pp. 152–153
Unlike other lemurs, ringtails spend half their time on the ground, which made it easy for me to join a troop that inhabits a riparian forest in southern Madagascar. For a while I documented their daily routine. It unfolds with an enviable serenity punctuated by bursts of complete commotion, which is when I photographed this mother and infant streaking through a forest clearing.

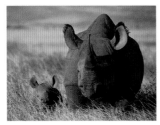

Black Rhinoceroses, Tanzania *Diceros bicornis*, pp. 154–155
A mother rhino in defensive posture is flanked by a calf who is mimicking her in an area hit hard by poachers.

240

Gray-Headed Albatrosses, South Georgia Island *Diomedea chrysostoma*, p. 157
The northern tip of South Georgia is the perfect place for a gray-headed albatross to raise offspring. It faces the nutrient-rich currents sweeping past Cape Horn that make the waters around the island among the most productive seas on earth.

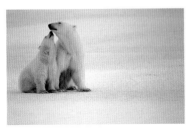

Polar Bears, Canada *Ursus maritimus*, pp. 158–159
In the fading light of a blustery November afternoon on the freshly frozen Hudson Bay, I sat for hours with this mother and cub as they rested and nuzzled.

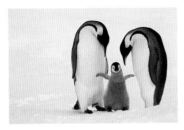

Emperor Penguins, Antarctica *Aptenodytes forsteri*, pp. 160–161
Emperor penguin parents bend their heads in a greeting ceremony over the chick they raise against the odds of Antarctica's brutal climate.

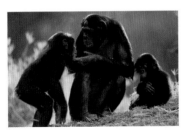

Bonobos <> *Pan paniscus*, p. 162
The social life of bonobos includes a level of nurturing eerily familiar to us.

Bonobos <> *Pan paniscus*, p. 163
A female bonobo shares in the care of another's young, overseeing the safety of his play.

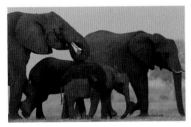

African Elephants, Botswana *Loxodonta africana*, pp. 164–165
Elephants are born into a close-knit family group that reaches beyond mothers to aunts who help share the burdens of raising young. Elephants have a lengthy childhood which, just as in humans, allows for the learning time needed to function properly in the complex social network that is part of being an elephant.

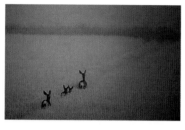

Mule Deer, California *Odocoileus hemionus hemionus,* pp. 166–167
On a foggy winter day I saw this doe lead her two fawns and a yearling on a path through a field of winter wheat next to the marsh of the Klamath Basin.

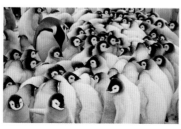

Emperor Penguins, Antarctica *Aptenodytes forsteri,* pp. 168–169
At the edge of a crèche, an emperor penguin is listening for the sound of her offspring, which she recognizes by voice rather than by sight.

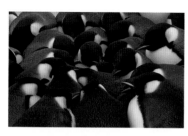

Emperor Penguins, Antarctica *Aptenodytes forsteri,* pp. 172–173
Huddling together enables emperor penguins to survive the brutal weather conditions of an Antarctic blizzard. It got so cold that evening that my fingertips froze, and I wished that I could have been inside one of their huddles.

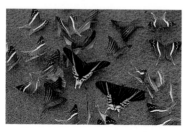

Moths and Butterflies, Peru *Urania leilus* and butterflies, pp. 174–175
Two butterfly-mimicking moths mingle with a gathering of swallowtails on a river beach in a remote part of the upper Amazon Basin.

Hippopotamuses, Congo *Hippopotamus amphibius,* p. 176
While searching for white rhinos from the air in a small plane, I spotted a large pod of hippos in the Garamba River. My pilot was skillful enough to get us into the tight spin necessary to photograph the gathering from straight overhead without spooking them.

Hippopotamus, Botswana *Hippopotamus amphibius,* p. 177
The bold face of this curious young hippo displays little of the belligerence for which adults are feared.

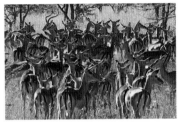

Impalas, Kenya *Aepyceros melampus,* p. 178
Eating, resting, mating—these slender herbivores do it all within the safety of the herd, where a multitude of eyes and ears guard against lion or leopard. Impala life begins in solitude, however. A female in labor will steal away to give birth under cover, where her baby remains hidden for several days until she feels it is strong enough to join the group.

Impala, Botswana *Aepyceros melampus,* p. 179
Wide-set eyes give an impala doe practically 360-degree vision. What little is not covered by her eyes gets picked up by ears cocked back.

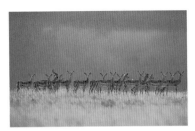

Impalas, Tanzania *Aepyceros melampus,* pp. 180–181
A snort from one impala alerted the rest of the herd and myself, dozing in a vehicle nearby, to an imagined danger lurking in the grass.

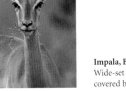

Scarlet Macaw, Peru *Ara macao,* p. 182
Backpedaling, a scarlet macaw prepares to land in a tree perch in the Amazon rain forest.

Red-and-Green Macaws, Peru *Ara chloroptera,* p. 183
It took weeks of effort to overcome the suspicion of this flock of wary macaws and convince them to accept my presence inside a camouflaged tower blind at the base of this flood-carved river wall, where macaws gather to eat clay—needed, scientists theorize, to neutralize toxins in their diet.

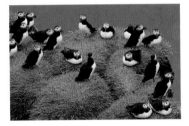

Atlantic Puffins, Iceland *Fratercula arctica,* p. 184
At the edge of a nesting colony on Iceland's Westmann Islands, groups of off-duty adults and single birds looking for partners mix and mingle in a non-threatening social environment that is the puffin equivalent of a private club.

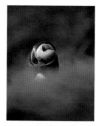

Atlantic Puffin, Scotland *Fratercula arctica,* p. 185
An adult stands guard at the edge of its burrow on the steep slope of a nesting colony in Scotland's Outer Hebrides, where I spent a few blustery summer weeks camped at the base of a cliff until my tent was smeared white with bird droppings.

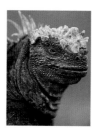

Marine Iguana, Galápagos *Amblyrhynchus cristatus,* p. 186
A marine iguana, the only seagoing lizard in the world, sports a salt-coated crest whose big spikes indicate that he is a male in his prime.

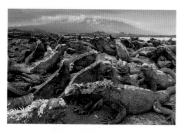

Marine Iguanas, Galápagos *Amblyrhynchus cristatus,* p. 187
Stony as the island on which they live, marine iguanas bask in the sun on Fernandina Island to raise their body temperature before they slither into the ocean to graze on marine algae.

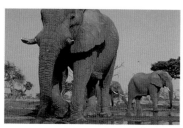

African Elephants, Botswana *Loxodonta africana,* pp. 188–189
Lying flat at the edge of a waterhole I was able to emphasize the gargantuan size of elephants contrasted against the delicate shapes of antelopes quenching their thirst.

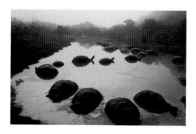

Giant Tortoises, Galápagos *Geochelone elephantopus,* pp. 190–191
For a memorable week I lived among giant tortoises inside the time capsule of their caldera world in the Galápagos Islands. Morning mist mingled with steam from fumaroles to create a primordial mood over a pond filled with slumbering tortoises.

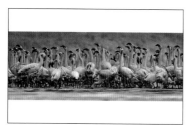

Lesser Flamingos, Kenya *Phoenicopterus minor,* pp. 192–193
For flamingos living in enormous flocks on East Africa's great rift lakes, there is little escape from the crowds. Even courtship is a social event. At times, groups that appear in a state of frenzied trance gather in a tight mass and move off together on stiff legs, tossing heads up or down in a ritual manner and humming all the time. How pair bonds between couples are fostered during these mass ceremonies has yet to be fathomed.

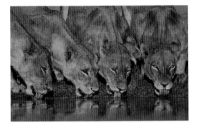

African Lions, Botswana *Panthera leo,* pp. 194–195
Four sisters in a pride of lions I got to know well strolled down to drink one morning at a water hole where I sat crouched in the open, so near that I could hear the quick huff of their breaths as they lapped. As they stared into my lens, I noticed that their bellies were still flat; they were hungry, and would hunt again soon.

Catfish and Cichlids, Brazil *Pimelodidae* and *Cichlidae* families, pp. 196–197
Trapped in a seasonal pond where water has become soupy and lacks oxygen, fish have come to the surface to gulp for air.

Pierid Butterflies, Peru *Pieridae* family, pp. 198–199
Drawn by minerals left on a sandbank by retreating flood waters near the eastern foothills of the Andes, hundreds of butterflies have massed together. So rare and sought after are such patches of minerals that I could crawl into the middle of this gathering until I was surrounded by fluttering insects coming and going.

Chinstrap Penguins, Antarctica *Pygoscelis antarctica,* pp. 200–201
While on an icebreaker cruise to Antarctica, our party came upon a magnificent iceberg the size of a cathedral, its contours sculpted by the eroding effect of waves that have created a haul-out for a flock of chinstrap penguins.

Monarch Butterflies, Mexico *Danaus plexippus,* p. 202
Morning light brushes the wings of monarch butterflies clustered on a pine tree in the Mexican highlands, where they gather each winter from all over the eastern United States.

Monarch Butterflies, Mexico *Danaus plexippus,* pp. 204–205
Like confetti, monarchs fill the air at their wintering colony in Mexico in one of the most dazzling displays of mass movement in the animal world. Millions of monarchs flutter through the air with the collective sound of gentle spring rain.

Sacred Ibises, Botswana *Threskiornis aethiopicus,* pp. 206–207
In the last light of day, a flock of ibises wings past my perch at the edge of a nesting colony in the middle of the Okavango Delta.

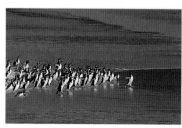

Gentoo Penguins, Falkland Islands *Pygoscelis papua,* pp. 208–209
Rushing ashore to get away from a sea lion patrolling the surf for potential victims, a flock of gentoos heads back to their colony. For several days in a row, I sat on a hillside overlooking the beach and watched the cat-and-mouse game. The sea lion, of course, knew perfectly well that at some point every day the penguins would have to return to land to feed their offspring.

Snow Geese, California *Anser caerulescens,* pp. 210–211
From summer nesting grounds on the Arctic island of Wrangell, hundreds of thousands of snow geese form huge flocks and migrate to North America along a traditional flyway that includes staging areas such as California's Klamath Basin. Here in the late fall, blizzards of birds can be seen taking to the sky in an exhilarating rush of wings.

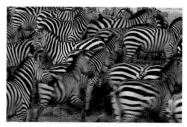

Plains Zebras, Kenya *Equus burchelli,* pp. 212–213
Panic ripples easily through the ranks of zebras, here gathered during their annual migration which passes through Kenya's Masai Mara. Zebras require drinking water every few days, and are most vulnerable when they crowd water holes, often wading in up to their bellies.

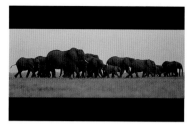

African Elephants, Botswana *Loxodonta africana,* pp. 214–215
Gray nomads of the African continent, elephants, by nature, are wanderers. A family's annual circuit may cover hundreds of miles along well-trodden trails they have followed for many years. Knowledge of the routes is part of an elephant family's collective memory, accumulated over generations and retained by the matriarch, who leads the family and passes on what she knows to the herd.

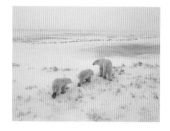

Polar Bears, Canada *Ursus maritimus,* pp. 216–217
The first blizzard of the season has covered the tundra along Hudson Bay with fresh snow, as a mother guides her two cubs towards the edge of the bay, which will soon freeze over and become a hunting ground on which she will teach her offspring the fine art of ambushing seals at breathing holes.

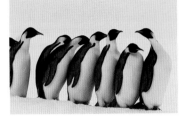

Emperor Penguins, Antarctica *Aptenodytes forsteri,* pp. 218–219
Indecision is evident in a group of emperor penguins pausing at the edge of a pressure ridge on sea ice as they try to figure out the best way to negotiate this barrier.

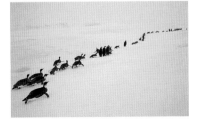

Emperor Penguins, Antarctica *Aptenodytes forsteri,* pp. 220–221
In a long procession, a large flock of emperor penguins travels across the frozen surface of the Weddell Sea, covering up to 50 miles between open water and their breeding colony, situated in the lee of a huge iceberg at the edge of the Antarctic continent, where I spent a month documenting their lives.

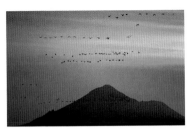

Snow Geese, California *Anser caerulescens,* pp. 222–223
The travels of snow geese follow an ancient pattern. In large flocks they migrate between barren grounds of the High Arctic and wintering areas such as California's Klamath Basin. Here, more than a quarter million can be seen gathered under the shadow of Mount Shasta.

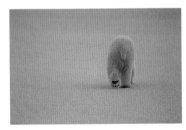

Polar Bear, Canada *Ursus maritimus,* p. 252
A polar bear pads off into the blue twilight of a Canadian winter evening.

<> symbol indicates animal photographed in captivity

ACKNOWLEDGMENTS

The photographs in this book are the results of fieldwork on five continents over a period of twenty years. When I think of the range of people and organizations who have contributed in one way or another to my work I feel humbled by the support, the trust, the knowledge, the enthusiasm, and the hospitality that has been extended to me over the years. Thank you all.

IN THE FIELD:

Africa *Botswana:* The late Jack Bousfield, Ralph Bousfield, David Dugmore, Jonathan Gibson, Mike Gunn, Dereck and Beverly Joubert, Tim and June Liversedge, Tim and Bryony Longden, Ewan Masson, Susan Masson, Elias Nkwane, Karen Ross, Paul Sheller, John Seaman, Lloyd Wilmot; Botswana Department of Wildlife and National Parks; Chobe Lion Research Camp; Ker, Downey and Selby. *Kenya and Tanzania:* Karl Ammann, Steve Turner; Dorobo Safaris; East African Ornithological Safaris; Ngorongoro Conservation Area. *Madagascar:* The DeHeaulme family, the late Bedo Jaosolo, Alison Jolly, Olivier Langrand, Bernhard Meier, Martin Nicoll, André Peyriéras, the late Georges Randrianasolo, Hubert Randrianasolo, Alison Richard, Patricia Wright; Madagascar Department of Water and Forestry; Tsimbazaza Park; University of Madagascar. *Namibia:* Des and Jen Bartlett, Wayne and Lise Hanssen, Eric Hesemans, Coralee Louw, Flip Stander. *Congo:* Kes Hillman-Smith, Hugh Lamprey; Garamba National Park; Kahuzi-Biéga National Park.

Antarctica and the Southern Ocean *Antarctica:* Anne Kershaw and the staff at Adventure Network International; Jerry Kooyman; Mike Messick and the staff at Zegrahm Expeditions; Hiroshi Moriya and the staff at Tokyo Broadcasting System; Frank Todd. *The Falklands and South Georgia Island:* The Chater family, Tui De Roy and Mark Jones, Peter Prince, the Poncet family; Bird Island Field Station; British Antarctic Survey; British Armed Forces at Grytviken; Scott Polar Research Institute.

Asia and the Pacific *Borneo:* Tengku Adlin, Hamid Ahmad, Lamri Ali, Simon Ambi, Patrick Andau, Elizabeth Bennett, Louise Emmons, Clive Marsh, Jamili Nais, Junaidi Payne, Rob Stuebing; Danum Valley Field Centre; Sabah Foundation; Sabah Ministry of Tourism and Environmental Development. *Hawaii:* The late Harvey Fisher, Jack and Gretchen Jeffrey, Brad and Annabelle Lewis; U. S. Fish and Wildlife Service; U. S. Navy.

Europe *Finland:* Hannu and Irma Hautala, Matti Torkkomaki. *Iceland:* Kristian Egilsson, Sigurgeir Jonasson, Hallgrimur Pordarson. *Norway:* Per and Tycho Anker-Nilssen, Asle Hjellbrekke and Hilde Svendsen, Hilde Støl Øyan. *Scotland:* Jamie Hepburn, Kenny Taylor.

Mexico and Central America *Belize:* Sharon Matola and the staff of the Belize Zoo, Tony Rath. *Mexico:* Patricia and Patricio Robles Gil, Pablo Cervantes, Carlos Gottfried, Fernando Holschneider; Agrupación Sierra Madre.

South America *Brazil:* Paulo Boute, Maria "Duka" do Carmo, Adalberto Eberhard, Renata Egito, Frederico de Freitas, Neiva Guedes, the late Claus Meyer, Orlando and Lea Rondon and the Rondon family, George Schaller; Estancia Caiman; Secretaria de Estado do Meio Ambiente, Mato Grosso do Sul. *Galápagos:* Linda Cayot and the staff at the Charles Darwin Research Station; Daniel and Tina Fitter, Godfrey Merlen and Gayle Davis-Merlen, Rafael Pesantes; Galápagos National Park Service. *Peru:* Alvaro del Campo, James Gilardi, Kurt Holle, Walter and Clotilde Mancilla, Jose Luis Moscoso, Charles Munn and Mariana Valqui Munn, Eduardo Nycander and the staff at the Tambopata Research Center, John Terborgh. *Surinam:* Frans Buissink, Henk and Judy Reichart; Stinasu.

North America *Canada:* The Borrowman family, Brian Ladoon, the MacKay family, Norbert Rosing, the late Peter Smith and the Kwikwasutinuxw band, Mark Thomas; Great White Bear Tours. *United States:* Bill Abbott, Ray Rodney, and the staff at Wilderness Travel; Bob and June Fields; Charles Horton and the staff at Zoo Atlanta; Burney LeBoeuf, Ken Norris, and the faculty of Environmental Studies at the University of California at Santa Cruz; Pete Myers; Sue Savage-Rumbaugh, Duane Rumbaugh, Kanzi, and the staff at the Language Research Center; David Tetzlaff, Tim Tetzlaff and the staff at Caribbean Gardens; Año Nuevo State Reserve; Cincinnati Zoo; Fossil Rim Wildlife Center; Klamath Basin National Wildlife Refuge; San Diego Zoo and Wild Animal Park; Santa Cruz City Museum of Natural History; U. S. Fish and Wildlife Service; Vancouver Aquarium.

PROFESSIONAL SUPPORT:

Many of the photographs were produced on assignment for magazine, book, and television projects for which I would like to thank the original sponsors. Others were made possible by the technical and professional support of the organizations and people mentioned below. Special thanks are due to the National Geographic Society for the resources, time, and trust that enabled me to go to the edge of my creative abilities.

National Geographic Society: John Agnone, Bill Allen, Leah Bendavid-Val, Bob Booth, Rich Clarkson, Bill Garrett, Bob Gilka, Bill Graves, Will Gray, Rob Hernandez, Tom Kennedy, Kent Kobersteen, Charles Kogod, Bob Madden, Bruce McElfresh, Al Royce, Mary Smith, Susan Smith. *National Wildlife Federation:* Jon Fisher, Steve Freligh, John Nuhn, Bob Strohm, Mark Wexler. *Gruner & Jahr:* Christiane Breustedt, Brigitte Barkley, Ruth Eichhorn, Uta Henschel, Josef Hurban, Sylvie Rebbot. *Nikon:* Scott Andrews, John Cole, Bill Giordano, Jerry Grossman, Steve Heiner, Richard Lopinto, Bill Pekala, Ron Taniwaki; Nikon Professional Services. *Fuji:* Tom Curley, John McCarthy.

Special thanks to: David Cavagnaro, Patrick Donahue, Jane and Russ Kinne, Barry Lopez, Roger Luckenbach, Tom Mangelsen, Peter Menzel and Faith D'Aluisio, Nick Nichols, Steve Pinfield, Galen and Barbara Rowell, and Isabel Stirling.

Sincere appreciation for help with this book to: George Steinmetz and Jane Vessels; to the staff at Frans Lanting Photography; Steve and Susan Kurtz; The New Lab in San Francisco; the staff at TASCHEN GmbH; and to Kristen Wurz for design and production assistance.

A personal word of thanks goes to Benedikt Taschen, who allowed for a creative freedom rare in book publishing today, and to Jenny Barry for her great sense of design, good judgment, and the kind of patience normally equated with wildlife photographers.

Finally I want to express my gratitude to Christine Eckstrom. Her talents, dedication, and encouragement have helped a caterpillar become a butterfly.

CONSERVATION ORGANIZATIONS:

In many of the wild places where I have traveled over the years I have been helped by dedicated representatives of the following conservation organizations. Without their support of my work, many of these photographs might not exist. Without our active support of their work, many of the animals featured in this book may not be around much beyond tomorrow. If these photographs affect you in any way, perhaps you might be inspired to find out how you can affect the survival of these creatures.

Wildlife Conservation Society
2300 Southern Boulevard
Bronx, New York 10460 USA
www.wcs.org

African Wildlife Foundation
1400 16th Street, N.W., #120
Washington, D.C. 20036 USA
www.awf.org

Conservation International
1919 M Street, N.W., #600
Washington, D.C. 20036 USA
www.conservation.org

The Nature Conservancy
4245 North Fairfax Drive, #100
Arlington, Virginia 22203 USA
www.tnc.org

World Wildlife Fund/USA
1250 24th Street, N.W.
Washington, D.C. 20037 USA
www.worldwildlife.org

WWF-Netherlands
Boulevard 12, 3707 BM Zeist
THE NETHERLANDS
www.wnf.nl

WWF-Germany
Rebstöcker Str. 55
60326 Frankfurt/Main, GERMANY
www.wwf.de

WWF International
Avenue du Mont-Blanc
1196 Gland, SWITZERLAND
www.panda.org

TERRA EDITIONS:

Fine prints of Frans Lanting's images are available through Terra Editions. Please visit www.lanting.com for details. For information about licensing Frans Lanting's images, please write to photo@lanting.com, or fax (831) 423-8324 (USA).

Terra Editions donates a portion of all proceeds to conservation organizations.

PAGE 252: *Polar Bear, Canada*

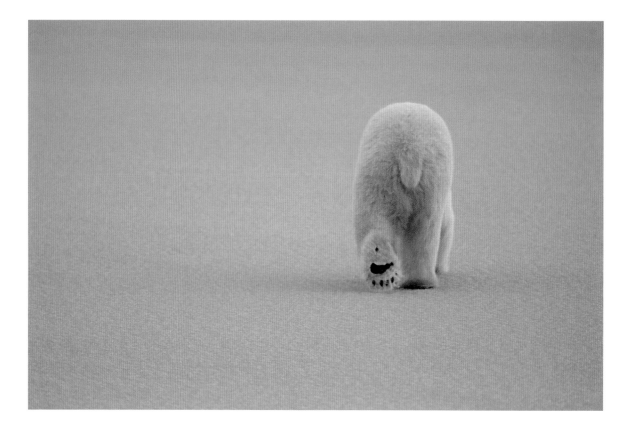